CHASING LIGHT

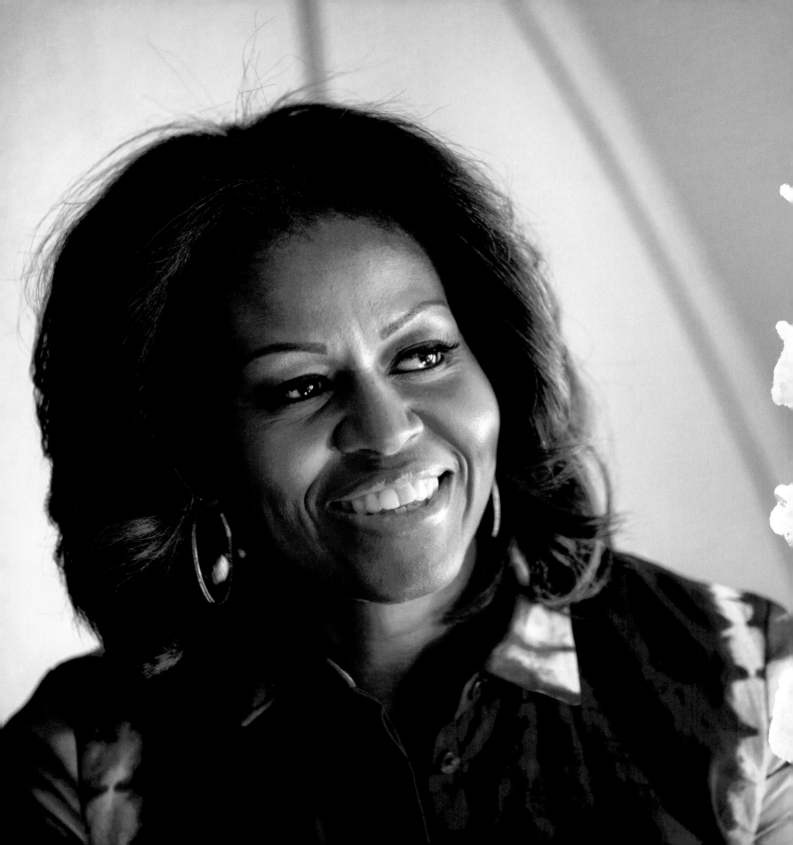

CHASING LIGHT

Michelle Obama

THROUGH THE LENS OF A WHITE HOUSE PHOTOGRAPHER

AMANDA LUCIDON

TEN SPEED PRESS
California | New York

For my mother, Janice, and my daughter, Eden, and to every mother encouraging her children to dream a bigger dream.

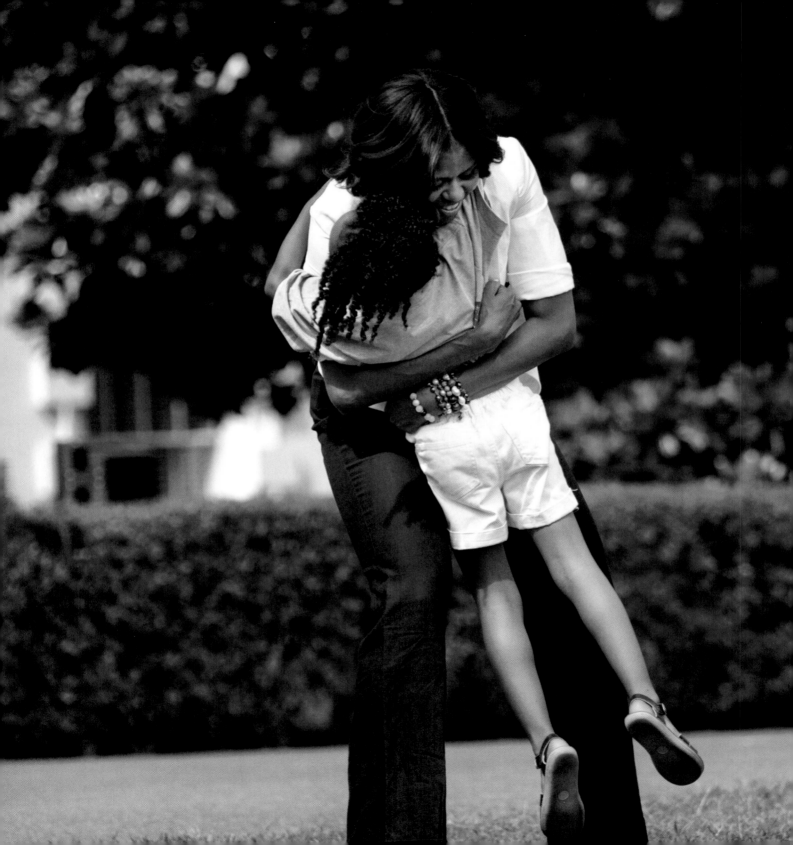

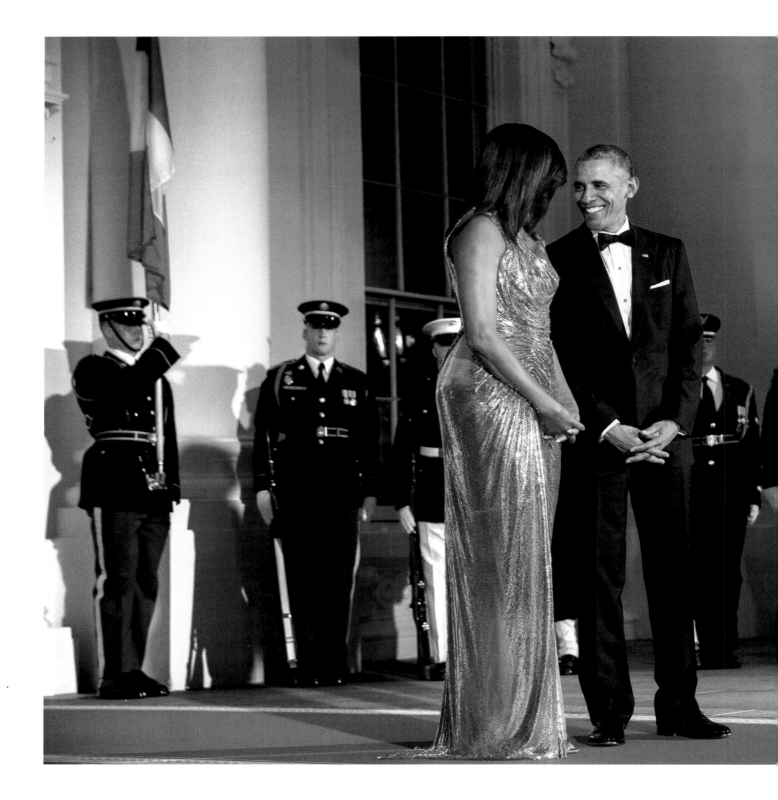

President Barack Obama and First Lady Michelle Obama share a moment on the North Portico as they await the arrival of Italian Prime Minister Matteo Renzi and Mrs. Agnese Landini for the State Dinner at the White House, October 18, 2016.

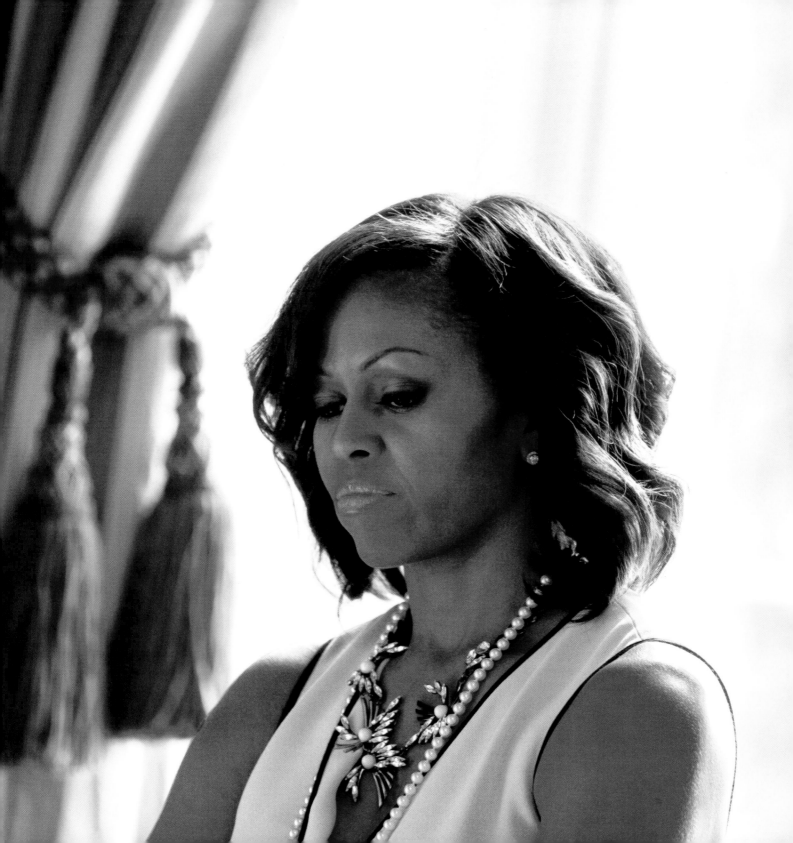

INTRODUCTION

January 20, 2009, is a day I will never forget.

I had just moved from California to Washington, DC, after taking a buyout from my job as a newspaper photographer. The industry was suffering, and the writing was on the wall. Rather than wait to be laid off, I took a leap of faith and relocated to an area that I believed would offer unlimited possibilities for a freelance photographer. But there was one thing I hadn't fully considered: DC was a very competitive market, and I had few connections on the East Coast. Working as a freelance photographer would prove to be a challenge.

As a photojournalist, I really wanted to cover the inauguration of President Barack Obama, since it was such an exciting time for our country. But for the first time in seven years, I wasn't affiliated with a newspaper, which meant I didn't have any press credentials. If I wanted to document the inauguration, I'd have to wake up early and get on a bus like everyone else. I'd have to brave the cold to hold a spot on the lawn among the masses.

So that's exactly what I did.

There was an energy and a kindness in the city that day, even as hundreds of thousands of people descended upon the National Mall. It was like nothing I had ever experienced. We were all tucked in tight without much space to move, but people were sharing snacks, hand warmers, and small talk with complete strangers. It was below 30°F, but there was a warmth about that special day.

I thought back to the conversation I'd had with my father the night before. We didn't typically talk about politics, but he brought it up because he was especially optimistic about the state of our country. He told me that Barack Obama reminded him of his own father—a kind man with a solid ethical core. And most important, he was a man of integrity. I felt the same way. Before moving to DC, I didn't spend much time following politics. But there was

something different about Barack and Michelle Obama. They seemed grounded and optimistic. Their message was about hope rather than despair. Their authenticity inspired me. It was the first time in my life that I felt like I could truly relate to our President and First Lady.

The night of the inauguration, my father stayed up late watching coverage of all ten inaugural balls. While the rest of America was watching our new President and First Lady dance and celebrate, my father was scanning the background of each event, looking for me in the crowd. He thought I might be there taking pictures with the press. But I wasn't. Instead, I was at home, editing the images I'd shot earlier that day from the crowd's perspective. He didn't know how far I still had to go to make it as a photographer in this city.

My father died of a heart attack the next morning.

Four years later, I got an unexpected phone call. The Chief White House Photographer, Pete Souza, called to ask if I'd be interested in applying for a job as an official White House photographer covering the First Lady. At first, I wondered if I was the right person for the job because I wasn't a seasoned political photographer. I had spent most of my career focusing on social issues, especially stories about equality. It took me a few days to connect the dots. But I got the position, along with the honor to document our nation's first African American First Family.

I couldn't help but think maybe my dad knew something all along.

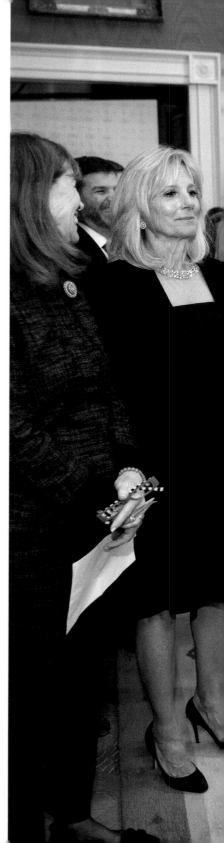

Mrs. Obama, Dr. Jill Biden, and staff share a moment in the Green Room before the last Joining Forces event at the White House, November 14, 2016.

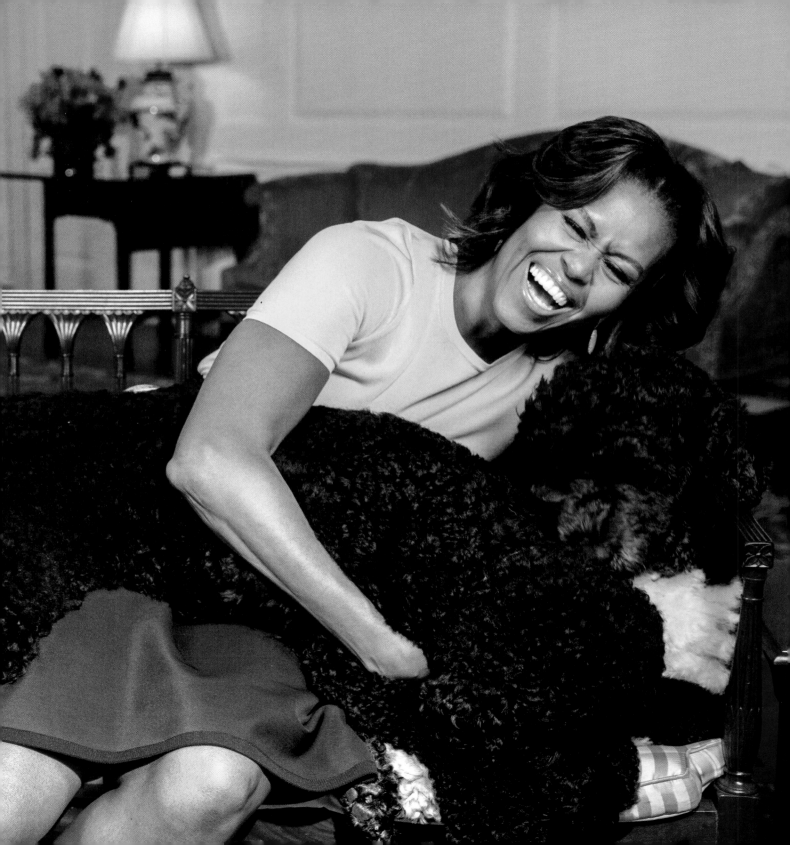

Chapter 1

INSIDE THE BUBBLE

I imagine that my first encounter with First Lady Michelle Obama was similar to many other people's experience—it was quick, I have no idea what I said, and I could hardly see because I was smiling so big. I imagine Mrs. Obama said something like "Welcome to the team. We are glad to have you." But I can't be certain, because it was all a blur. In my head I was thinking, *Wow! She's so tall . . . and pretty . . . and nice!* When she walked away, I immediately started thinking, *Geez, I hope I didn't look or sound foolish.* It was hard to imagine that I would spend the next four years in her company.

I would come to learn that I wasn't alone in my shell shock. For my first few weeks at the White House, I shadowed the other photographers before I started taking pictures on my own. On the first assignment with Mrs. Obama, I was shadowing my colleague Lawrence Jackson as he shot a very long photo line in the Blue Room. About three hundred people were lined up to meet the First Lady and have their photo taken with her before an event. I watched each of them have their own reaction to meeting her. Some covered their mouths in awe, while others fanned themselves or had trouble catching their breath. Some laughed, some cried, some couldn't speak. Others just stood there with a big goofy grin as they smiled and nodded (while I kicked myself for doing the same thing!). During my time as a White House photographer, I would see this time and time again. The First Lady was accustomed to meeting a lot of people. But *they* were not used to meeting the First Lady. I realized that if I was going to do my job effectively, I'd have to find a way to get comfortable being in Mrs. Obama's presence.

· · ·

What's a typical day for a White House photographer? I've been asked that many times. The truth is, there wasn't a typical day. Every day was different, and I loved that. It could be busy and exciting or slow and routine. But we always had to be ready, because slow days could turn into busy ones quickly and unexpectedly. Our

team of five White House photographers documented the day-to-day duties and the official events of the President, First Lady, and Vice President. Pete Souza, the Chief White House Photographer, documented the President, while David Lienemann covered the Vice President. I primarily covered the First Lady. But Chuck Kennedy, Lawrence Jackson, and I often found ourselves photographing both the President and First Lady, especially for big events where two or three photographers were needed to cover multiple angles. Our job was to document the presidency for the historical record. It was a responsibility that we took very seriously.

I felt like I had the best of both worlds: I was fortunate to be able to assist with coverage of President Obama, while spending most of my time with the First Lady. I covered meetings, formal remarks, official events, photo lines, tapings, performances, and state visits as well as domestic and international travel. Mrs. Obama enjoyed adding some fun to the mix. She loved to drop by and surprise people, in and out of the White House, which always made for great photos. I really admired the way the First Lady maintained such a serious role, yet she loved to laugh. Mrs. Obama's interactions with kids and animals, skits with comedians and celebrities, and light-hearted moments with staff members brought a refreshing levity to this high-pressure environment.

I learned that arriving early was essential. It was not only important to stay inside "the bubble"; being early also meant I could assess the setting, capture some interesting behind-the-scenes moments, and be prepared for any last-minute changes. A certain phrase became ingrained in my mind: "The motorcade only waits for one person . . . and it's not you." I had heard stories from White House staffers of current and past administrations who warned, "Don't get left behind." I heard about a photographer who missed the motorcade after trying to get a unique angle, and about a staff member sleeping through an alarm on an exhausting overseas trip. Missing the motorcade (or worse yet, the plane)

was by far my biggest fear. For a White House photographer responsible for documenting history, missing the motorcade or plane would mean there would be no official photos taken of the event. This anxiety never really went away throughout my time at the White House.

But it was a thrilling job that afforded me amazing opportunities. I was able to witness and document history, while learning from and being inspired by the President and First Lady. There were so many things that never stopped being exciting, like flying on Air Force One. The first time I boarded the President's plane, I was overwhelmed. I had no idea how I'd find my seat on this enormous, beautiful plane. I just followed the seasoned White House staffers, who led me past the President's cabin, doctor's office, and conference room back to the roomy staff cabin. There were two pods of four chairs around two tables, plus another two chairs on the far side of the plane by the window.

"Ms. Lucidon, you're seated over there," said the Air Force One attendant.

I walked over to the window seat and saw the place card that read "Welcome to Air Force One, Ms. Lucidon." I remember feeling so proud to see my family name on that card. My great-grandfather changed our last name from Lucidonio to Lucidon because he found it was too difficult to get a good job with an Italian last name. I looked at our modified family name and thought about the generations of immigrants that came before me and the struggles they endured as manual laborers. Now the Lucidons (and the Lucidonios!) had a seat on Air Force One.

I looked around at the cabin of staff members and recognized that we came from many different backgrounds. We each had a place card with our family name represented, and everyone was welcome.

Moments like those constantly reminded me how special it was to work in the White House.

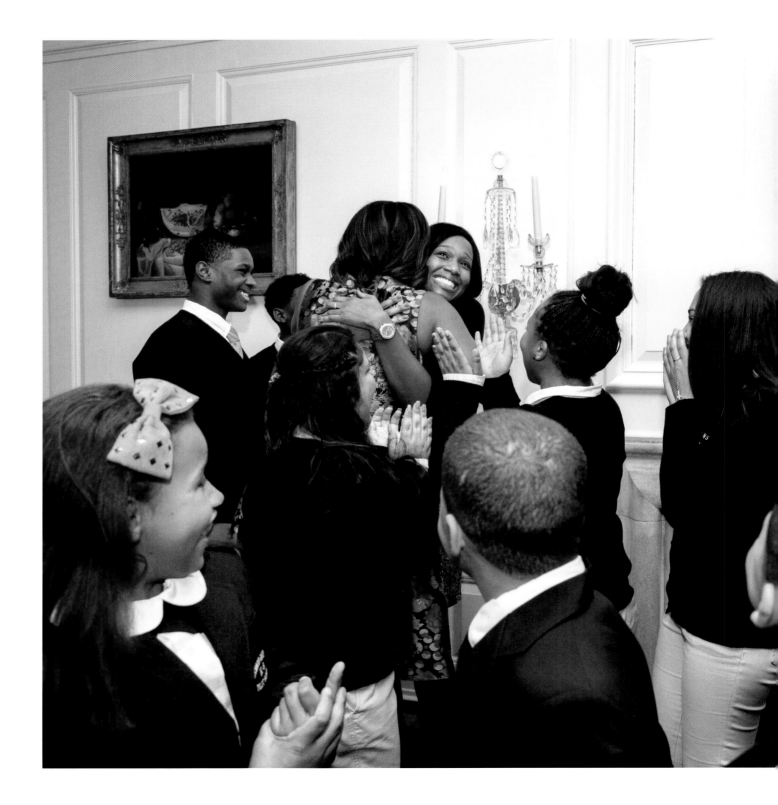

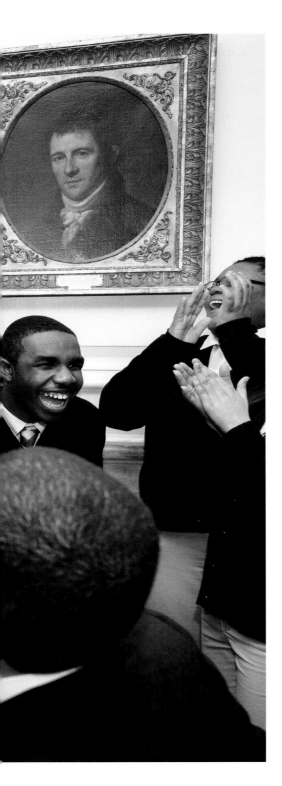

It would have been easy to make Mrs. Obama central to every photo. But I've always found that some of the most interesting moments are the ones happening at the edges of the frame.

At one time, Orchard Gardens was one of the lowest-performing schools in Massachusetts and among the lowest-ranked 5 percent of schools in the country. In 2010, Orchard Gardens was named a "Turnaround Arts" school, one of several arts and humanities pilot schools supported by the Obama Administration. After three years of integrating the arts into school programming, Orchard Gardens became one of the most improved Massachusetts schools.

When Orchard Gardens students performed during a White House luncheon for Mrs. Obama and the National Governors Association spouses, they rapped about not letting circumstances define them. They challenged the audience not to judge a book by its cover. And they recited a beautiful and humorous poem about the First Lady. Mrs. Obama was very moved by the students and the performance. After the luncheon, she stopped into the Map Room to surprise them. The whole room burst with excitement when Mrs. Obama walked in.

Mrs. Obama surprises students
from Orchard Gardens of Boston,
Massachusetts, in the Map Room of
the White House, February 24, 2014.

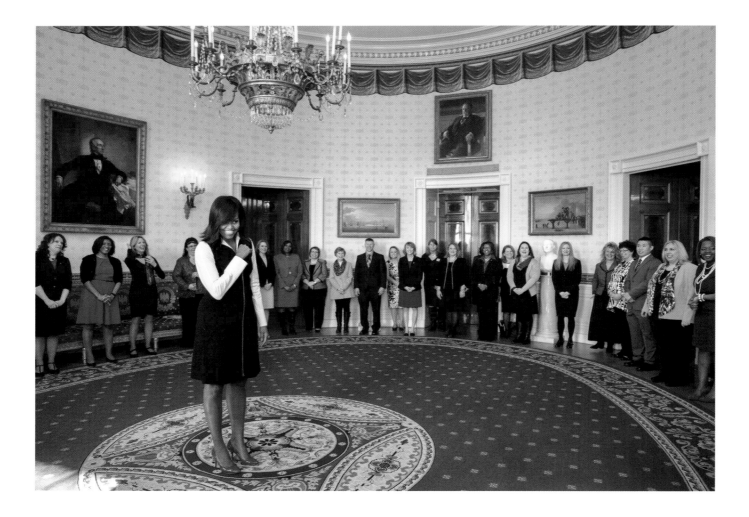

The First Lady greets counselors
in the Blue Room prior to the Reach
Higher Counselor of the Year event,
January 28, 2016.

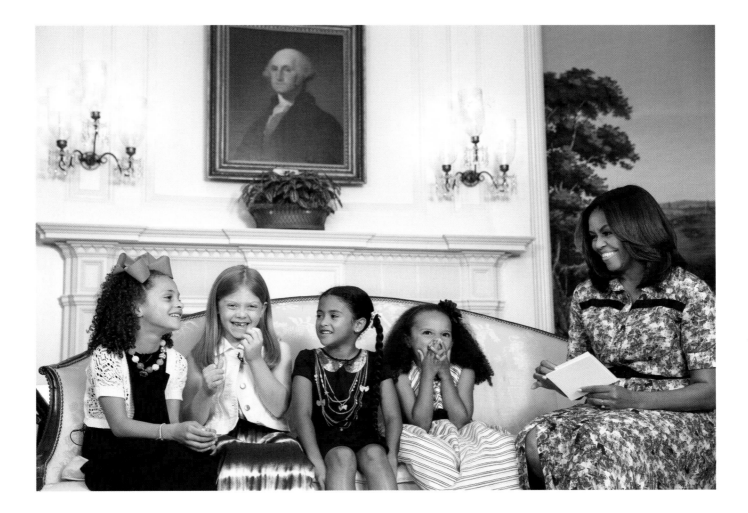

Mrs. Obama receives travel advice from girls during a taping for *Cosmopolitan*, in the Diplomatic Reception Room, June 22, 2016.

The First Lady often hosted spouses of foreign dignitaries at the White House. To make her guests feel welcome, Mrs. Obama would hold a special event in honor of their visit.

In this case, Mrs. Obama learned that her guest, Kalsoom Nawaz Sharif, wife of Pakistan's Prime Minister, enjoyed poetry, so she held a poetry recital in the Blue Room. She invited several American poets to participate, including former Poet Laureate Billy Collins. The room was filled with laughter as he recited "The Lanyard," a humorous poem about the gift he made for his mother at summer camp.

Mrs. Obama welcomes Kalsoom Nawaz Sharif before a poetry recital in the Blue Room of the White House, October 23, 2013.

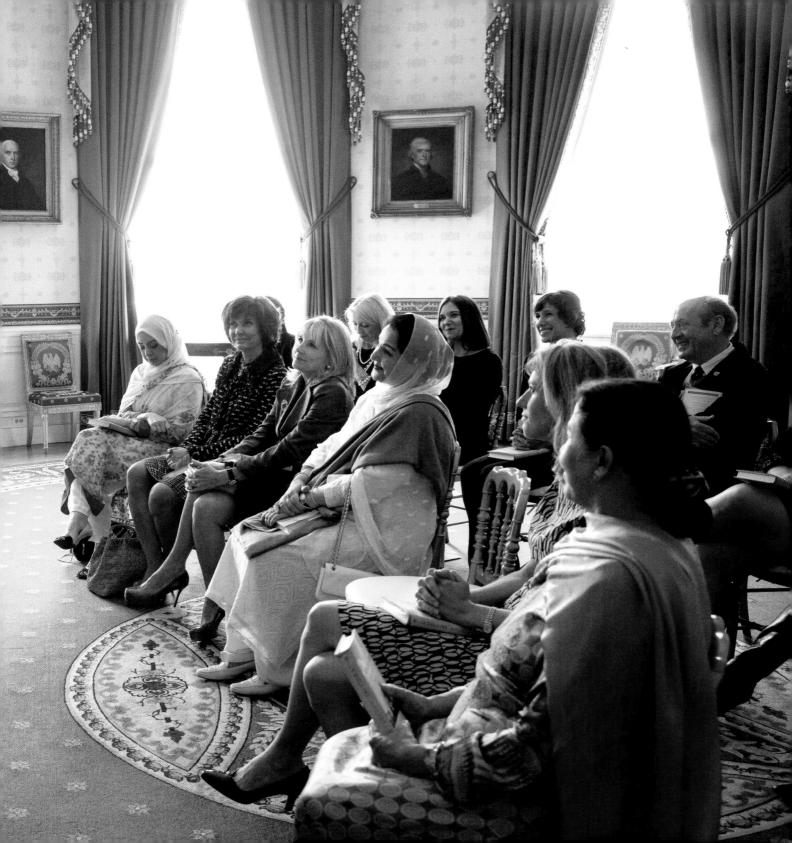

Mrs. Obama sings and dances along with Soul Children of Chicago as they perform during a symposium on advancement for women and girls in Africa at the John F. Kennedy Center for the Performing Arts in Washington, DC, August 6, 2014.

Following spread, left and bottom right: Mrs. Obama greets Mathtastic girls and joins Oprah Winfrey for a conversation about "Trailblazing the Path for the Next Generation of Women" during the United State of Women Summit at the Walter E. Washington Convention Center in Washington, DC, June 14, 2016.

Following spread, top right: Mrs. Obama greets students following keynote remarks at *Fortune* magazine's annual Most Powerful Women Summit dinner at the National Portrait Gallery, Smithsonian Institution in Washington, DC, October 13, 2013.

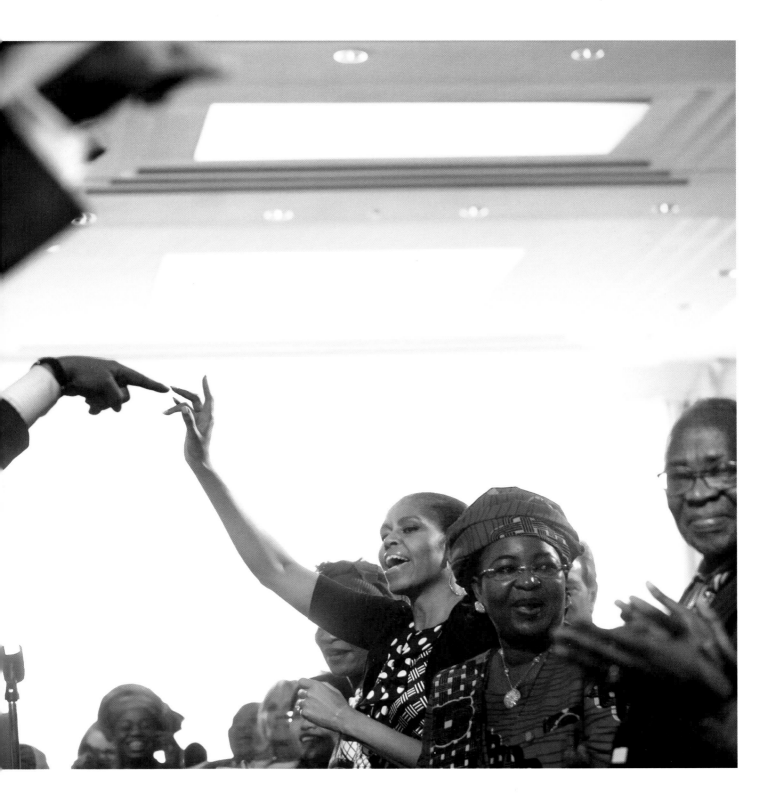

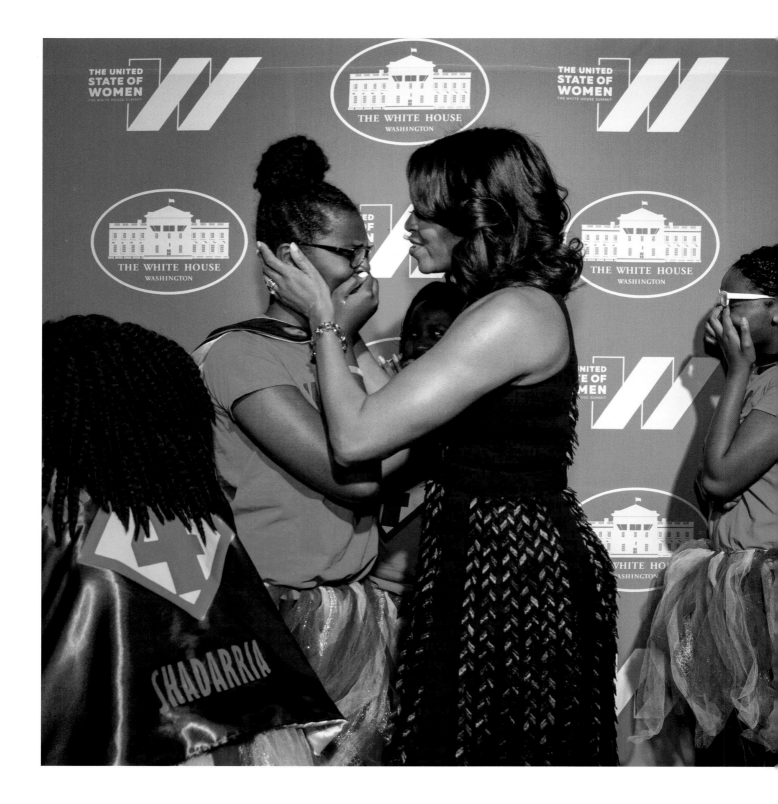

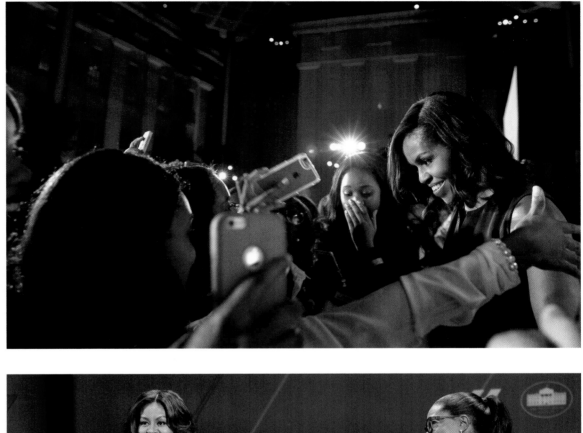
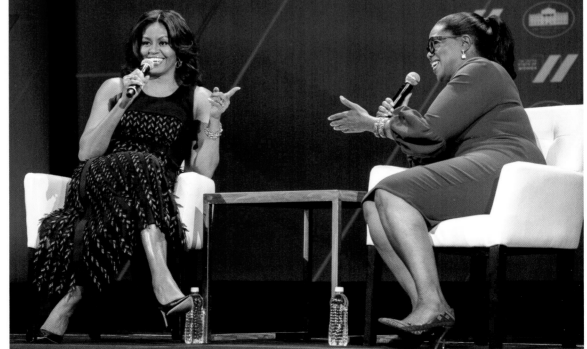

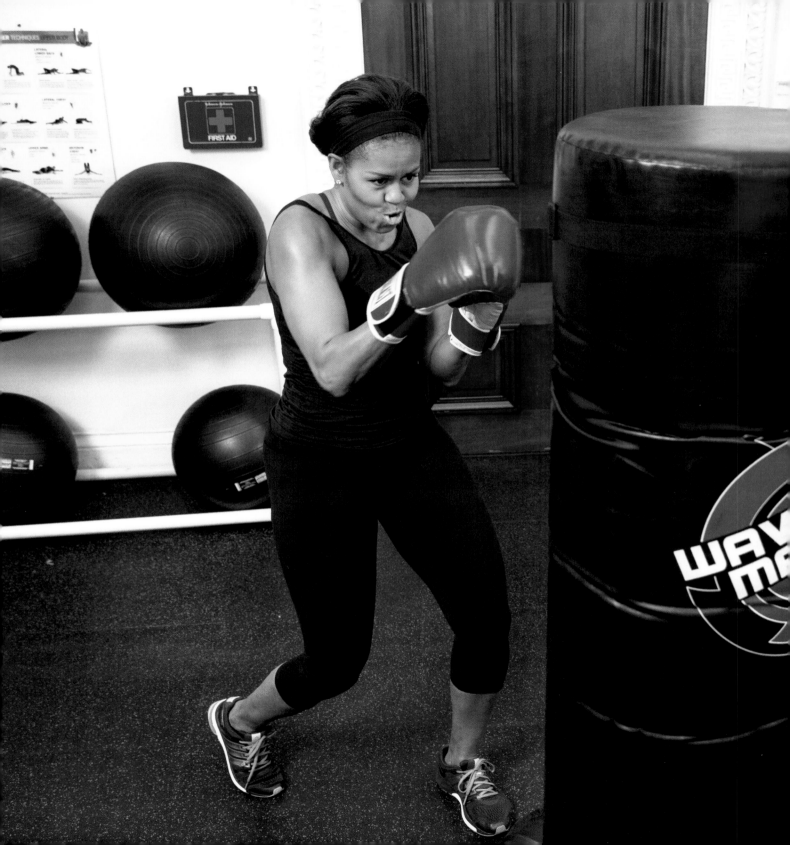

Mrs. Obama demonstrates her boxing skills during a Let's Move taping in the Eisenhower Executive Office Building Gymnasium of the White House, May 12, 2015.

Students react to seeing the First Lady during a ceremony to unveil the name of the baby panda at the Smithsonian's National Zoo in Washington, DC, September 25, 2015.

Several times a year, Mrs. Obama made surprise visits to children's hospitals. The rooms were often very small and the staff stayed out so Mrs. Obama could have candid discussions with the patients and families.

I usually trailed behind the First Lady, making my presence known quietly and only taking photos when I got the nod of approval from the parents. Even though I had my camera on quiet mode, I made a few frames to avoid interfering with the intimacy of the conversation.

Mrs. Obama talked to them about school, favorite hobbies, and their treatment. She adapted to each situation: being the nurturing mother, a sympathetic listener, or a silly friend.

We brought cookies made by the White House pastry chef to leave with the kids. They were shaped and frosted to look like Bo and Sunny, the Obamas' dogs. Since it was only me and Mrs. Obama in the room, I put the cookies in my suit pocket and waited for the cue to hand them to her. It was nice to see the kids light up when Mrs. Obama presented them with the Bo and Sunny cookies.

Mrs. Obama visits with Camron Stevens in his room at St. Jude Children's Research Hospital in Memphis, Tennessee, September 17, 2014.

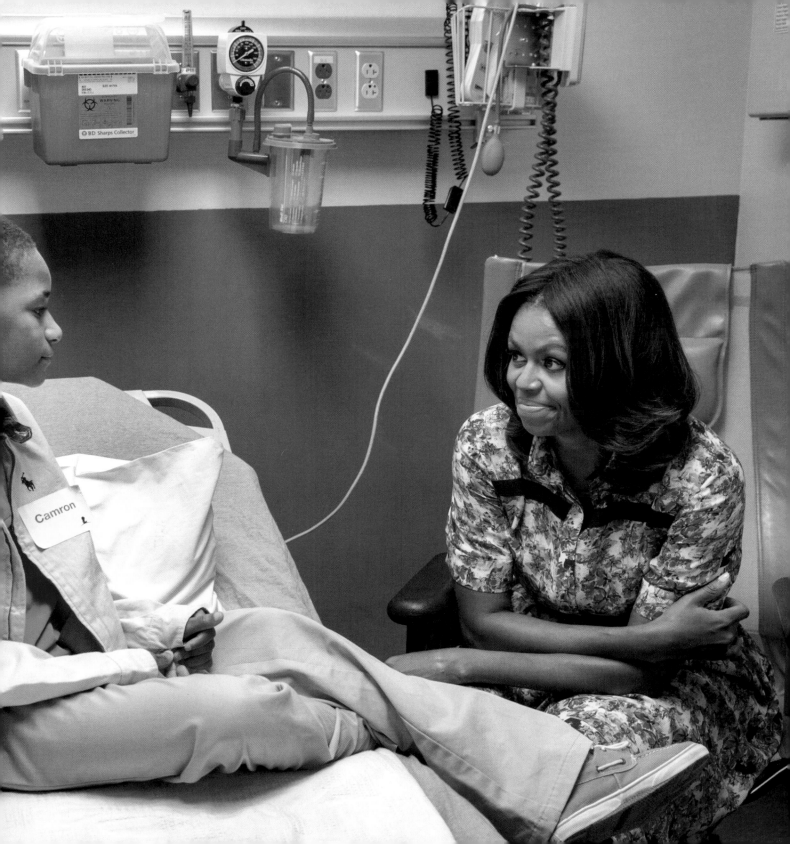

Every fall, spring, and summer, the White House welcomed a new class of interns. One of the perks of the internship program was the opportunity to hear from prominent leaders in the Obama Administration through the speaker series. Interns were always especially excited to hear from the President, Vice President, and First Lady.

Instead of giving formal remarks, Mrs. Obama preferred to create a relaxed environment. She made the students laugh and feel comfortable, and she encouraged them to take advantage of the time by asking questions.

I really enjoyed shooting these events because I learned so much from the answers to students' questions. The First Lady gave great advice and offered inspiring words that benefited everyone in the room, including me.

The First Lady gets comfortable after a long day of official events, while answering questions from White House spring interns in the South Court Auditorium of the Eisenhower Executive Office Building, April 2, 2014.

President Barack Obama and First Lady
Michelle Obama walk from Marine
One on the White House South Lawn,
September 29, 2015.

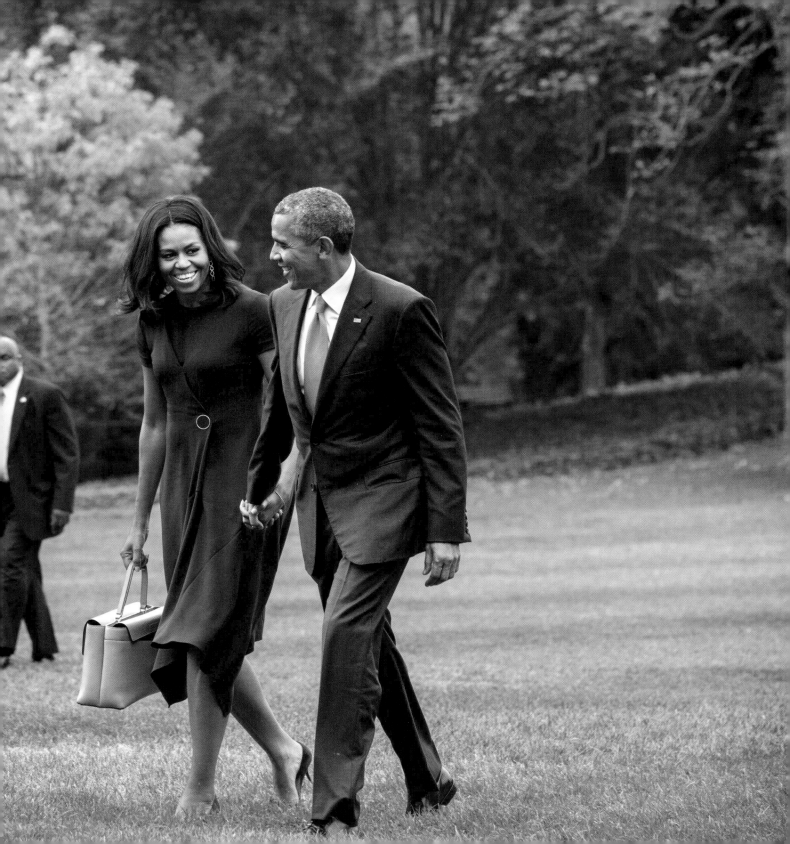

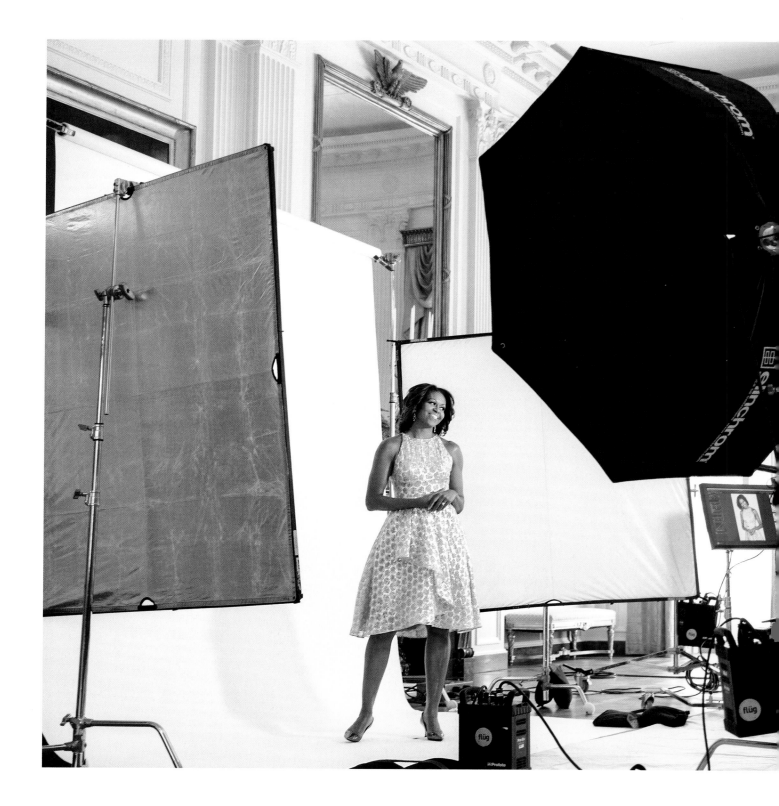

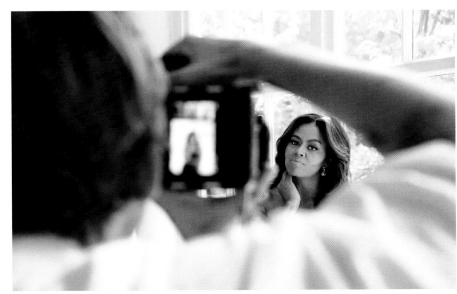

Above: The First Lady participates in an *InStyle* cover photo shoot in the East Colonnade of the White House, July 13, 2016.

Left: Mrs. Obama participates in a photo shoot for *Ladies' Home Journal* in the East Room of the White House, September 18, 2013.

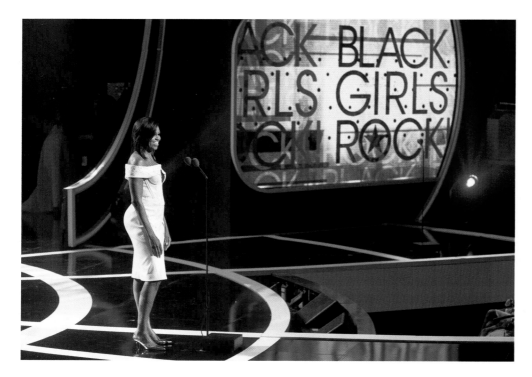

Above: Mrs. Obama delivers remarks at the "Black Girls Rock!" event at the New Jersey Performing Arts Center in Newark, New Jersey, March 28, 2015.

Right: Attendees, including Will Smith, Jada Pinkett Smith, Willow Smith, and Cicely Tyson, give the First Lady a standing ovation.

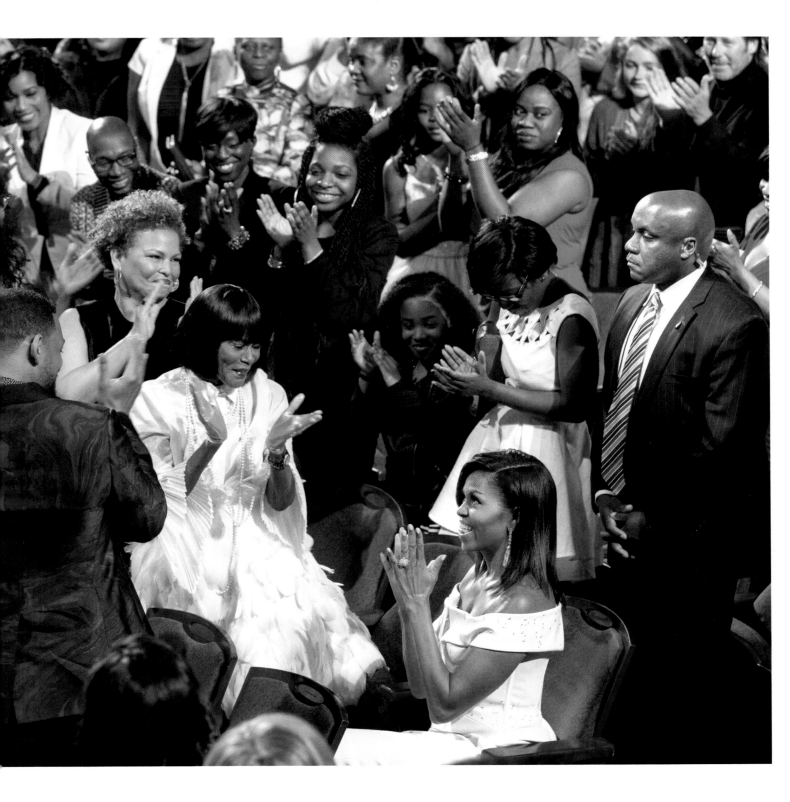

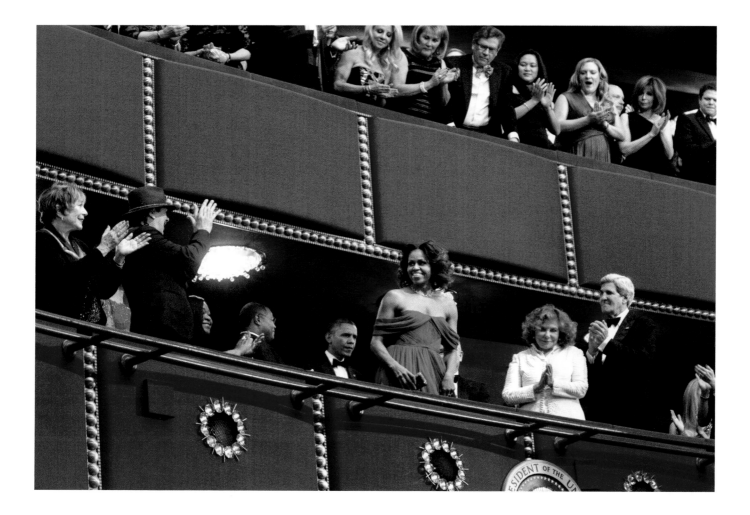

Above and right: President Obama and
Mrs. Obama attend the Kennedy Center
Honors at the John F. Kennedy Center for
the Performing Arts in Washington, DC,
December 8, 2013.

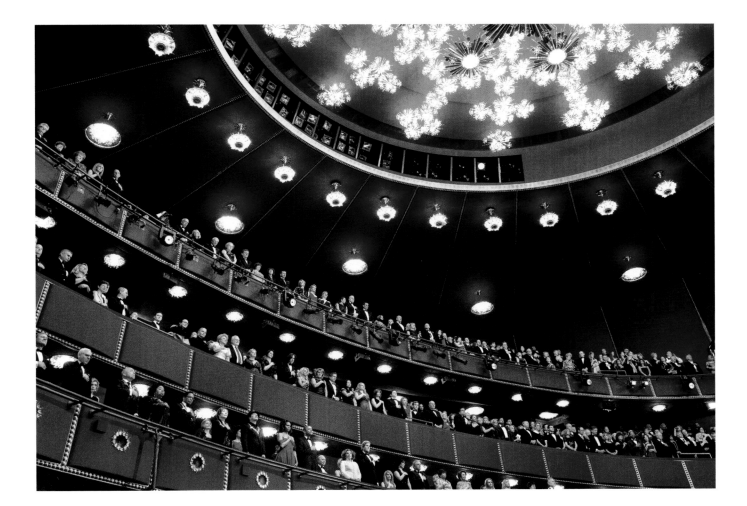

President Obama and Mrs. Obama typically attended cultural events at the John F. Kennedy Center together. But on this night, Mrs. Obama arrived alone and took her seat in the Presidential Box for the Kennedy Center Honors. Meanwhile, the President was delivering unscheduled remarks to the nation regarding the terrorist attacks in San Bernardino, California.

Although this was a difficult time for our country, it was important to show the world that we are resilient. Even in our darkest times, Mrs. Obama was a shining beacon of light and hope.

A Secret Service agent opens the door as Mrs. Obama enters the Presidential Box for the Kennedy Center Honors at the John F. Kennedy Center for the Performing Arts in Washington, DC, December 6, 2015. Tyler Perry, along with other box guests, stands to greet her.

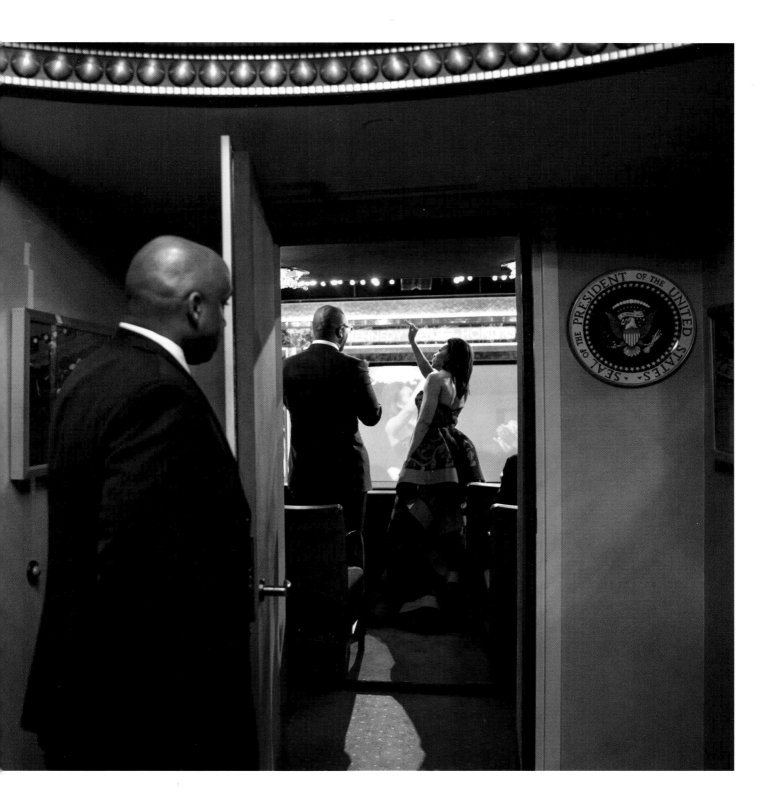

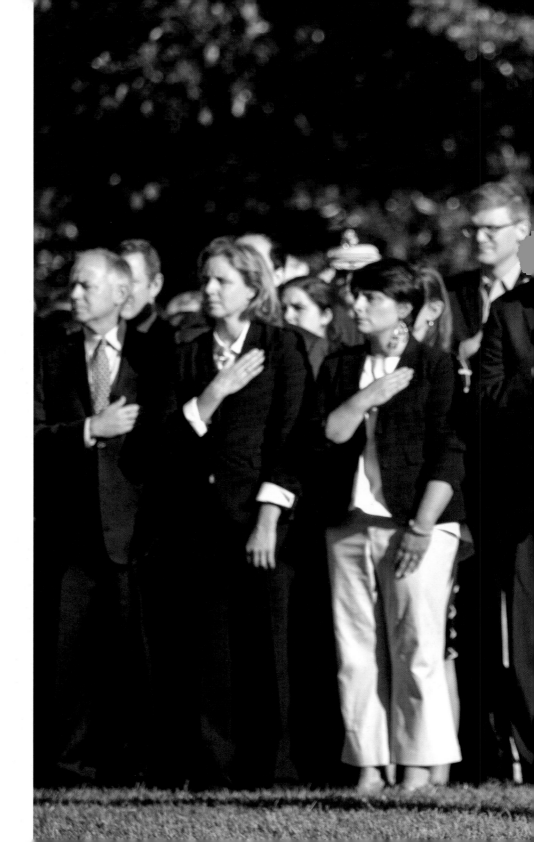

President Obama and Mrs. Obama observe a moment of silence to mark the anniversary of the 9/11 attacks, on the South Lawn of the White House, September 11, 2015.

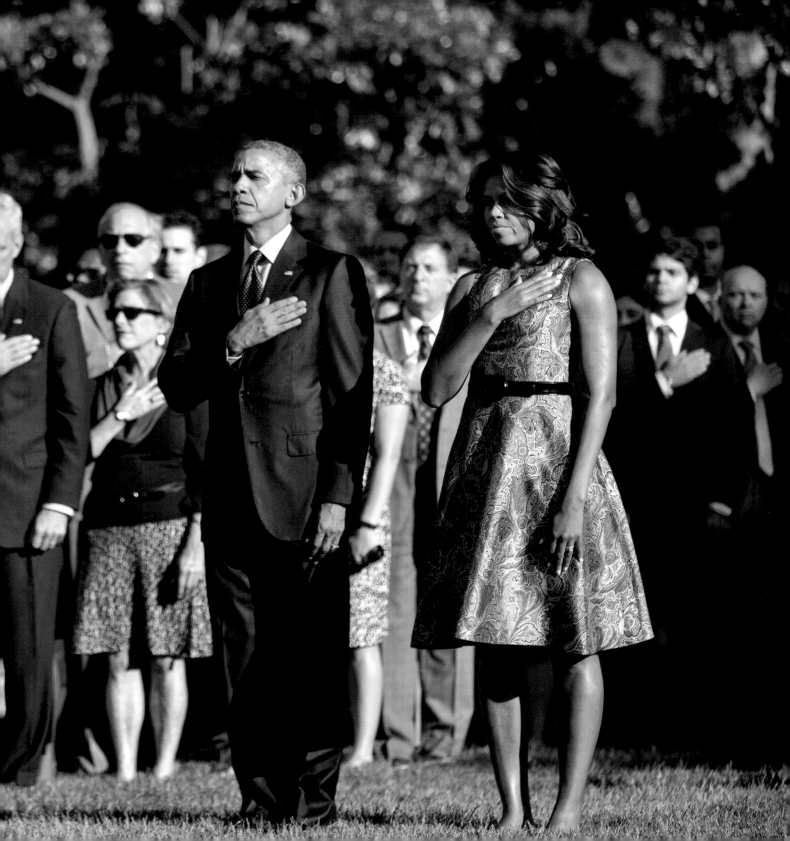

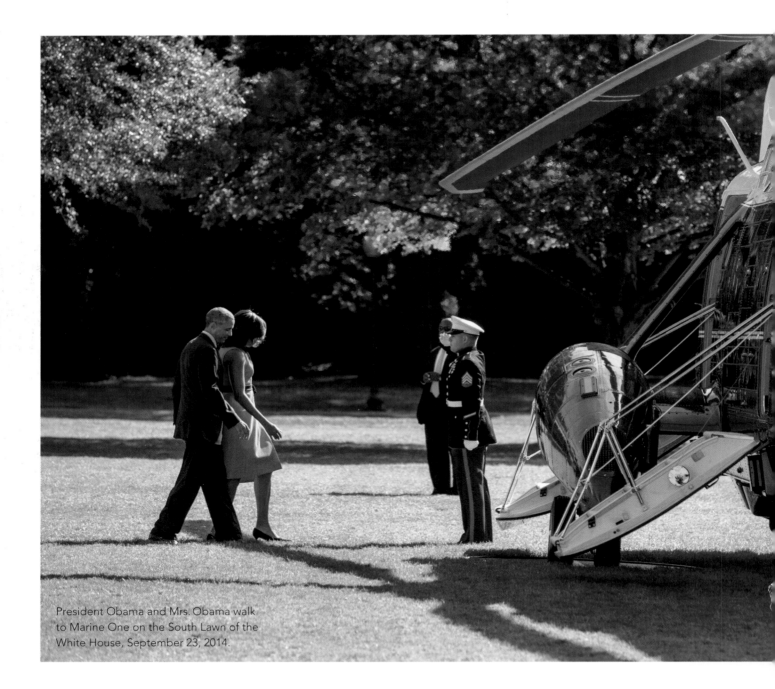

President Obama and Mrs. Obama walk to Marine One on the South Lawn of the White House, September 23, 2014.

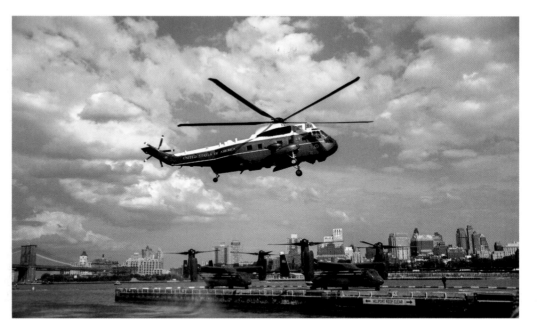

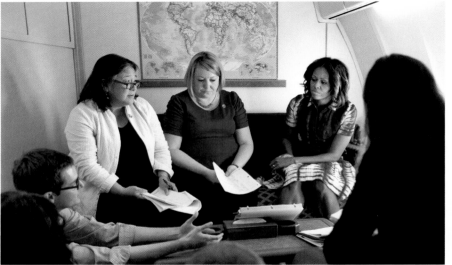

Mrs. Obama meets with members of
her staff aboard her plane, Bright Star,
September 12, 2013 (above), and
May 2, 2016 (right).

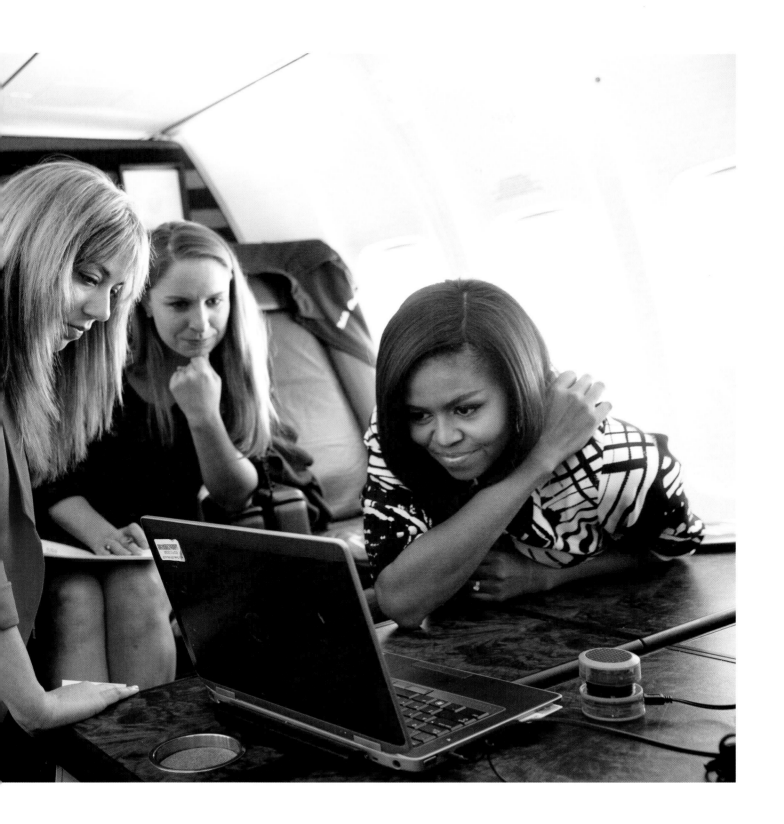

The First Lady boards Bright Star at Orlando International Airport, July 1, 2014.

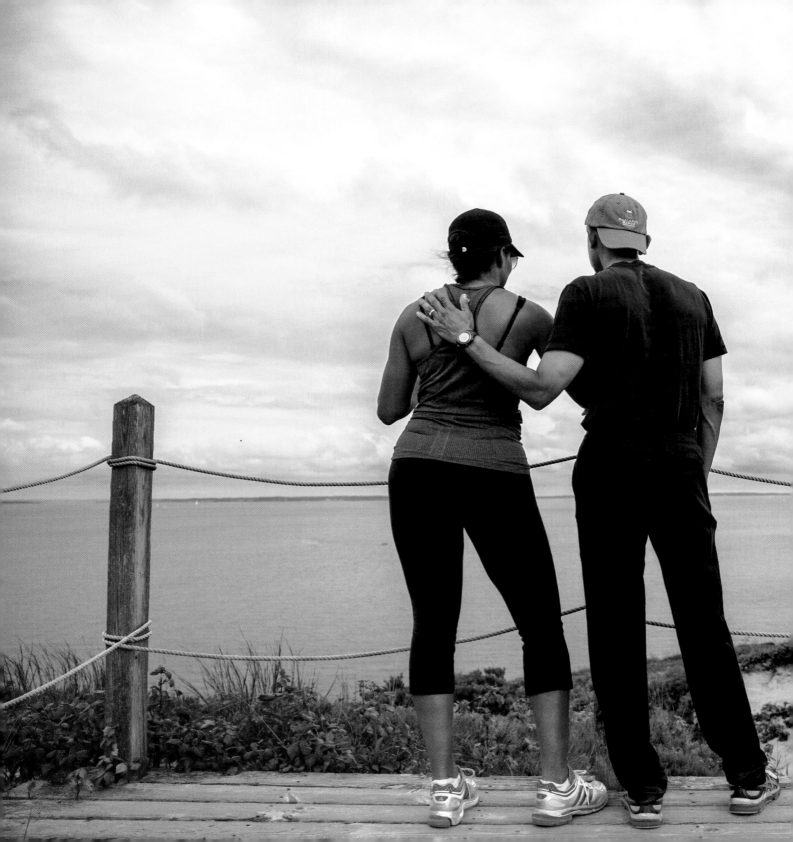

President Obama and Mrs. Obama take in the view while on a hike in Chilmark, Martha's Vineyard, Massachusetts, August 22, 2014.

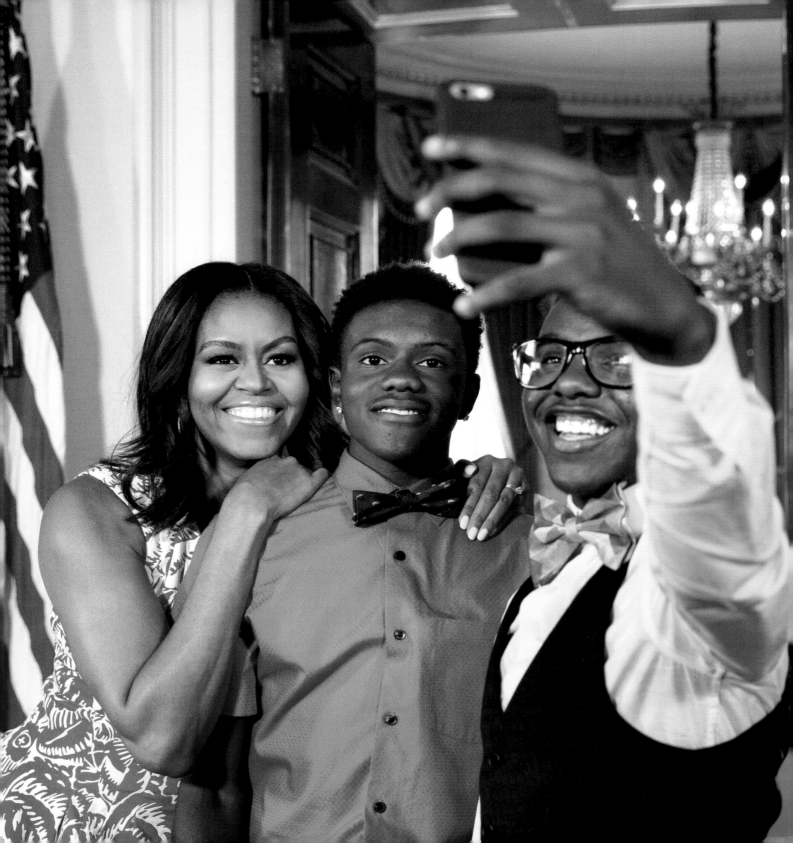

Chapter 2

THE PEOPLE'S HOUSE

I once heard a longtime White House usher refer to the White House as a "living, breathing museum." It seemed like the perfect way to describe it, because it paid homage to the history of the residence, art, and furniture, and most important, the people who came before us.

One of my favorite things was to slowly ascend the stairs from the Lower Cross Hall to the East Room. If you're paying close attention, you can feel the indentations in the steps where the marble is worn with history. I liked to imagine whose footsteps I was walking in.

Often, because I arrived early for my assignments, I would find myself alone in various rooms of the White House. That meant that I had the time to study details on a lamp in the Grand Foyer, the ornate feet on the sofa in the Red Room, the Native American art in the Library, and the wallpaper in the Diplomatic Reception Room. I could take a moment to admire Mrs. Obama's choices of art by Alma Thomas and Josef and Annie Albers in the Old Family Dining Room.

It also gave me time to talk with the ushers and butlers who've cared for the White House residence for decades. They shared their favorite personal memories from varied administrations and interesting facts about the history of each room. I learned that Teddy Roosevelt held a wrestling match in the East Room, while Abigail Adams used it to dry laundry. And Dolley Madison saved the portrait of George Washington from the fire set by British troops in 1814. It still hangs in the East Room today. There was so much to learn and appreciate.

President Barack Obama and First Lady Michelle Obama wanted everyone to be able to experience the history of the White House. They made it their mission to open the doors to as many people as possible. The First Lady often referred to it as the "People's House" and emphasized that it belongs to every American. It was amazing to witness the Obamas' efforts to make sure that White House guests

felt welcome there. The guests of the Obama White House reflected our diverse nation: young, old, black, white, rich, poor, religious, agnostic, gay, straight. It was a place of inclusion. Everyone was welcome, even those who felt like they didn't belong, including myself.

Through the lens of my camera, I watched Mrs. Obama make everyone feel at home. She inspired students through arts education workshops and highlighted their talents in performances presented at the White House. She delivered poignant remarks that moved her audiences; she hosted foreign leaders with dignity and grace. She made guests feel loved through her kind words and thoughtful consideration.

It was inspiring to see. Many times, as I photographed a special moment in history, I had tears in my eyes. I will never forget the chills I felt when I saw the determination of seventy-five young black girls practicing an African-inspired dance in the State Dining Room under Abraham Lincoln's portrait. Or the time when a student poet nervously introduced her two moms to Mrs. Obama, only to be greeted with open arms. Or the squeals of excitement from a group of Liberian schoolgirls who got the opportunity to leave their small town for the first time in their lives to be welcomed as Mrs. Obama's special guests at the White House for the screening of a documentary they were featured in about global girls' education.

Mrs. Obama led by example and showed that the People's House was really ours, and that inclusivity leaves no one out.

President Obama, Mrs. Obama, and former Presidents Jimmy Carter and Bill Clinton depart a ceremony commemorating the fiftieth anniversary of the historic March on Washington for Jobs and Freedom and Dr. Martin Luther King Jr.'s "I Have a Dream" speech, at the Lincoln Memorial in Washington, DC, August 28, 2013.

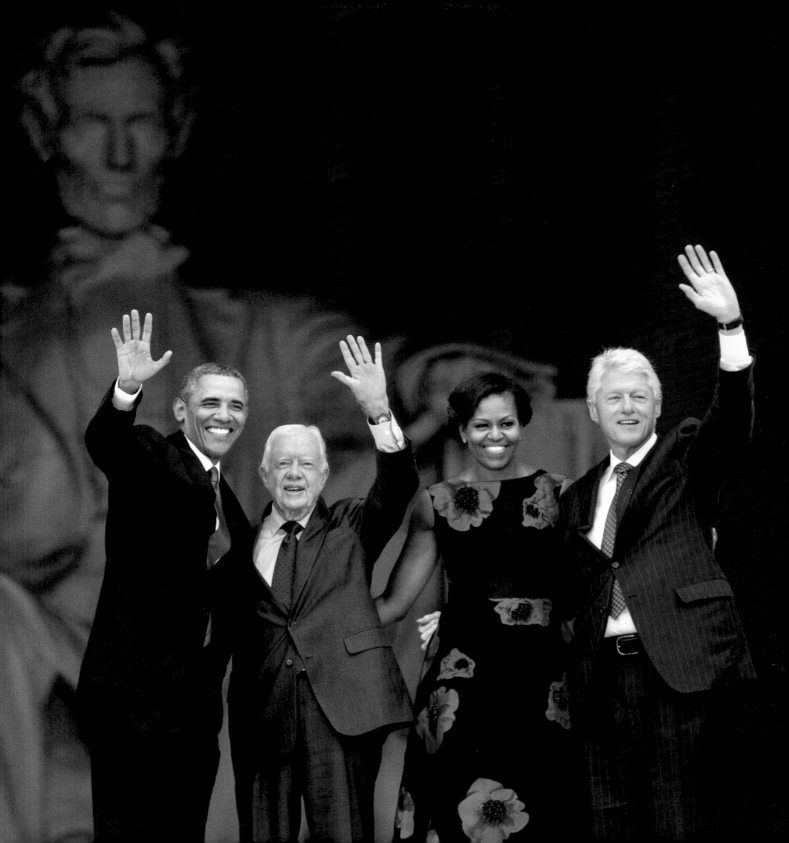

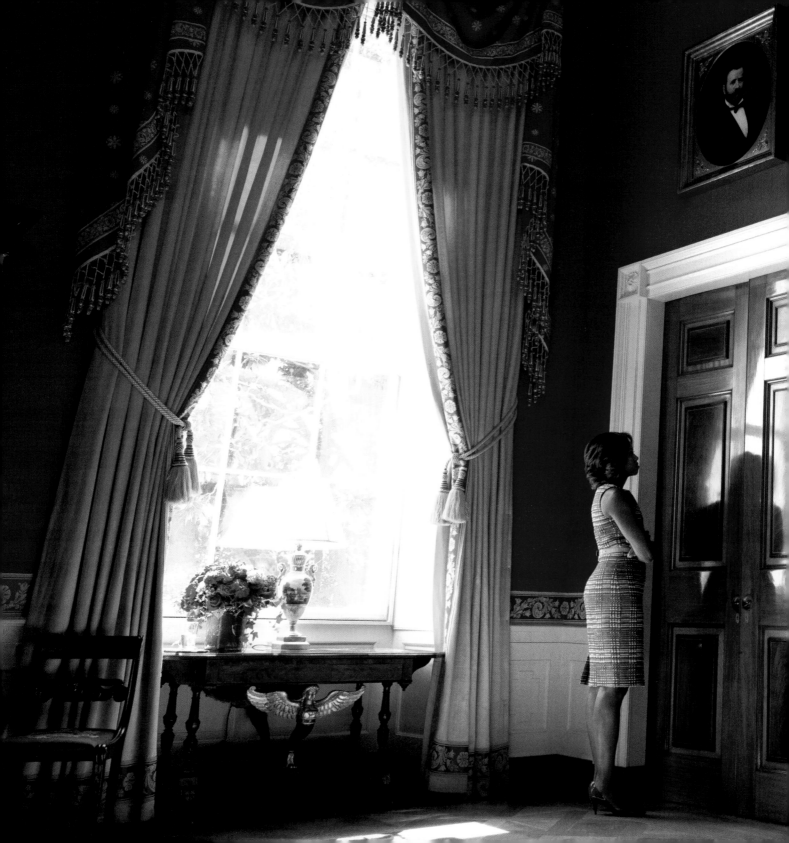

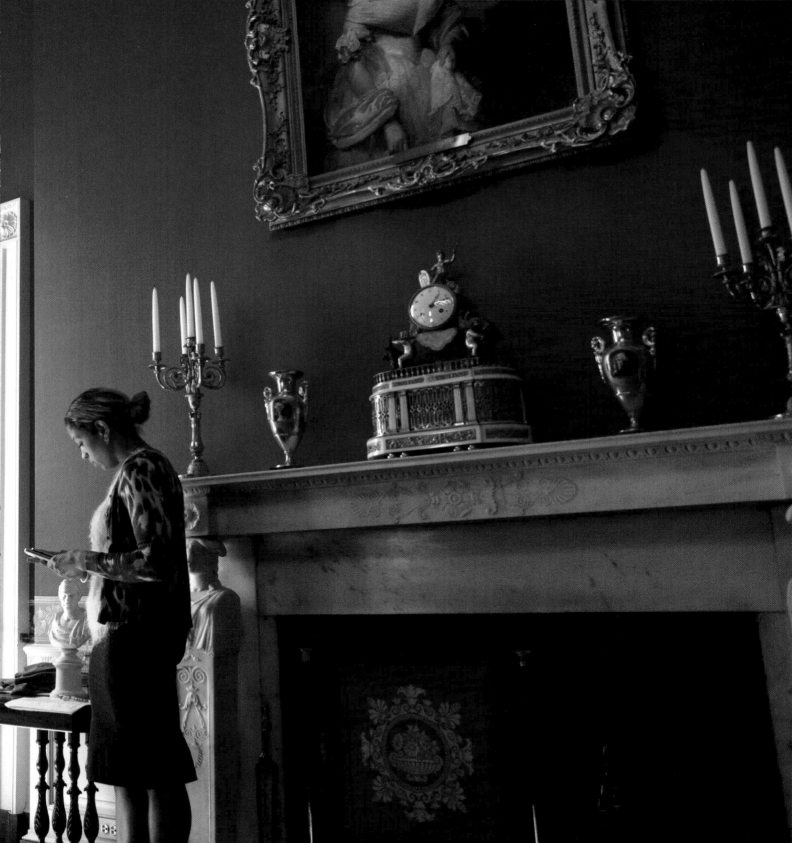

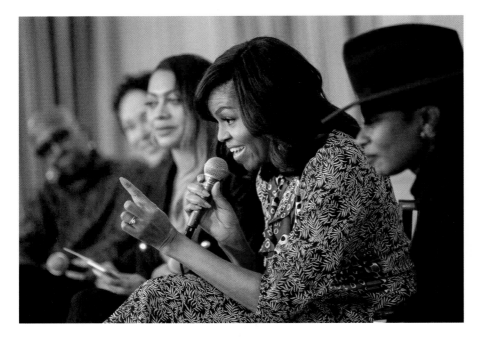

Above and right: The First Lady participates in a panel discussion with students during a dance workshop in the State Dining Room of the White House, February 8, 2016.

Previous spread: Mrs. Obama waits in the Red Room with personal aide Kristin Jones prior to a Let's Move! event at the White House, September 18, 2013.

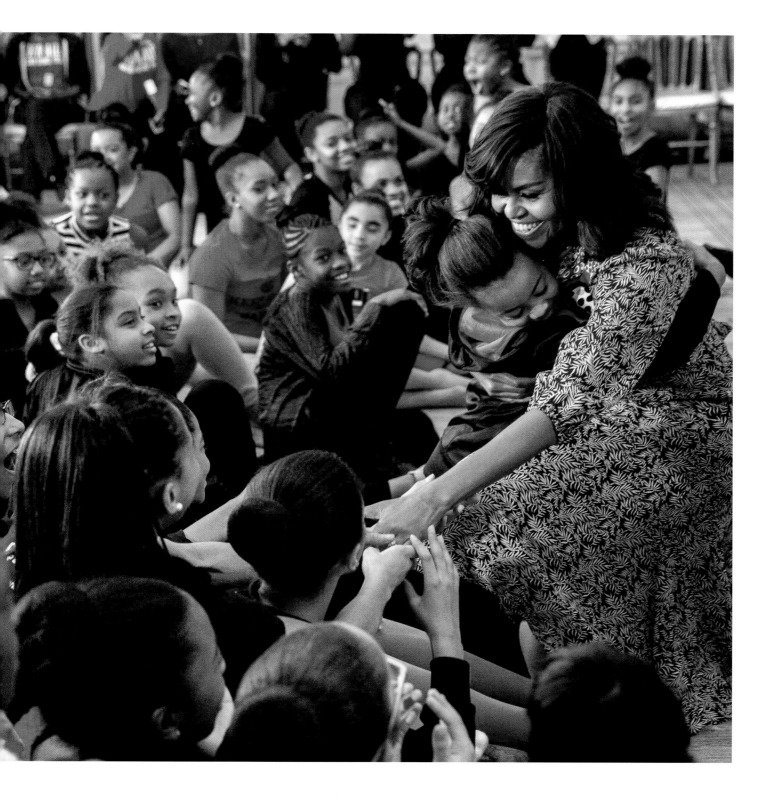

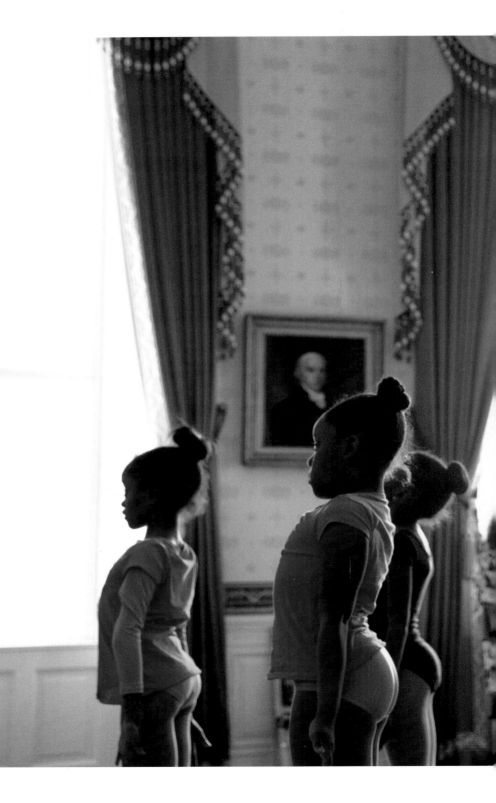

Students rehearse for their performances in the Blue Room during a day-long dance workshop in celebration of Black History Month, February 8, 2016. Workshop leaders included Debbie Allen, Alvin Ailey American Dance Theater's Judith Jamison, the Dance Theatre of Harlem's Virginia Johnson, and hip-hop choreographer Fatima Robinson.

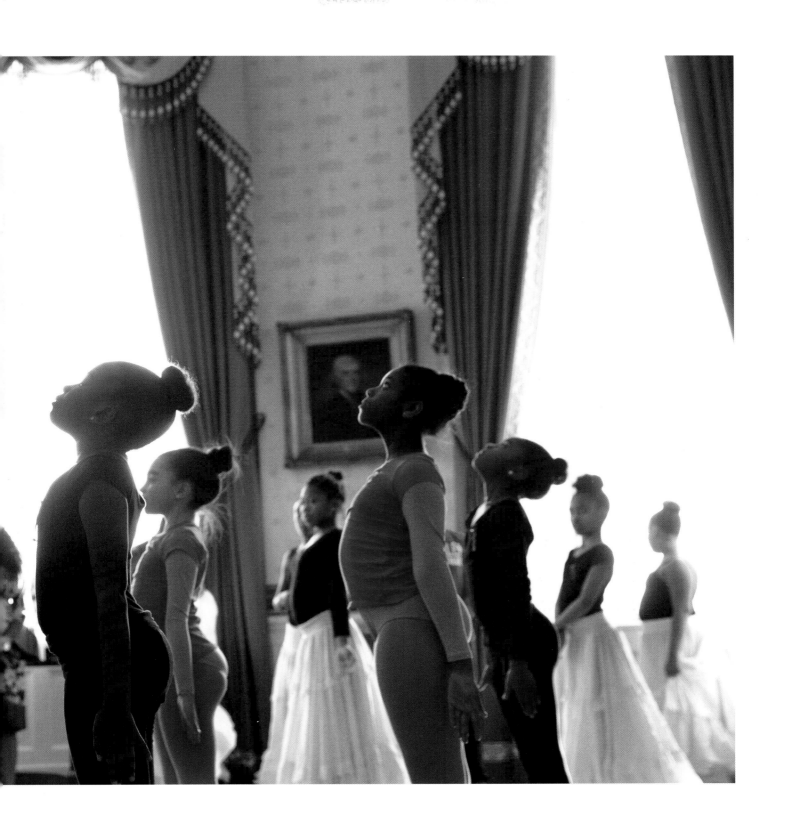

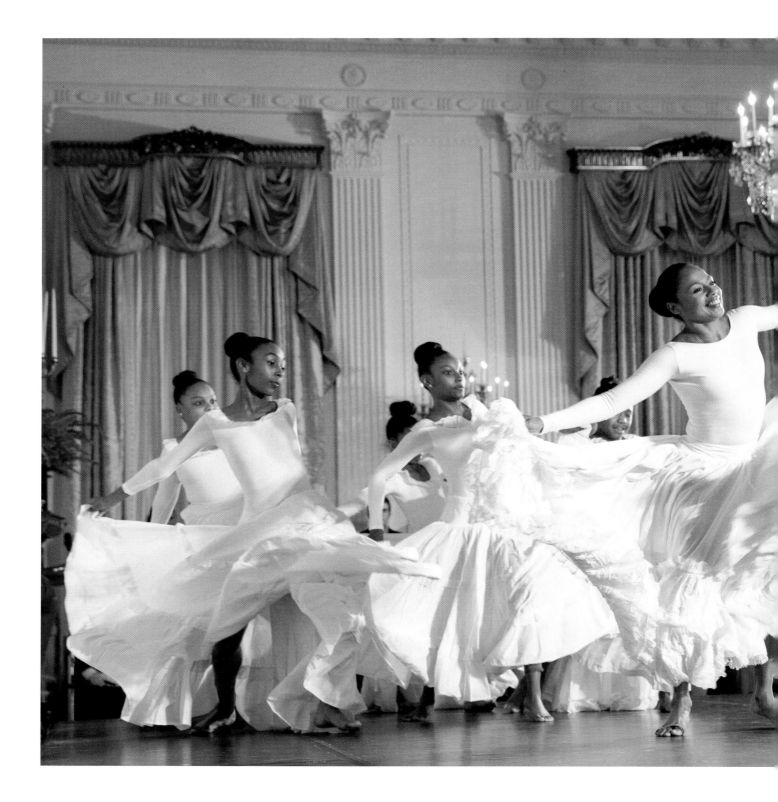

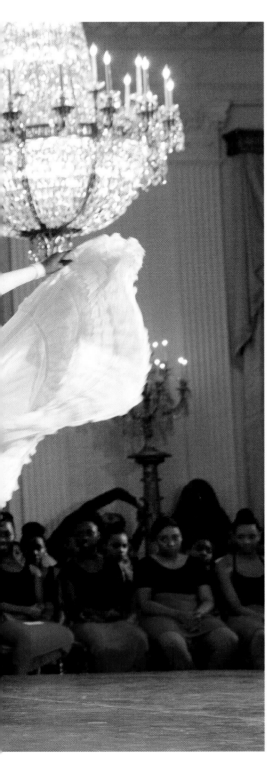

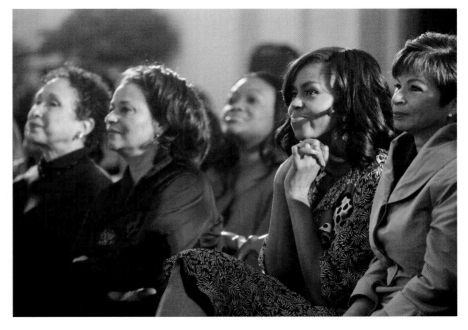

Above: Mrs. Obama and Senior Advisor Valerie Jarrett watch student performances in the East Room of the White House, February 8, 2016.

Left: Students perform in celebration of Black History Month, highlighting the contributions African American women have made to dance, in the East Room of the White House, February 8, 2016.

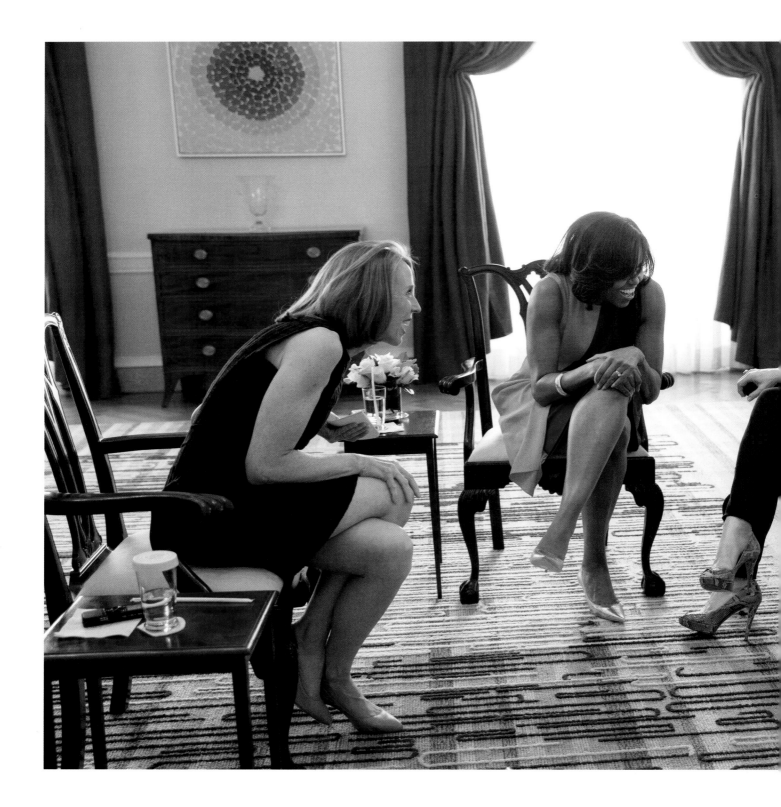

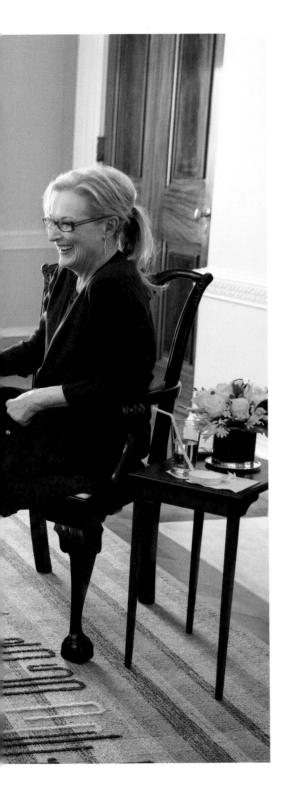

Mrs. Obama redesigned the Old Family Dining Room and opened it to the public on White House tours for the first time in history.

She preserved the crystal chandelier from 1780, as well as the Kennedy-era antiques. She also updated the room with the addition of modern art and design, including original paintings by Robert Rauschenberg and Josef Albers, as well as a custom rug adapted from a pictorial weaving by Anni Albers.

My favorite piece in the room is *Resurrection*, a painting by Alma Thomas, the first African American woman to have her art included in the White House permanent collection.

First Lady Michelle Obama, Meryl Streep, and Susan Pocharski share a laugh during an interview for *MORE* magazine in the Old Family Dining Room of the White House, February 24, 2015.

Mrs. Obama and Mr. Sindre Finnes
of Norway tour the Renwick Gallery in
Washington, DC, with Nordic leaders'
spouses, May 13, 2016.

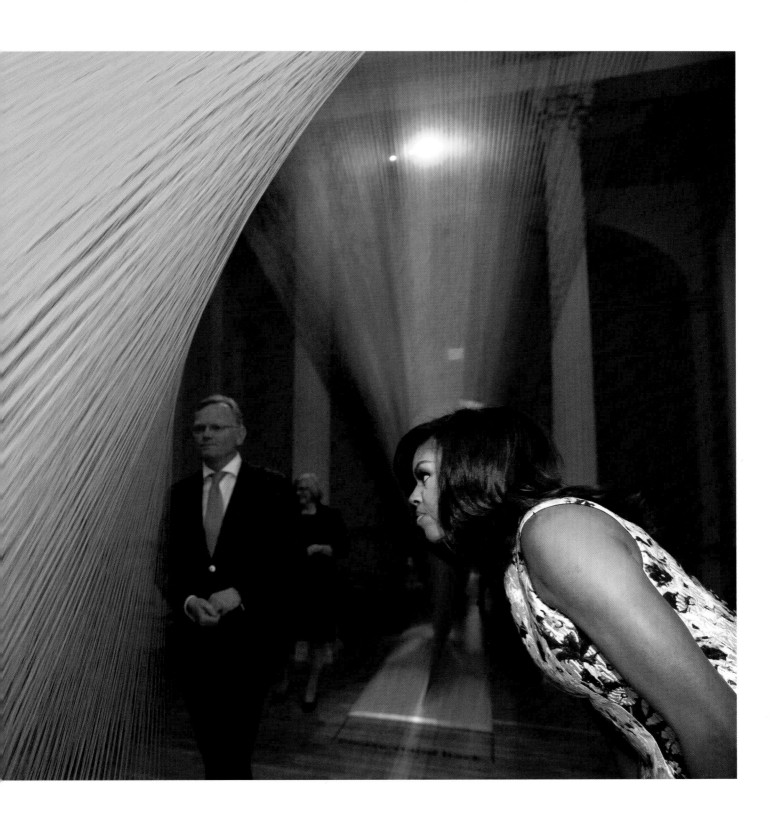

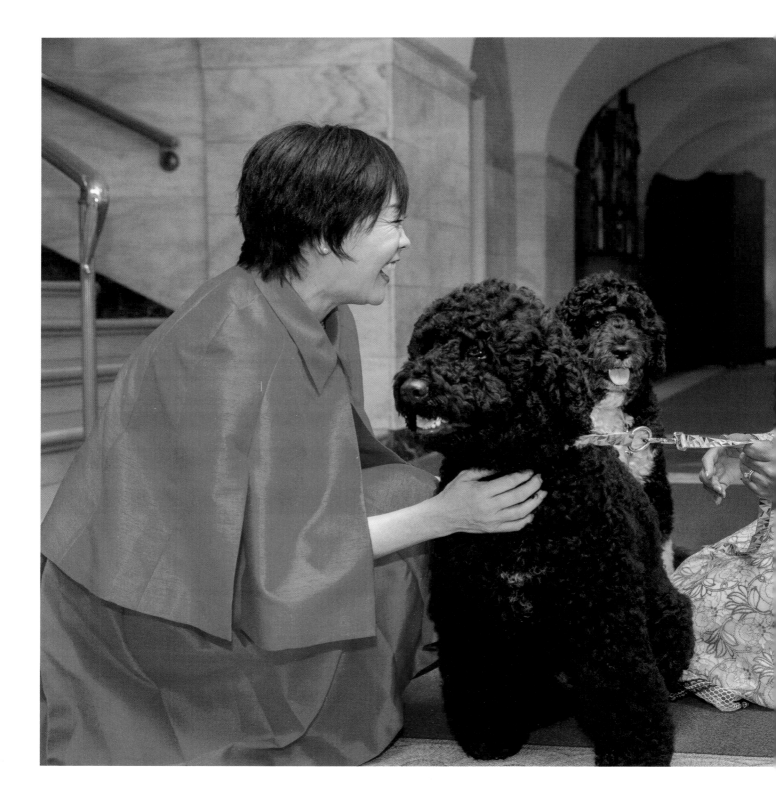

Several times a year, the White House hosts a State Arrival Ceremony to welcome foreign dignitaries and strengthen the bonds between countries. The day is filled with pomp and circumstance, from the flags, military marching band, and formal remarks to the beautiful attire worn by the First Ladies of both countries.

Mrs. Obama learned that Mrs. Akie Abe, wife of the Prime Minister of Japan, loves dogs. So she arranged for Mrs. Abe to meet the First Family's dogs, Bo and Sunny, after the ceremony. To my surprise, the First Ladies sat on the floor in their formal attire as they laughed and played with the dogs. It was such a sweet and informal moment—I could imagine both women as little girls doing the same thing.

Mrs. Obama and Mrs. Akie Abe of Japan are greeted by Bo and Sunny in the Ground Floor Corridor of the White House, April 28, 2015.

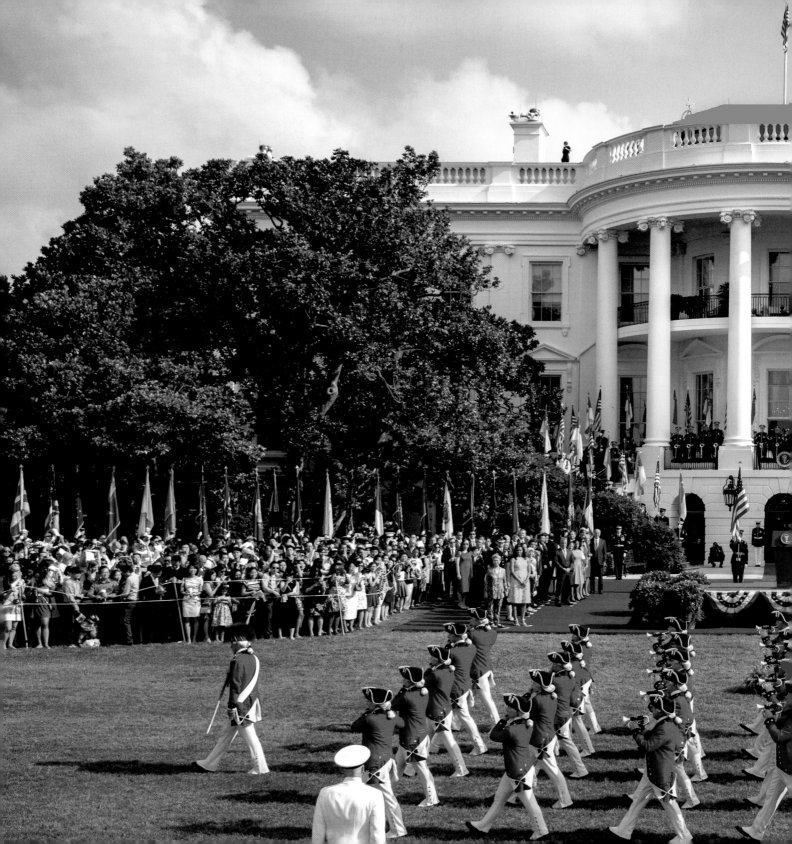

The US Army Old Guard Fife and Drum Corps performs during the Singapore State Arrival Ceremony on the South Lawn of the White House, August 2, 2016.

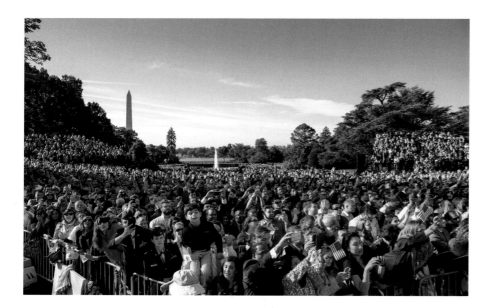

Above and right: President Obama,
Mrs. Obama, and Pope Francis wave to
the crowd from the Blue Room Balcony
following the State Arrival Ceremony
on the South Lawn of the White House,
September 23, 2015.

Following spread: President Obama and
Mrs. Obama take their place on the North
Portico for the arrival of the Nordic leaders
for the State Dinner at the White House,
May 13, 2016.

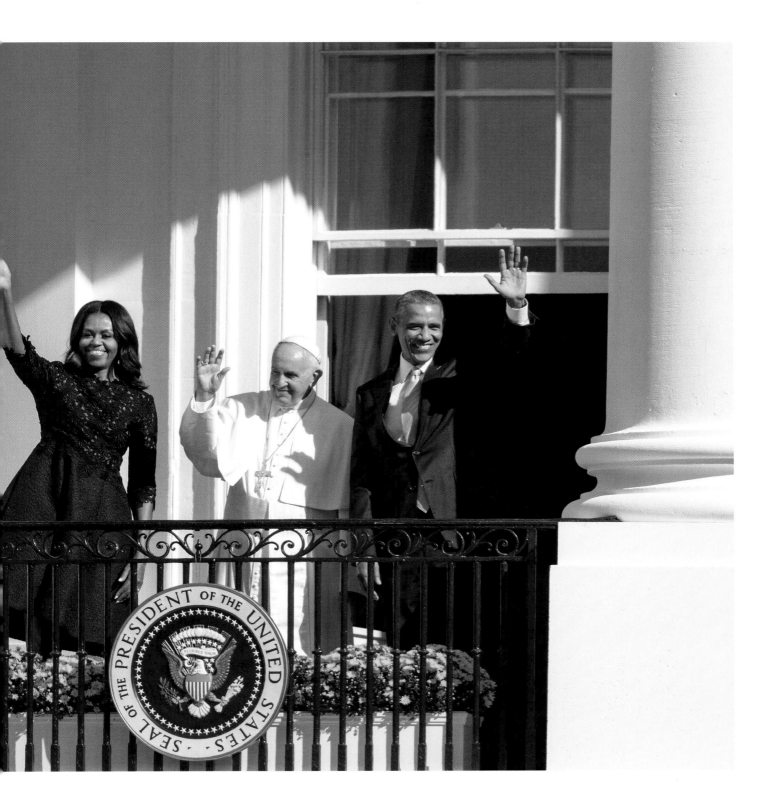

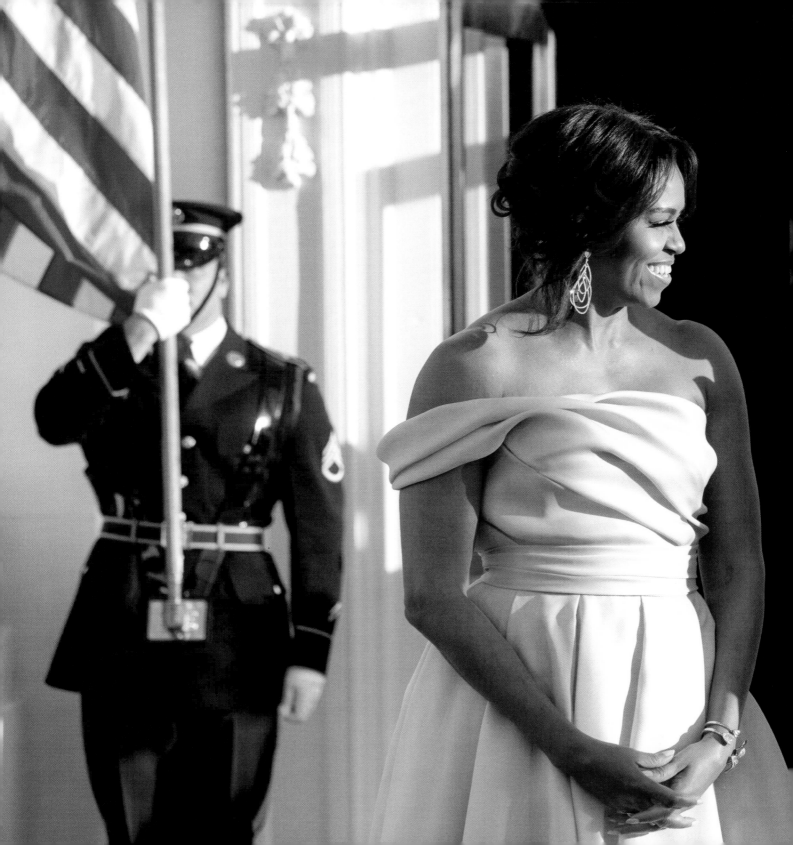

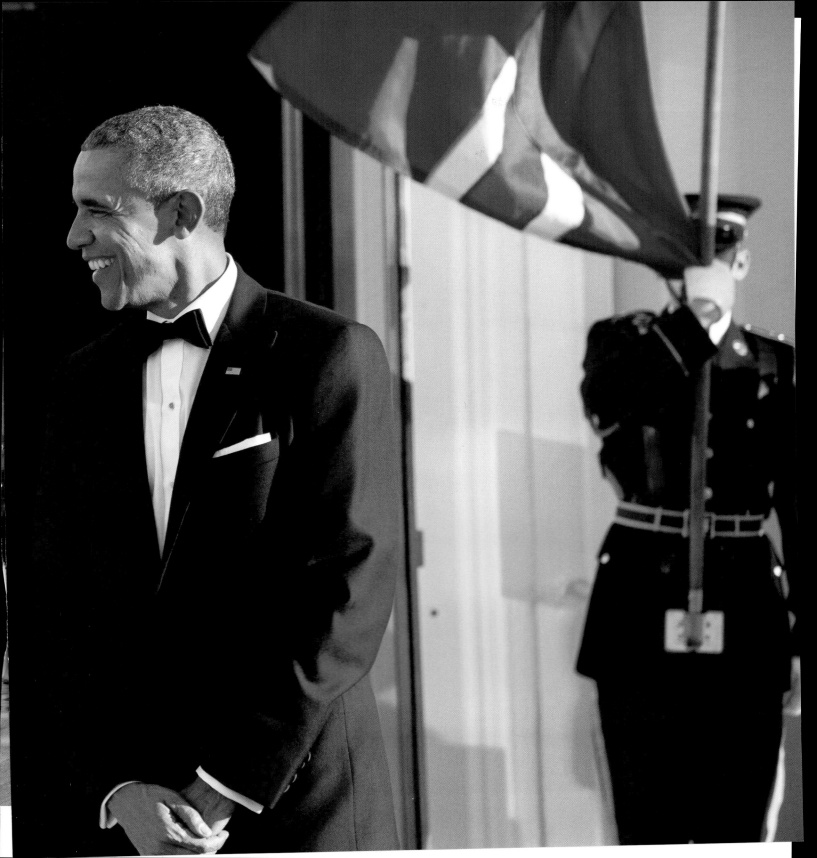

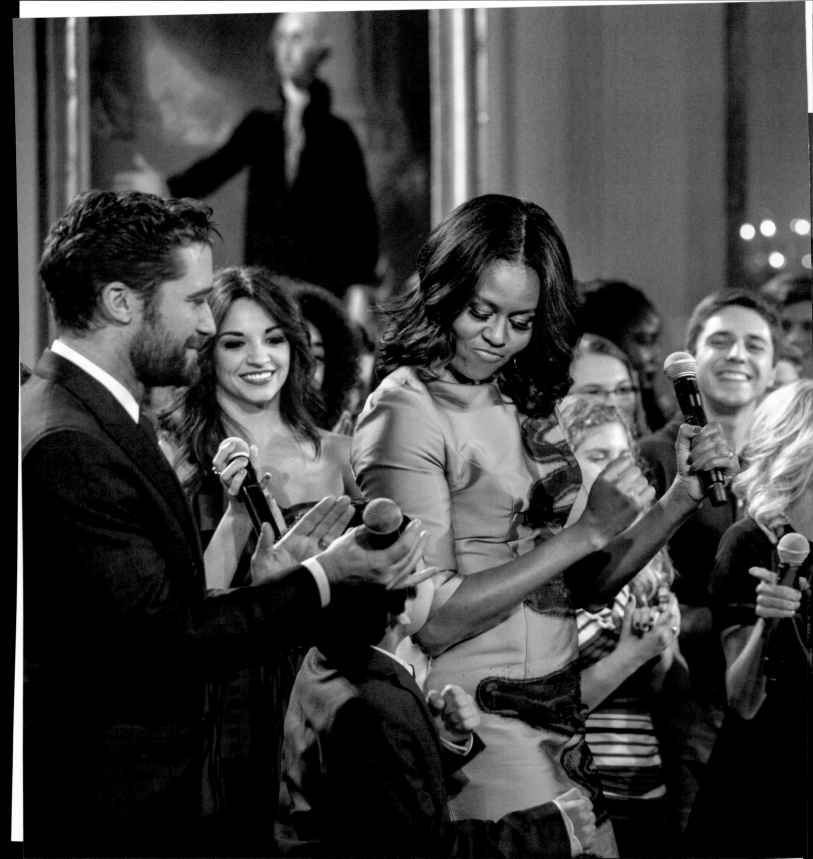

Mrs. Obama dances on stage following a Broadway performance hosted by Matthew Morrison and Kristin Chenoweth in the East Room of the White House, November 16, 2015. The event featured music from *Finding Neverland*, *Fun Home*, *Something Rotten!*, *School of Rock*, *An American in Paris*, and *On Your Feet!* Students were invited to participate in a day-long workshop with the artists.

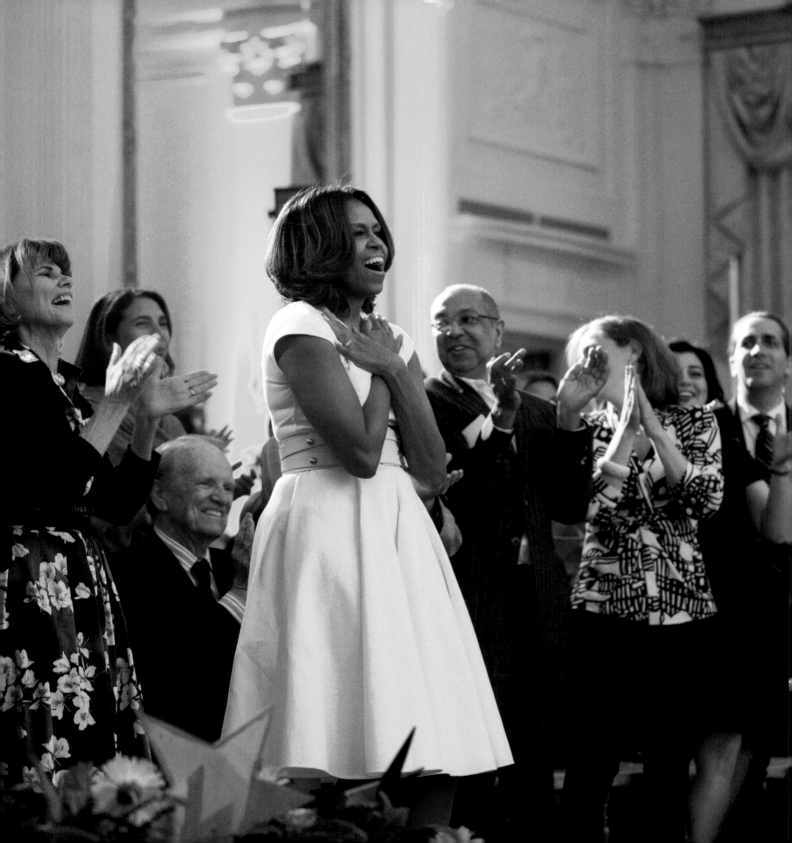

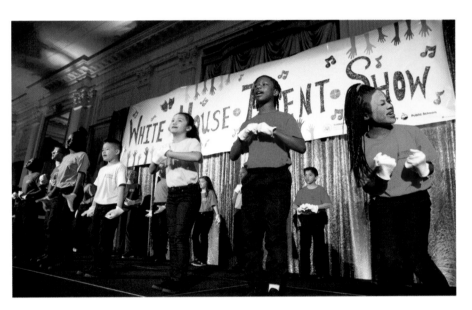

Left: First Lady Michelle Obama and the President's Committee on the Arts and the Humanities host the White House Talent Show in the East Room of the White House, May 20, 2014. The event showcased the talents of students from schools participating in Turnaround Arts, a program to help turn around low-performing schools and increase student achievement through arts education.

Above: Students from the Minnesota Schools of North Port, North Side, and Bethune perform at the White House Turnaround Arts Talent Show in the East Room of the White House, May 25, 2016.

When students from the Sphinx Overture took the stage in the East Room, it was so quiet you could hear a pin drop. The audience, which included the First Lady, waited in anticipation for the performance to begin.

I was photographing from the side of the stage so I could compose an image that included Mrs. Obama in the background with the musicians in the foreground. I watched the faces of the crowd as the silence continued. The musicians tuned their instruments with a few squeaky adjustments. I held my breath and hoped they wouldn't freeze in such a high-pressure environment.

But the leader of the quartet gave a quick head nod and the music began. They were phenomenal! The audience erupted with joy, and I could see the look of amazement and pride on Mrs. Obama's face as they finished their performance.

The First Lady congratulates Sphinx Overture students following their performance during the 2016 National Arts and Humanities Youth Program Awards ceremony in the East Room of the White House, November 15, 2016.

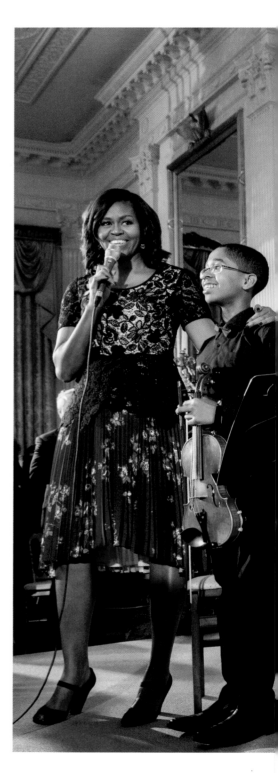

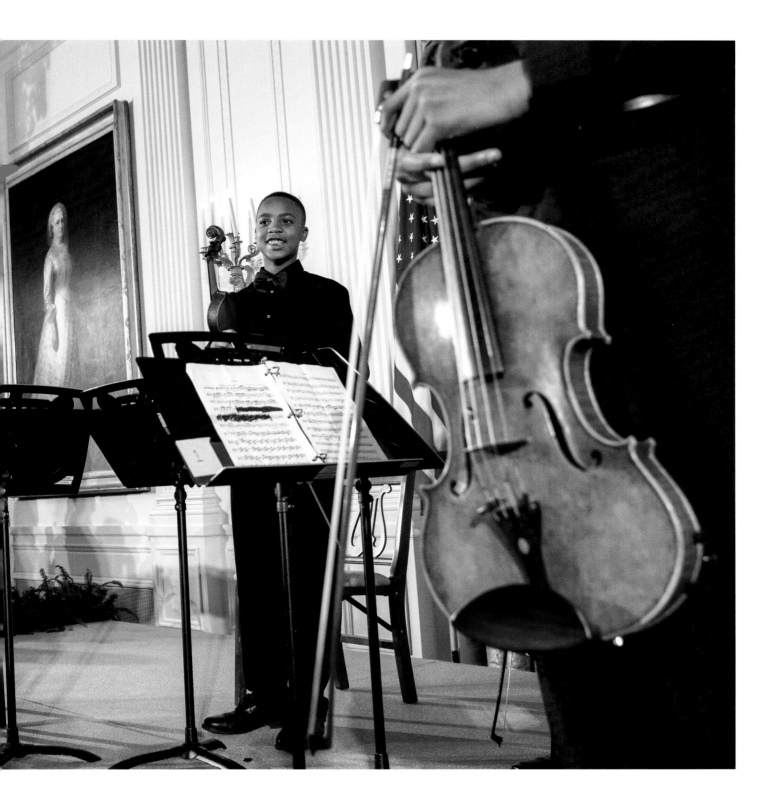

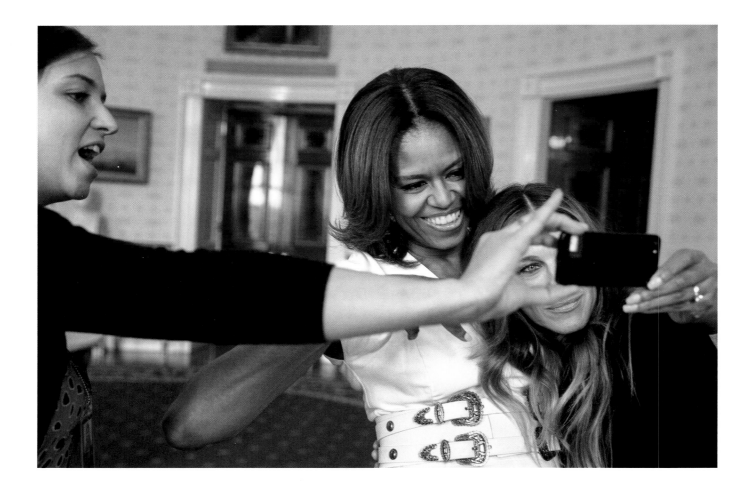

First Lady Michelle Obama and Sarah
Jessica Parker take a selfie in the Blue
Room prior to the White House Talent
show, May 20, 2014. Kori Schulman,
Director of Online Engagement, assists.

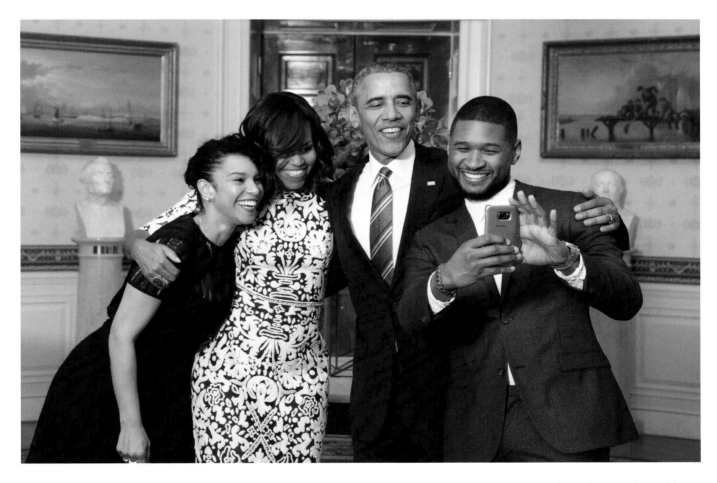

Above: President Obama and Mrs. Obama pose for a photo with Usher and Grace Raymond in the Blue Room prior to "Smithsonian Salutes Ray Charles," February 24, 2016.

Following spread: Mrs. Obama welcomes girls from Morocco and Liberia in the State Dining Room before a screening of *We Will Rise: Michelle Obama's Mission to Educate Girls Around the World*, October 11, 2016.

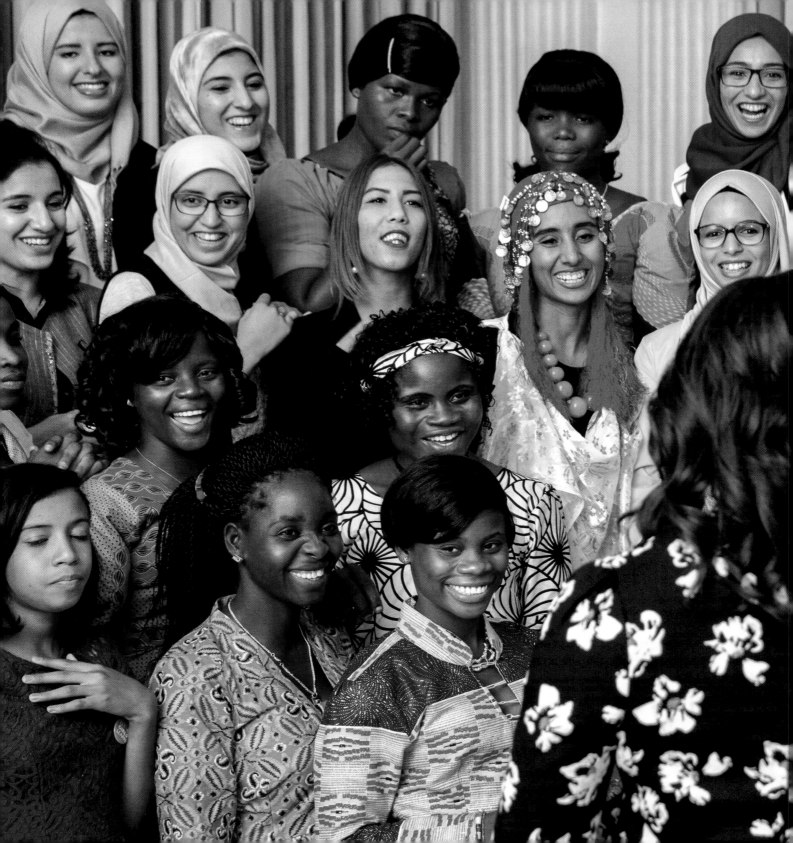

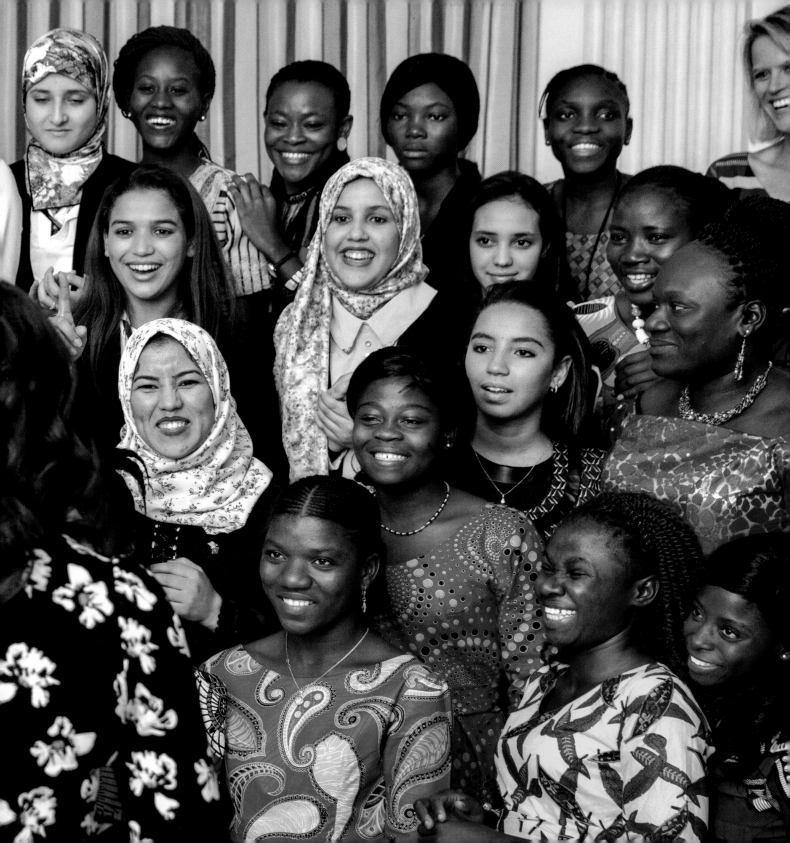

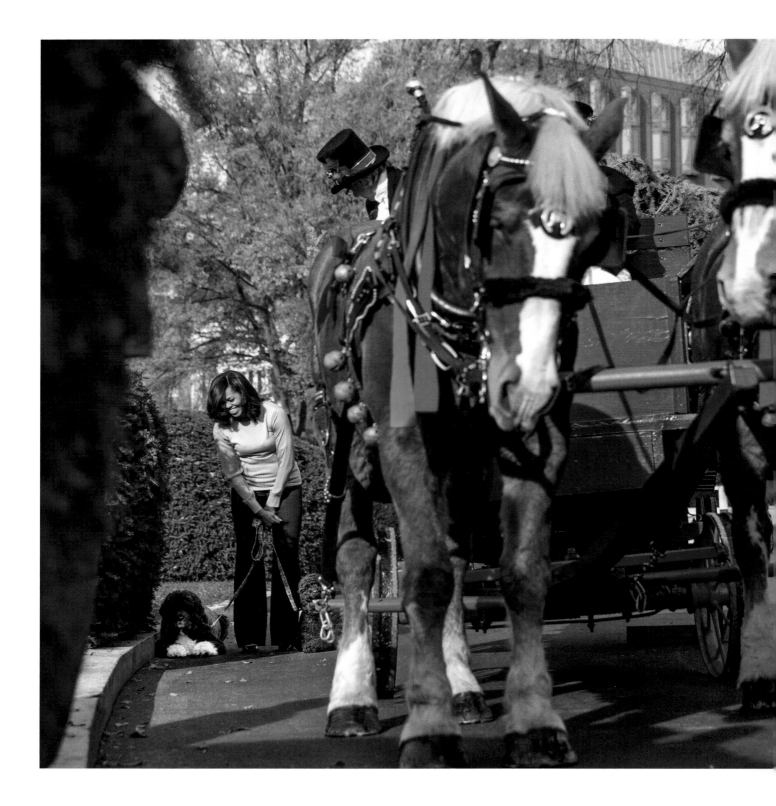

The First Lady and the Obama family dogs, Bo and Sunny, get a sneak peak of the official White House Christmas tree at the White House, November 27, 2015. The eighteen-and-a-half-foot Fraser fir arrived by horse-drawn wagon.

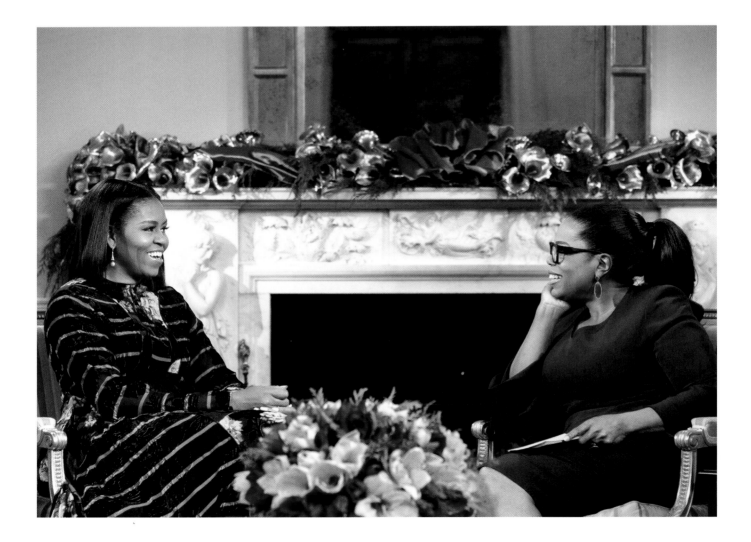

Above and Right: Mrs. Obama talks
with Oprah Winfrey during their last
interview in the Yellow Oval Room
of the Private Residence of the White
House, December 14, 2016.

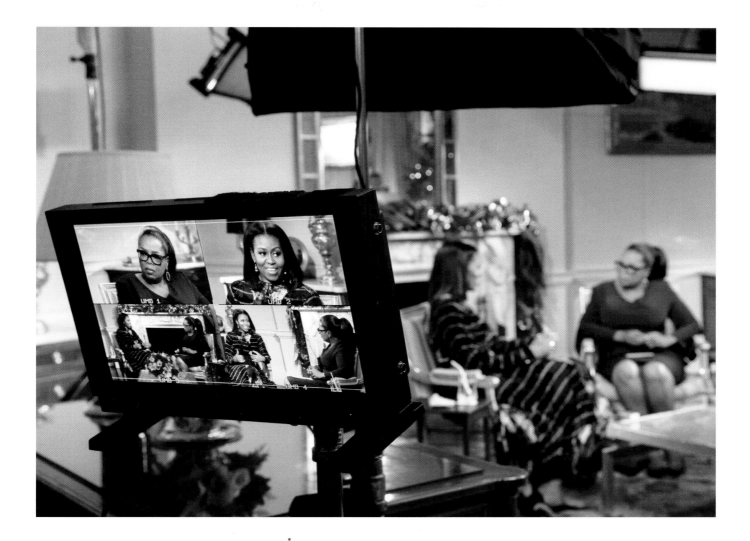

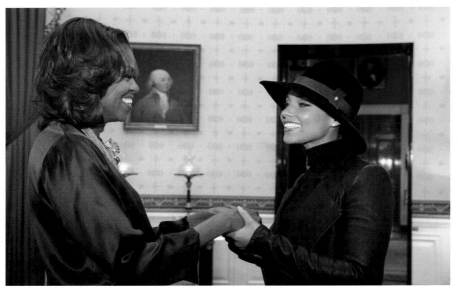

Above: Mrs. Obama greets Alicia Keys prior to a screening of the movie *The Inevitable Defeat of Mister and Pete*, at the White House, January 15, 2014.

Right: Mrs. Obama waits in the Red Room as she watches Alicia Keys introduce her to the audience gathered in the State Dining Room.

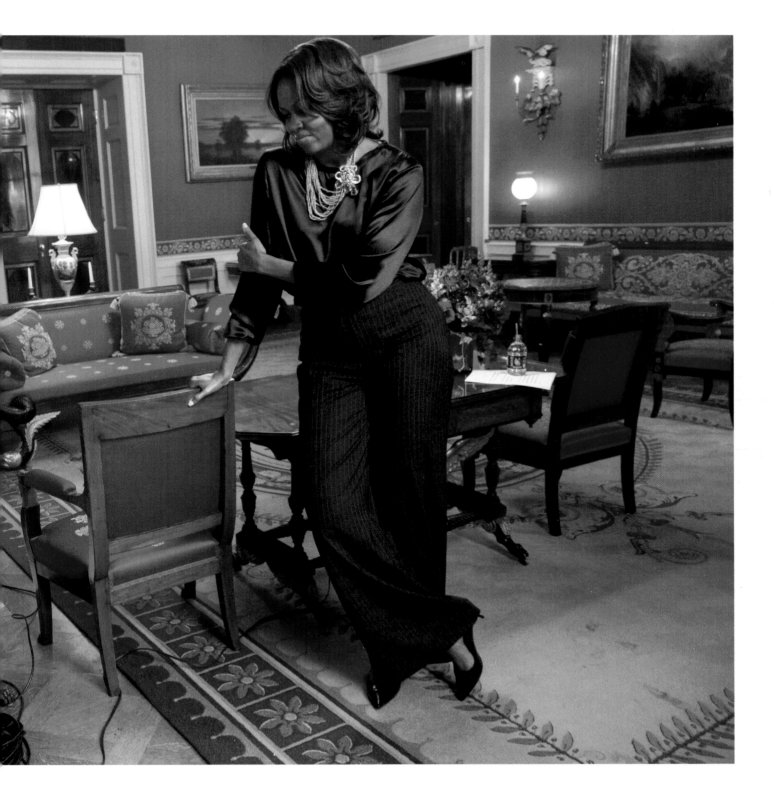

It was really touching to watch Mrs. Obama greet Keniya Brown in the Blue Room prior to the Take Your Daughters and Sons to Work Day event. As a foster child, Keniya was a guest invited by DC's Child and Family Services Agency.

Keniya had tears in her eyes. She couldn't believe she was in the same room as the First Lady. Mrs. Obama gave her a big hug and spent time talking with her and sharing encouraging words. I was fortunate to be able to witness and document this meaningful interaction.

Mrs. Obama embraces Keniya Brown in the Blue Room prior to the Take Your Daughters and Sons to Work Day event at the White House, April 20, 2016.

Following spread: Guests line up in the State Dining Room to meet Mrs. Obama (top right: July 10, 2015) before the Kids' State Dinner in the East Room of the White House (left and bottom right: July 14, 2016).

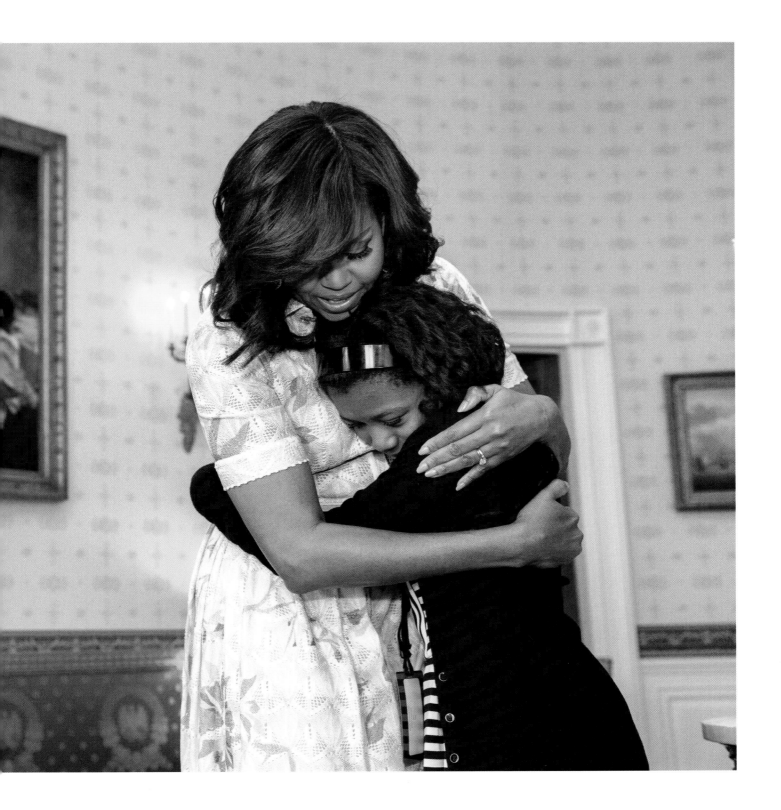

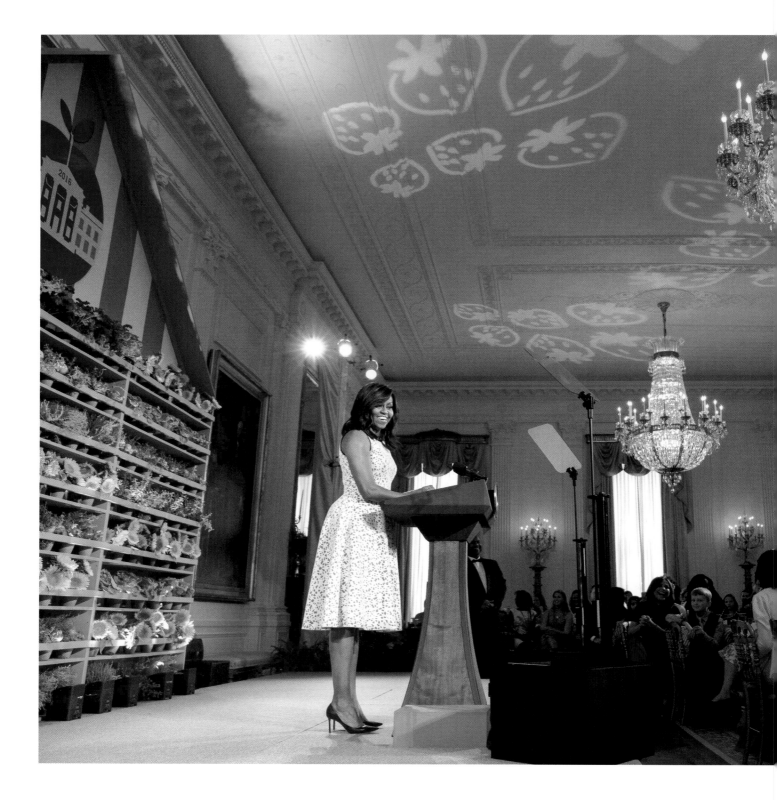

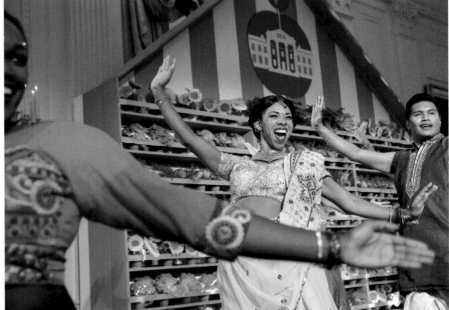

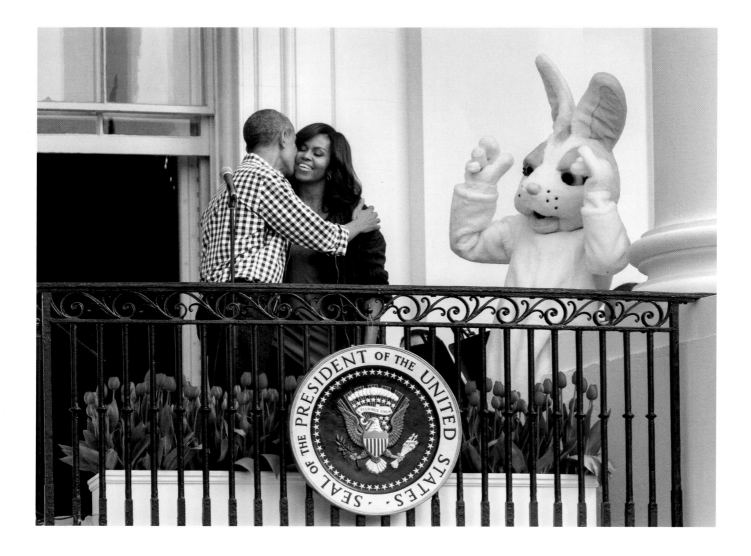

President Obama gives Mrs. Obama
a kiss on the Blue Room Balcony after
welcoming guests to the annual
Easter Egg Roll on the South Lawn
of the White House, March 28, 2016.

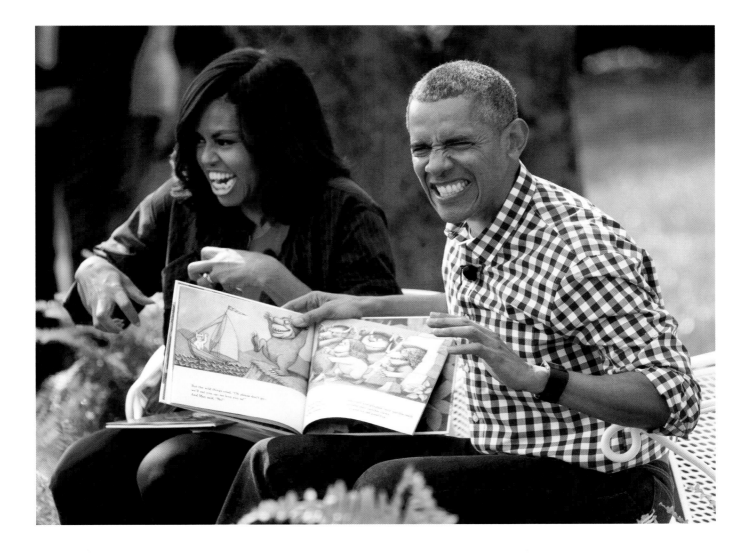

President Obama and Mrs. Obama
read *Where the Wild Things Are* by
Maurice Sendak to children during
the Easter Egg Roll on the South Lawn
of the White House, March 28, 2016.

The First Lady kicks off an obstacle-course activity in the Rose Garden during the Easter Egg Roll on the South Lawn of the White House, March 28, 2016.

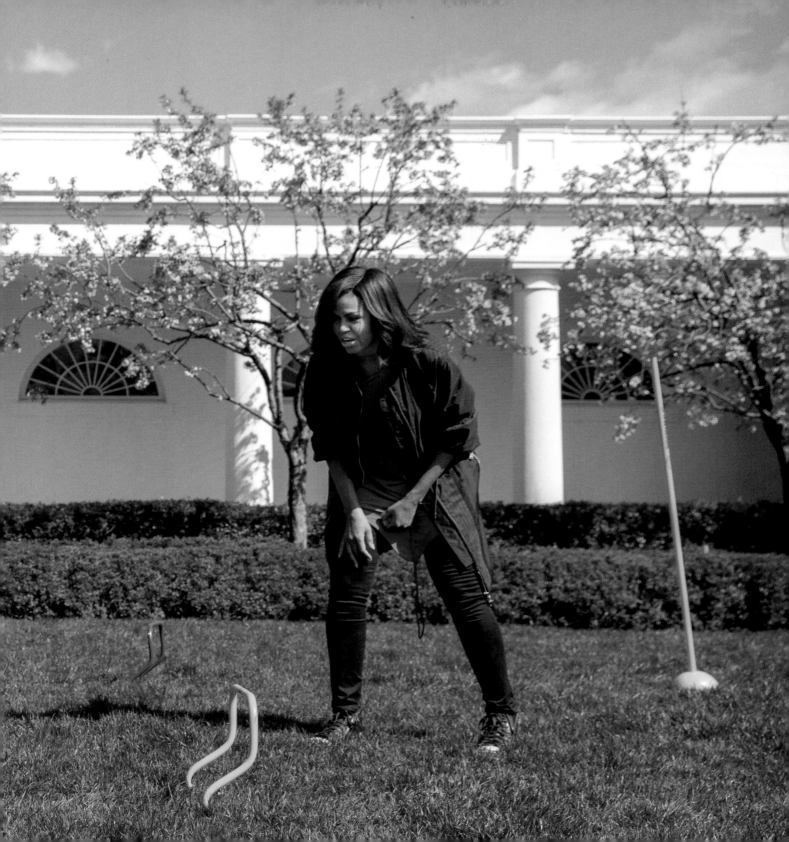

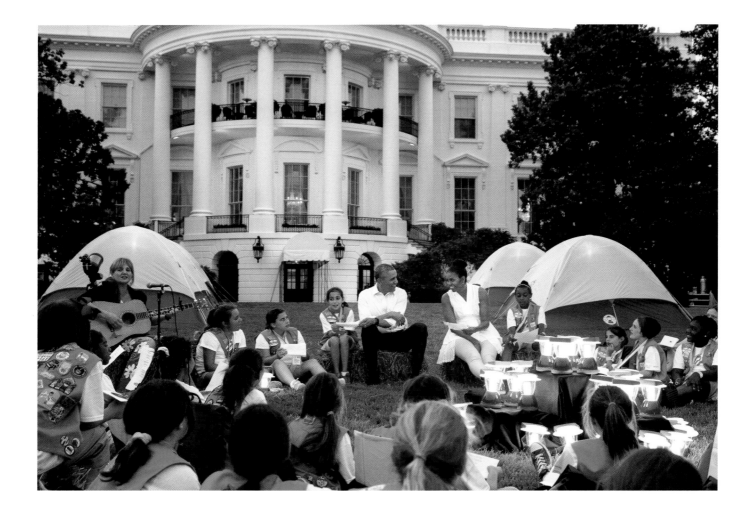

Above and right: President Barack Obama
and First Lady Michelle Obama sing songs
with Girl Scouts during the White House
Campout, on the South Lawn of the White
House, June 30, 2015.

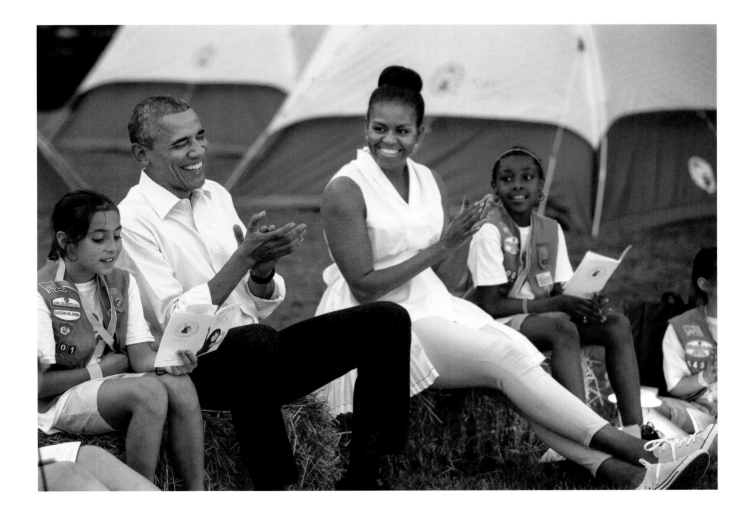

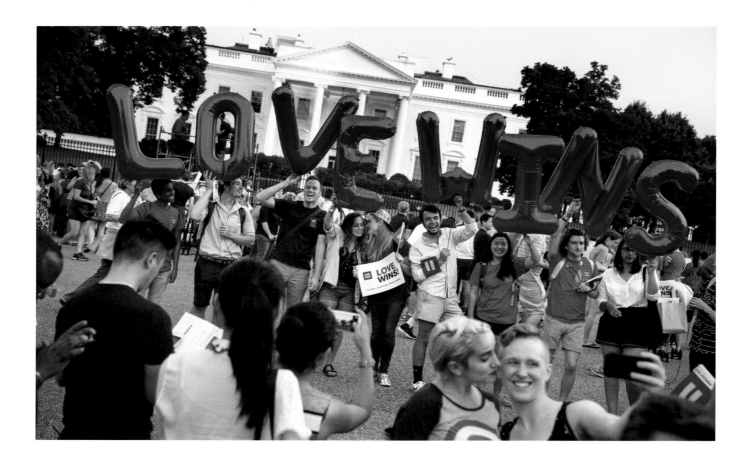

Above and Right: People gather on
Pennsylvania Avenue to celebrate
as the White House is lit with the colors
of the rainbow marking the Supreme
Court ruling on same-sex marriage,
June 26, 2015.

Mrs. Obama talks with Mr. Brainwash, a Los Angeles–based graffiti artist, during an event marking the one-year anniversary of Let Girls Learn at Union Market in Washington, DC, March 8, 2016. The mural was commissioned by The Girls' Lounge.

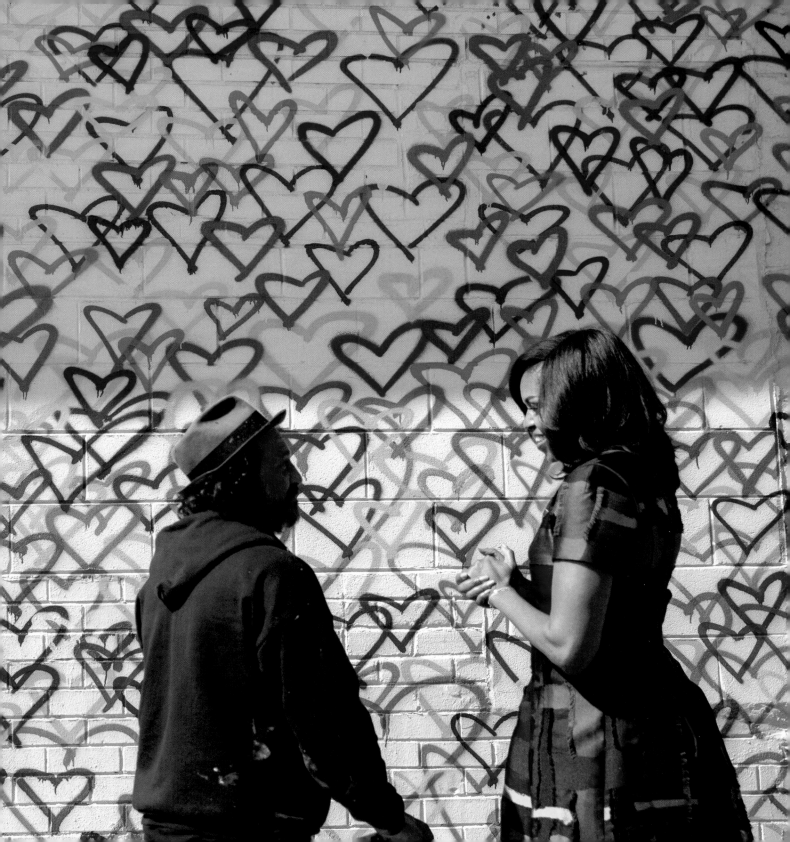

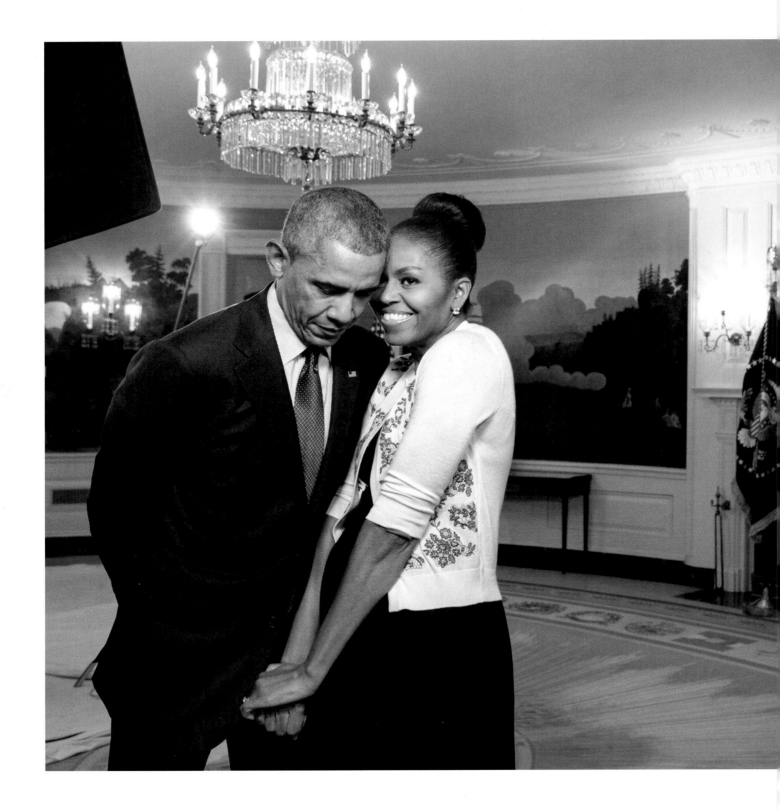

It was a common occurrence for President Obama and the First Lady to participate in tapings for various greetings, events, and public service announcements. A camera crew would set up in one of the rooms of the White House to film the message, and I would also be there to document the scene.

Most times, tapings were quick and straightforward. But there was always a chance for spontaneous moments, especially when President Obama and Mrs. Obama did the tapings together. On this day, they were taping multiple greetings for the 2015 World Expo. After the first taping, the camera crew readjusted their equipment to set up for the next shot. There was a lot of movement in the room, which allowed the President and First Lady to have a moment to enjoy each other's company. It was just long enough for me to make one quick photo. It happened so quickly that I didn't even have time to compose the image.

I typically like a photo that is clean and thoughtfully composed. At first, this shot felt like an "almost" for me because it was so cluttered with the lights and equipment visible in the shot. Luckily, Al Anderson, our wonderful White House photo editor, convinced me that it was great despite its composition because the moment was so sweet and special. This photo has since been shared widely and has become one of the most well-known images that I captured during my time as a White House photographer.

President Obama and Mrs. Obama share a moment in the Diplomatic Reception Room of the White House, March 27, 2015.

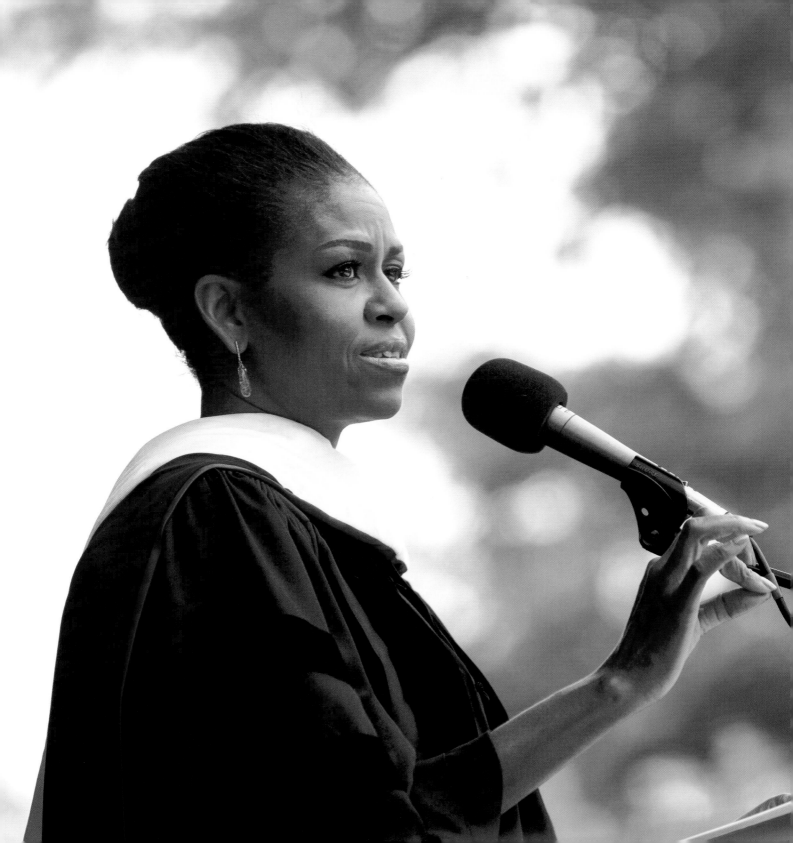

Chapter 3

REACH HIGHER

The First Lady of the Unites States doesn't earn a salary. She has a small staff and no budget for her initiatives. But that didn't limit Mrs. Obama's goals— she used her platform to shine light on the issues that were most important to her. She harnessed the strength of her relationships to build partnerships in support of her initiatives. And she used her voice to inspire and empower people throughout the country and the world.

Mrs. Obama and her staff knew the significance of reaching people through various outlets. She embraced the power of social media and celebrity support. She wasn't afraid to be silly, to dance, to get dirty in the garden, to exercise, or to participate in funny skits, especially if it would help to communicate an important message. Mrs. Obama was candid and authentic. She was always willing to share her personal stories because she knew it could help others.

She fought to combat childhood obesity with the Let's Move! campaign and her expansion of the White House Kitchen Garden. Mrs. Obama invited students to help harvest in her garden every spring, summer, and fall to reinforce the importance of healthy eating. To promote childhood nutrition, she hosted a Kids' State Dinner every year that highlighted the innovative recipes of America's youngest chefs.

She also challenged young adults to continue their education after high school through her Reach Higher initiative. This included talking with students about the opportunities and resources available to make higher education a reality. Each year she gave commencement speeches at graduations across the country, selecting schools with social, cultural, and historical significance. Mrs. Obama is an accomplished and compelling public speaker, but more important, her remarks resonated with people because she spoke from the heart.

Through her Joining Forces initiative, Mrs. Obama worked with Dr. Jill Biden to support veterans and military families. Together they focused on the important issues of combating veteran homelessness and providing employment opportunities and mental health services, while celebrating the contributions of those who have served our country.

Regardless of the event, she always took the time to greet people. She shared smiles, encouraging words, and plenty of hugs. This was not always ideal for the staff members responsible for scheduling her time. But the First Lady insisted that you never know what people are going through in their lives. Sometimes the extra hug or compliment can mean all the difference—and that's worth taking the extra time.

Mrs. Obama and her team proved that you can accomplish a lot with a little. You just need the courage to reach higher.

Mrs. Obama talks with students during a meal they prepared following the harvest of the White House Kitchen Garden, June 6, 2016.

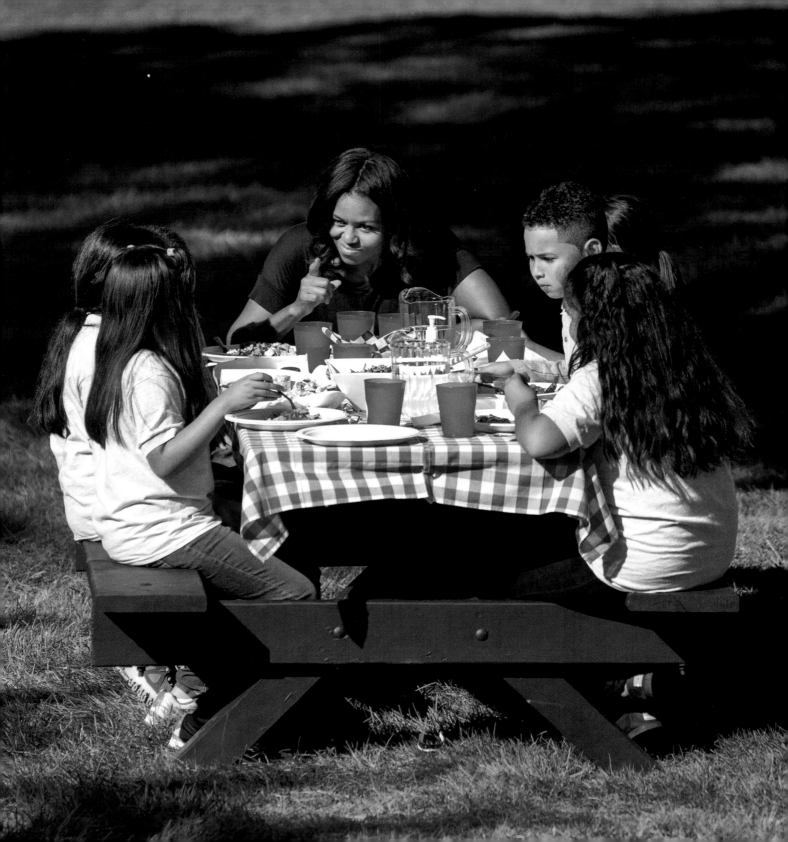

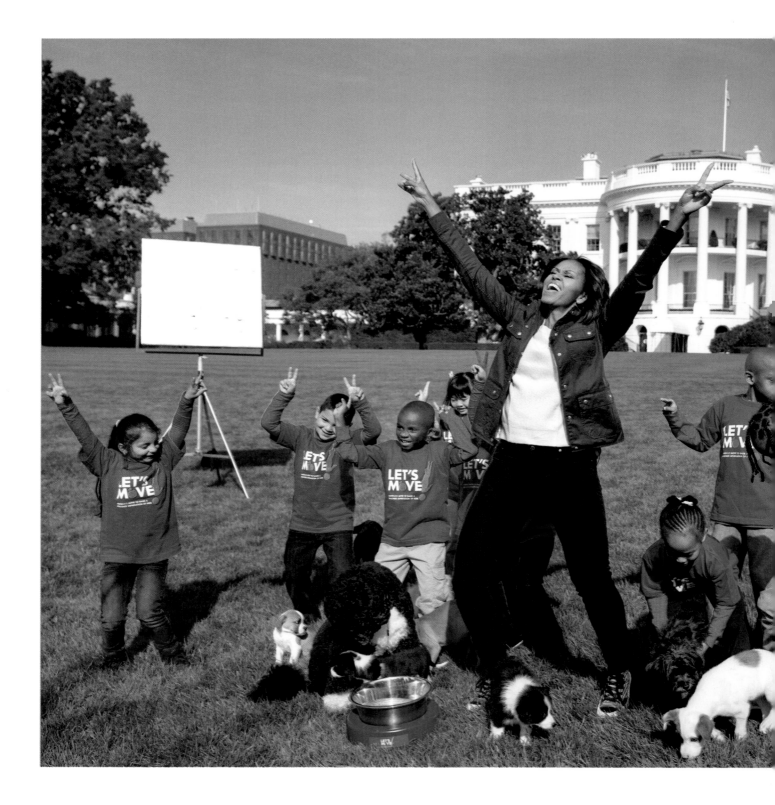

Everyone knows there are two things that Mrs. Obama absolutely adores: kids and puppies.

This taping on the South Lawn seemed to have the perfect ingredients to make a great segment promoting the Let's Move! campaign. But as everyone knows, there are also two things that are completely unpredictable: kids and puppies.

The film directors had to figure out how to keep the kids' attention while also making sure the puppies didn't run away. Luckily, I was just there to capture the scene.

The First Lady participates in an Animal Planet Puppy Bowl filming on the South Lawn of the White House, October 28, 2013. Harriet Tubman Elementary School students, the Obamas' dog Bo, and puppies participate in the filming.

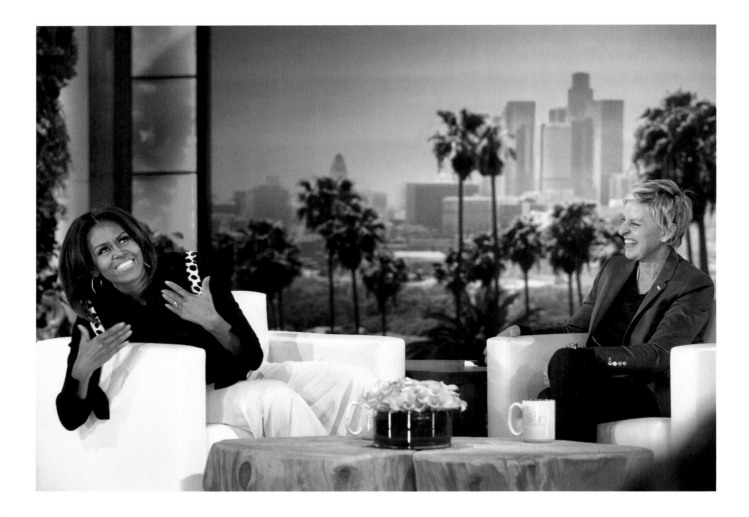

First Lady Michelle Obama and Ellen
DeGeneres share a laugh during an
interview for *The Ellen DeGeneres Show*
in Burbank, California, March 12, 2015.

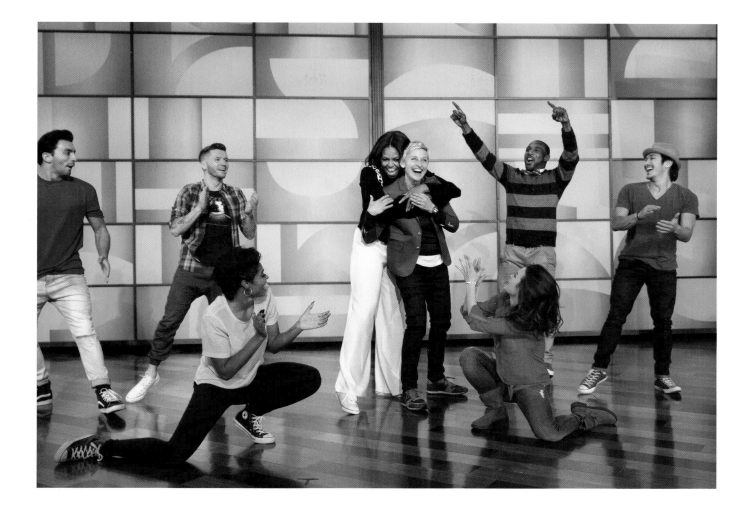

First Lady Michelle Obama hugs
Ellen after preforming a Let's Move!
dance with the *So You Think You
Can Dance* dancers, March 12, 2015.

First Lady Michelle Obama tapes a
Funny or Die segment to promote healthy
eating with Billy Eichner of "Billy on
the Street" and Big Bird at a Safeway
in Washington, DC, January 12, 2015.

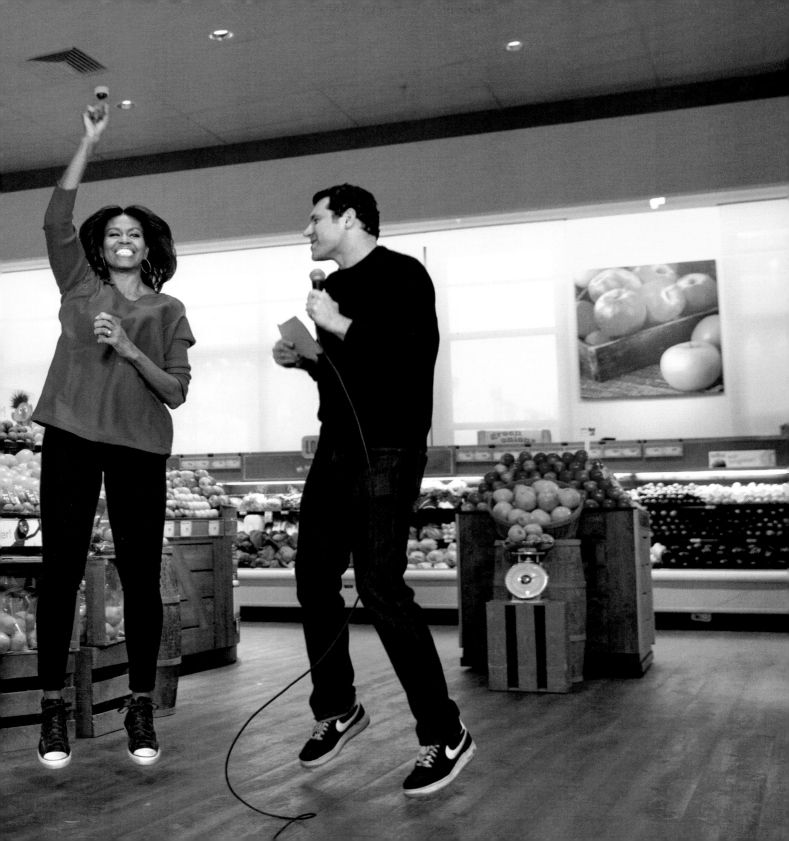

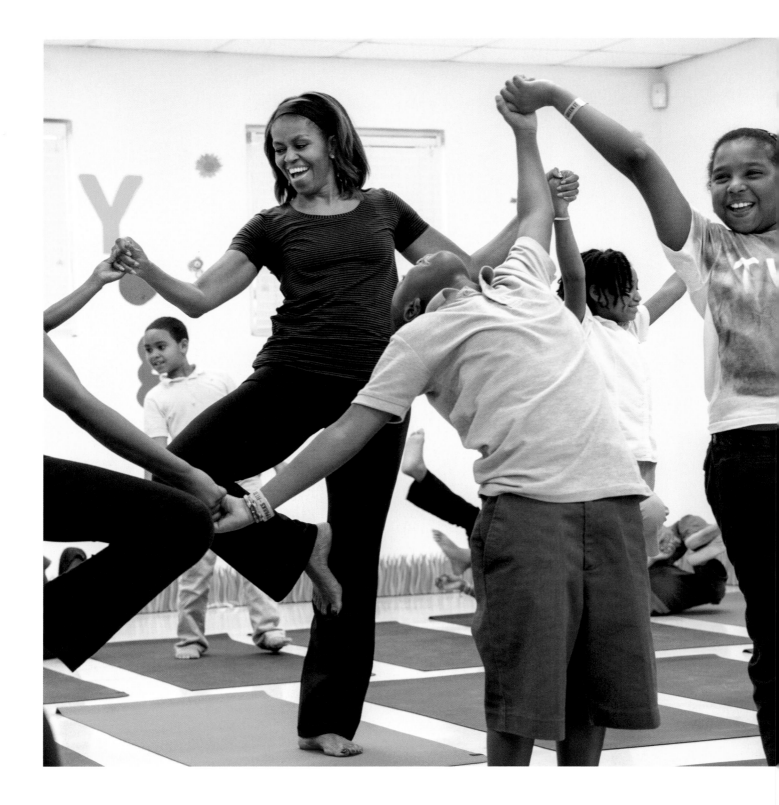

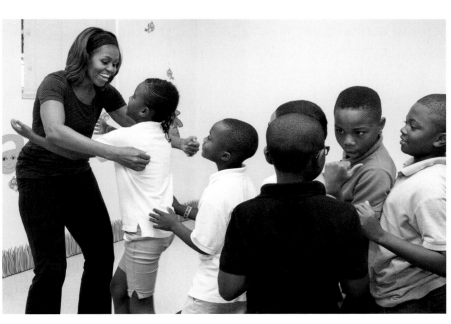

Above: Children line up (while others try to cut in line) to get a hug from Mrs. Obama following the Let's Move! event.

Left: First Lady Michelle Obama joins children for a yoga class during a Let's Move! after-school activities event at Gwen Cherry Park in Miami, Florida, February 25, 2014.

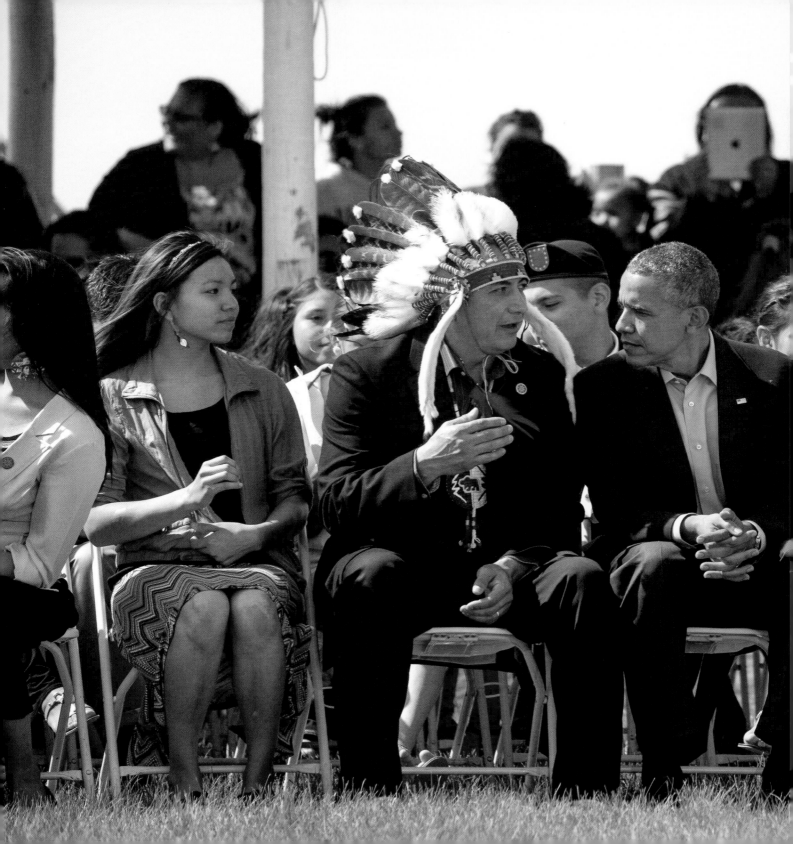

President Obama and Mrs. Obama attend the Cannon Ball Flag Day Celebration at the Standing Rock Sioux Tribe Reservation in Cannon Ball, North Dakota, June 13, 2014.

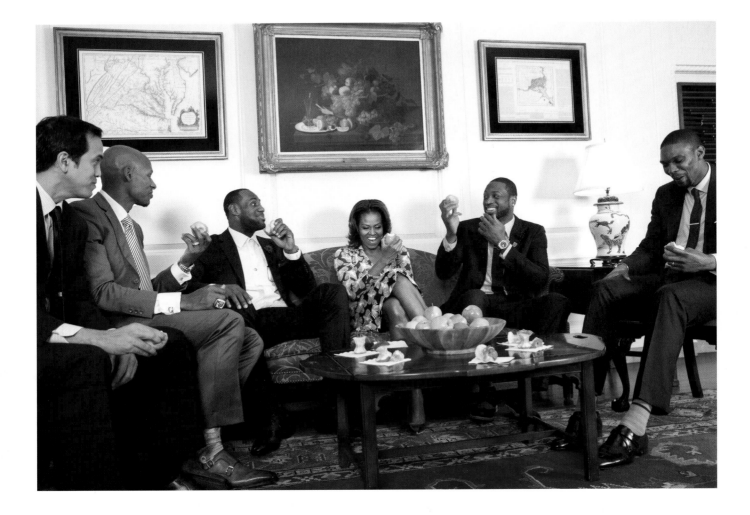

The First Lady and 2013 NBA Champion
Miami Heat Coach Erik Spoelstra and
players Ray Allen, LeBron James, Dwyane
Wade, and Chris Bosh tape a Let's Move!
nutrition PSA segment in the Map Room
of the White House, January 14, 2014.

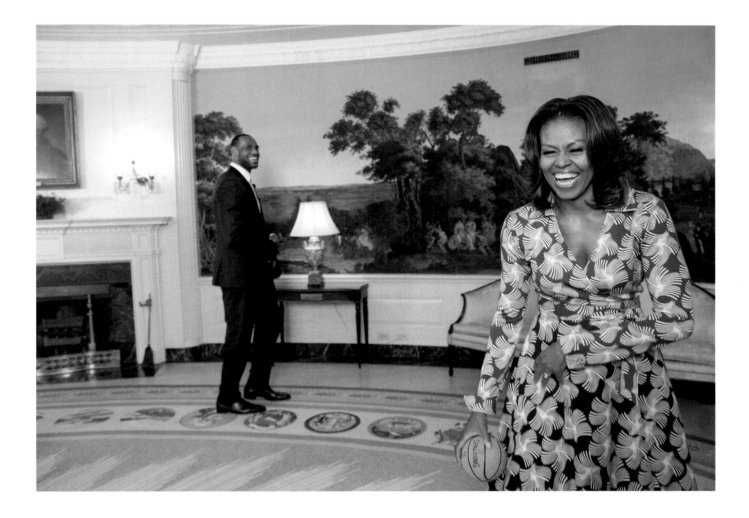

Mrs. Obama and LeBron James participate in videobomb pranks during a taping in the Diplomatic Reception Room of the White House, January 14, 2014.

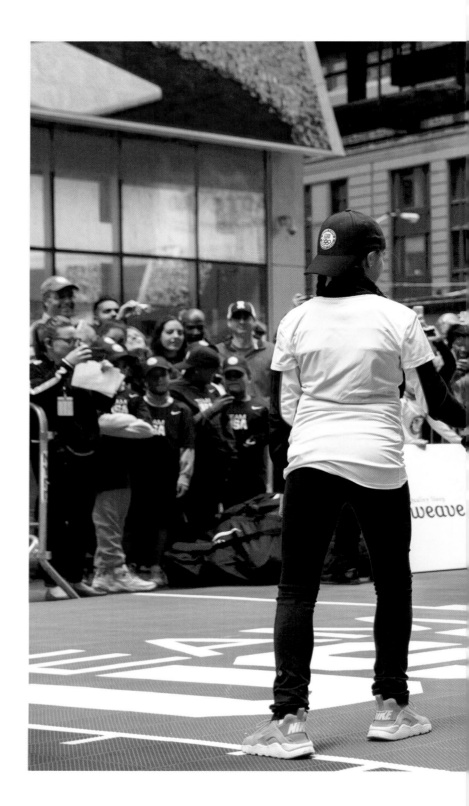

Mrs. Obama takes part in a fencing
demonstration with Ibtihaj Muhammad
of the US Olympic Fencing Team during
the 2016 Olympics 100 Days Out event
in Times Square, New York, New York,
April 27, 2016.

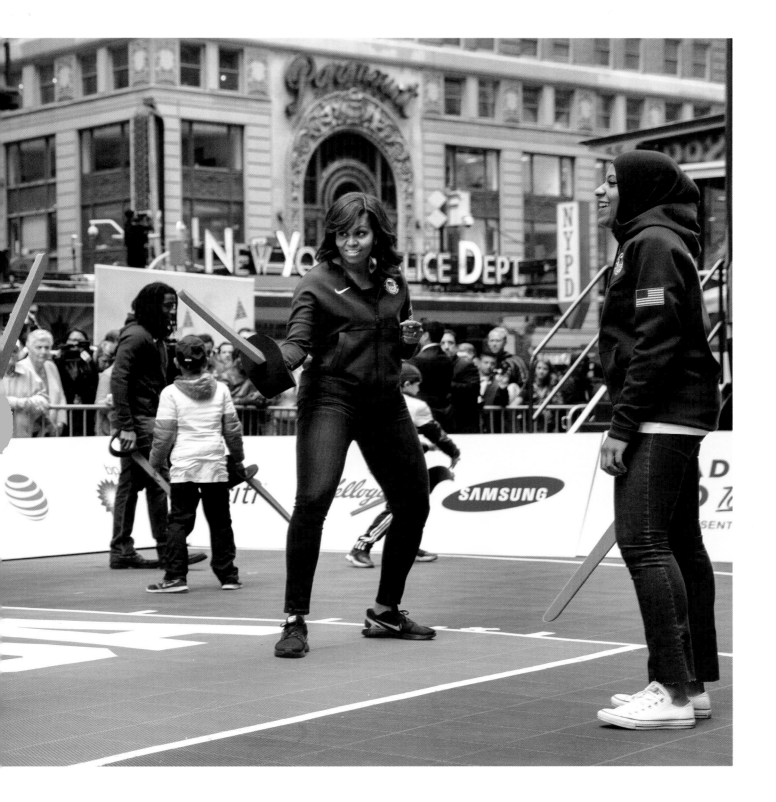

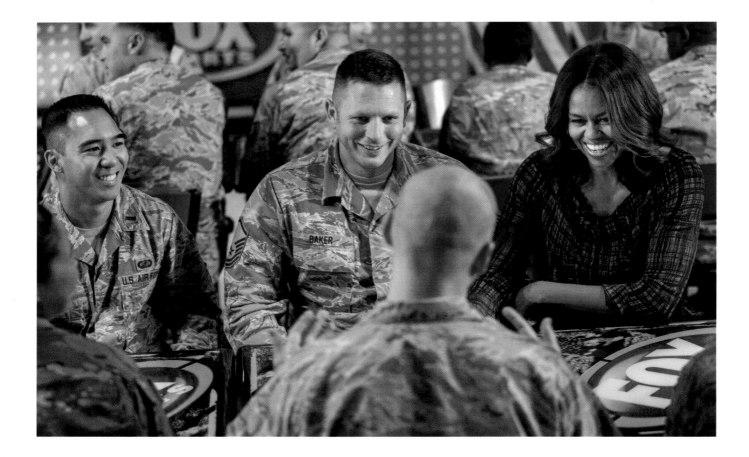

Above: The First Lady talks with service members at Al Udeid Air Base in Qatar, November 3, 2015.

Right: Mrs. Obama takes a selfie with a service member following a veterans job summit at Fort Campbell, Kentucky, April 23, 2014.

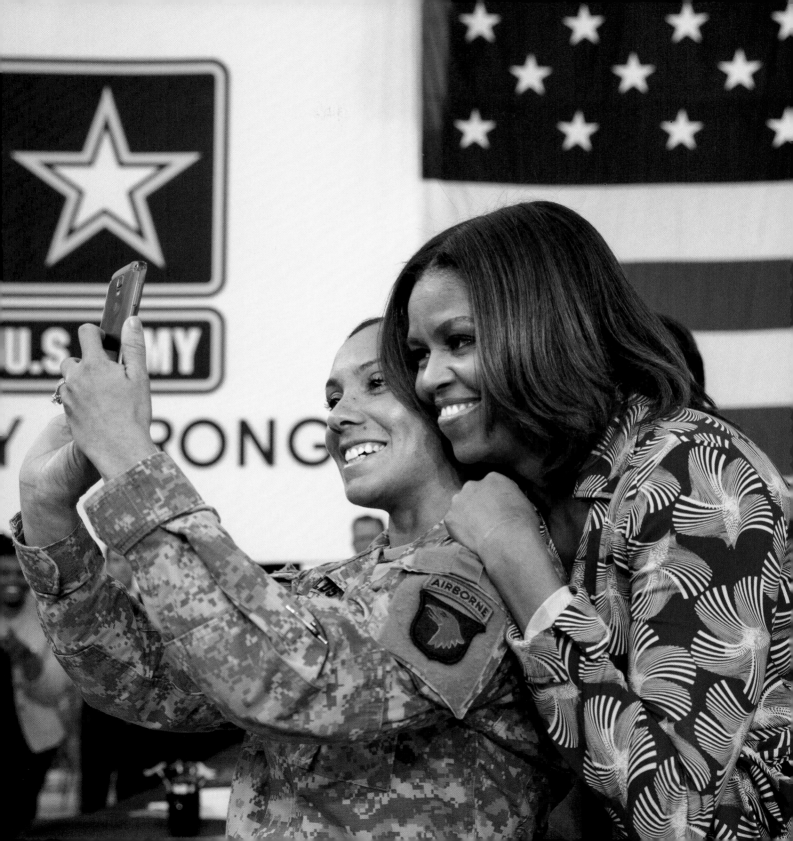

First Lady Michelle Obama listens to the challenges faced by tenth-grade students at Bell Multicultural High School, in Washington, DC, November 12, 2013.

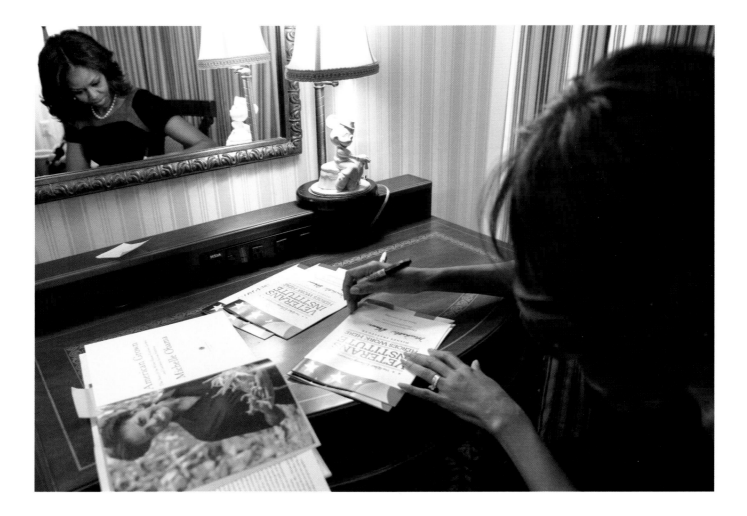

Mrs. Obama signs autographs in a
hotel room after delivering the keynote
address at Disney's Veterans Institute
workshop at the Disney Boardwalk Inn,
Walt Disney World Resort in Orlando,
Florida, November 14, 2013.

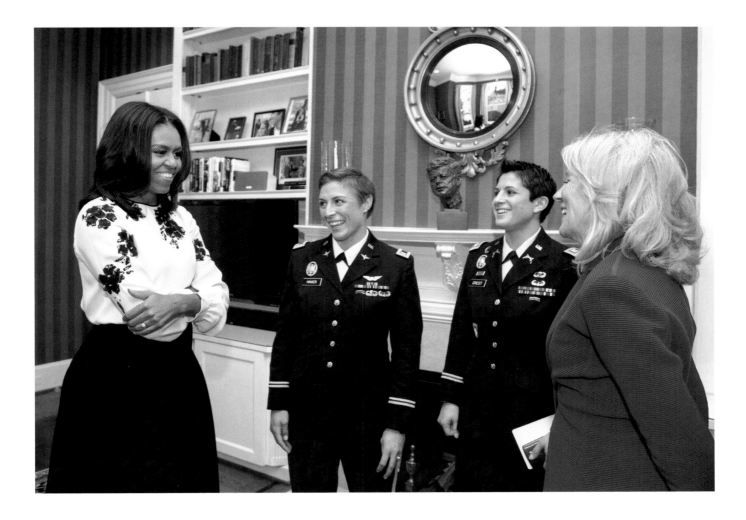

First Lady Michelle Obama and Dr. Jill Biden greet Lieutenant Shaye Lynne Haver and Captain Kristen Griest, the first women to graduate from the US Army Ranger School, during a Joining Forces luncheon on Veterans Day at the Naval Observatory Residence in Washington, DC, November 11, 2015.

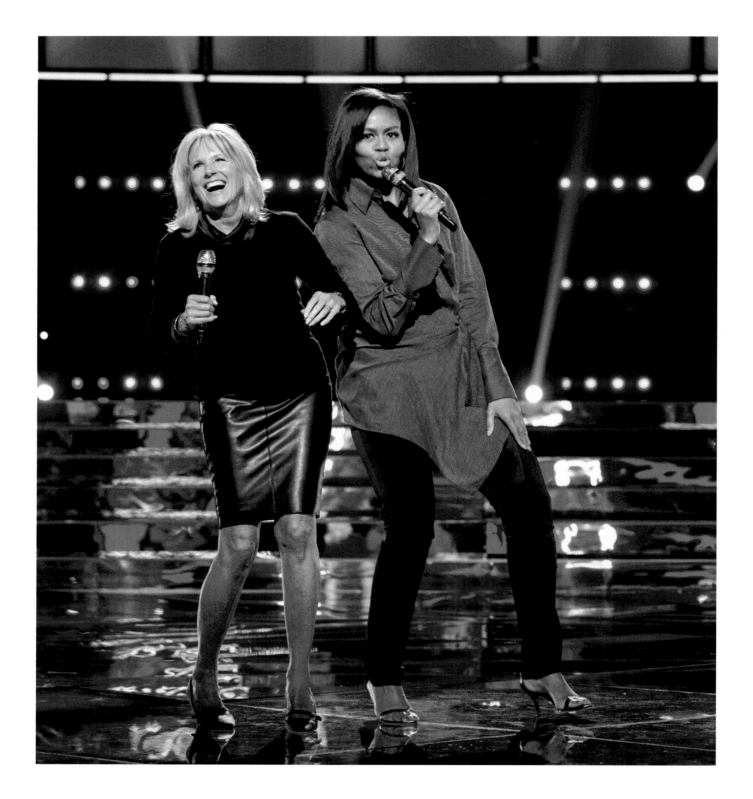

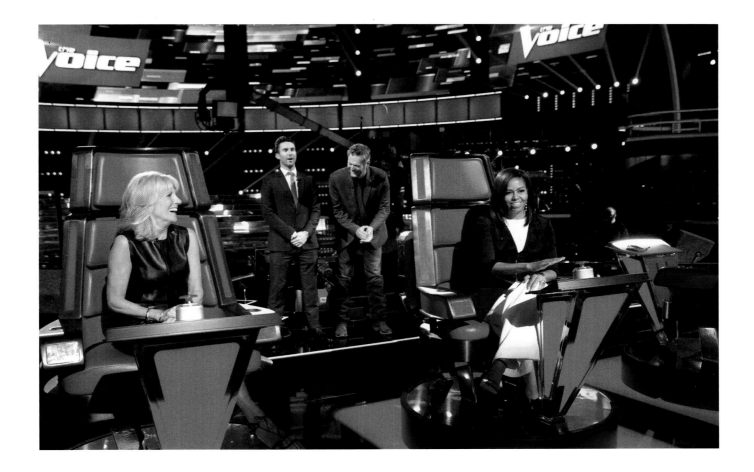

Left and Above: First Lady Michelle Obama and Dr. Jill Biden share some light moments, along with Adam Levine and Blake Shelton, during rehearsal prior to the kick-off of the fifth anniversary of their Joining Forces initiative on NBC's *The Voice* in Burbank, California, May 2, 2016.

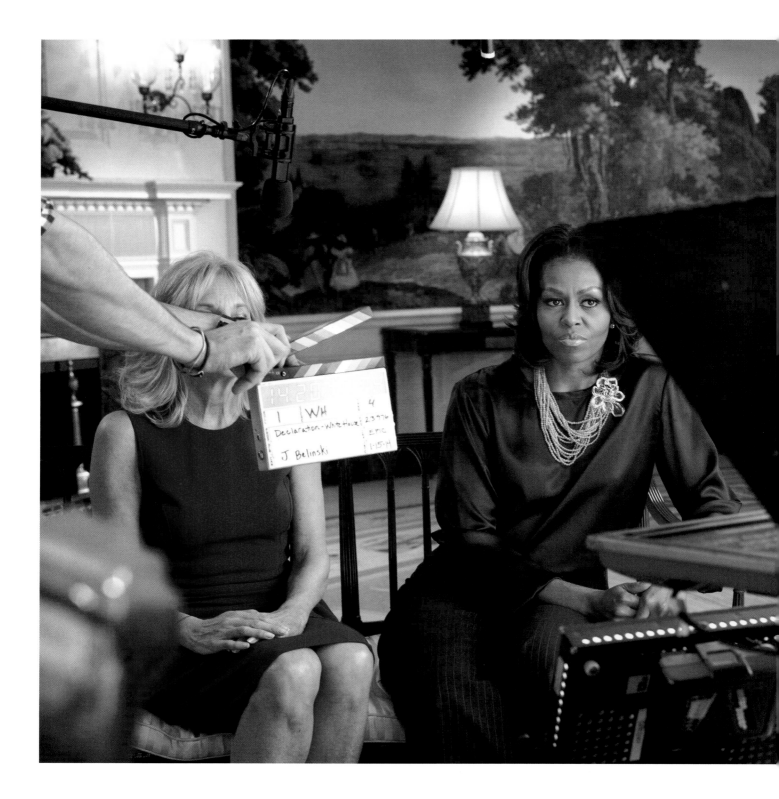

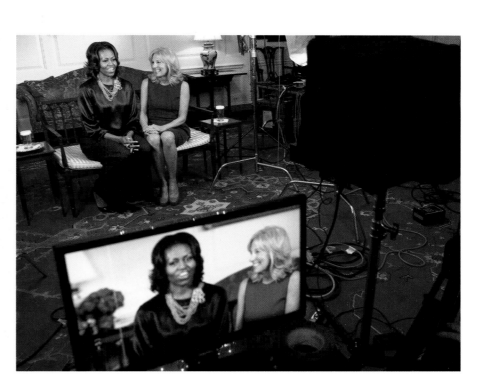

First Lady Michelle Obama and Dr. Jill Biden participate in a taping in the Diplomatic Reception Room (left) and the Map Room (above) of the White House, January 15, 2014.

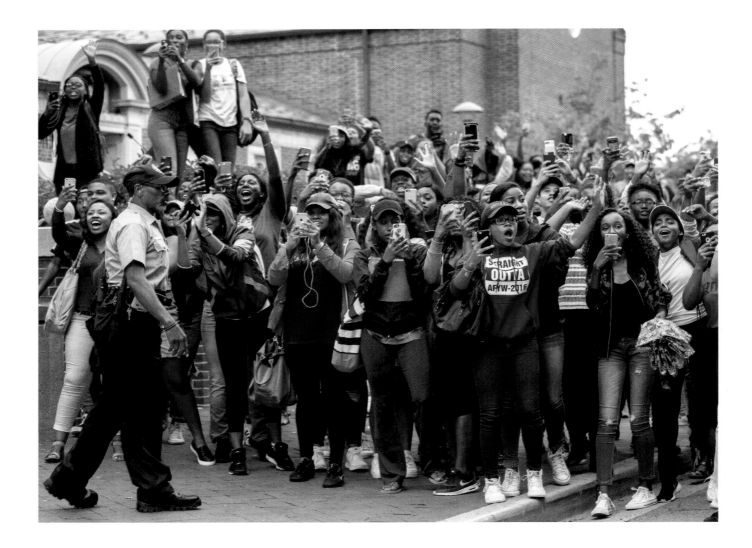

Above: Students react to seeing the
First Lady's motorcade following a
surprise visit to Howard University in
Washington, DC, September 1, 2016.

Right: Mrs. Obama listens to the
concerns of high school and college
students during a discussion about
higher education at Howard University
in Washington, DC, April 17, 2014.

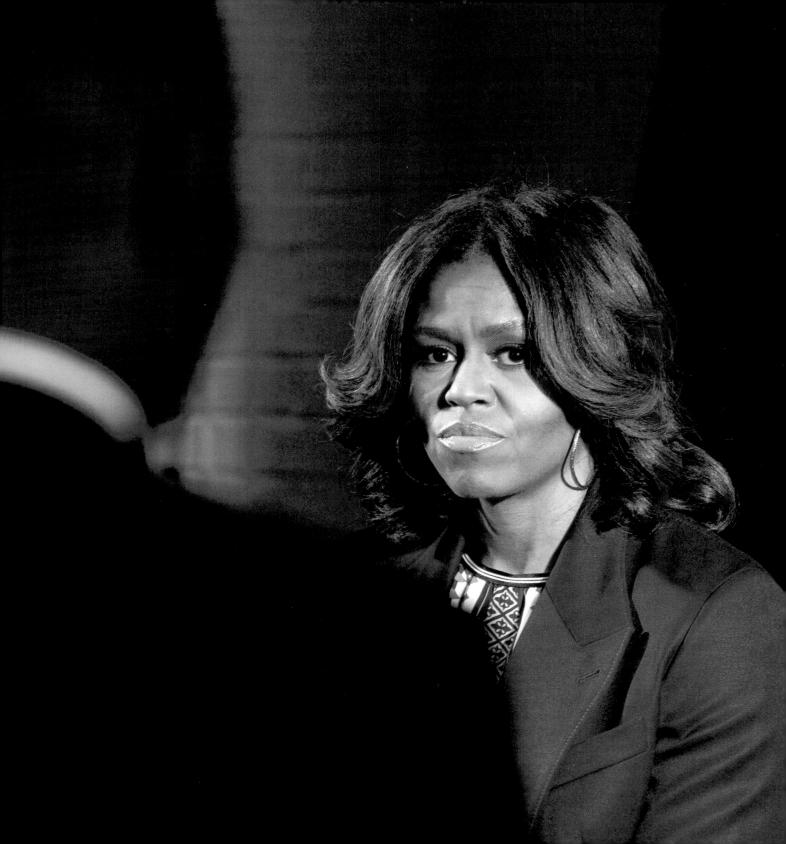

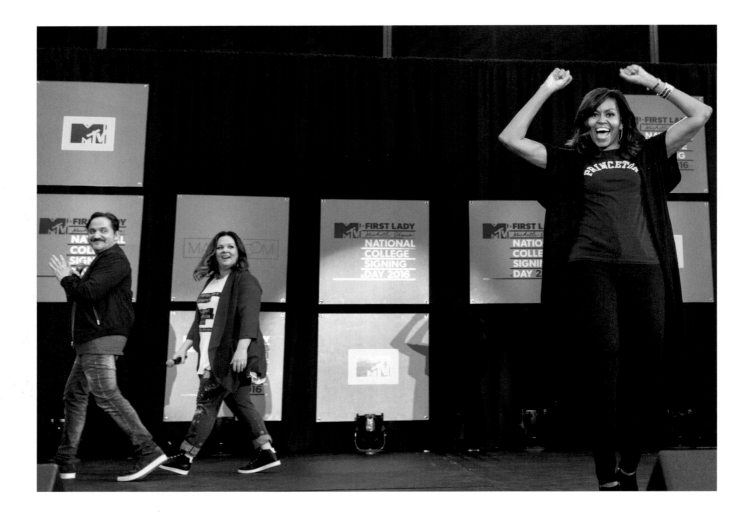

Above and Right: The crowd reacts as
the First Lady arrives on stage after being
introduced by comedians Ben Falcone
and Melissa McCarthy during a College
Signing Day event at the Harlem Armory
in New York, New York, April 26, 2016.

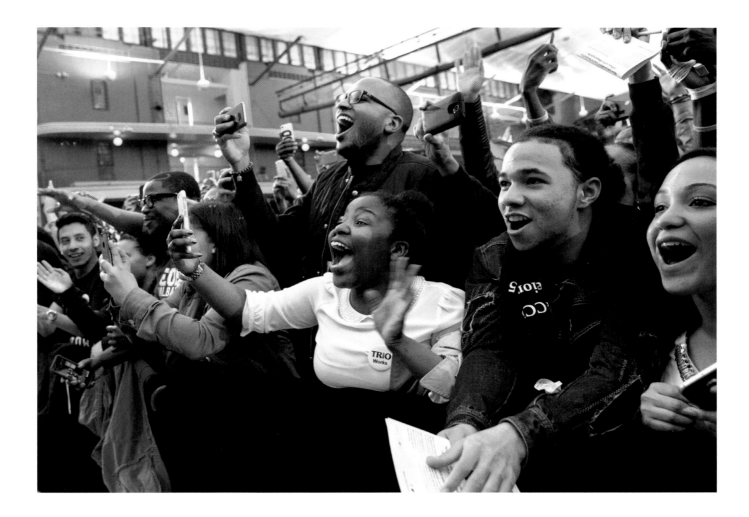

Mrs. Obama talks with students who have overcome substantial personal challenges to graduate from high school, during her first Beating the Odds roundtable discussion in the East Reception Room of the White House, July 8, 2014.

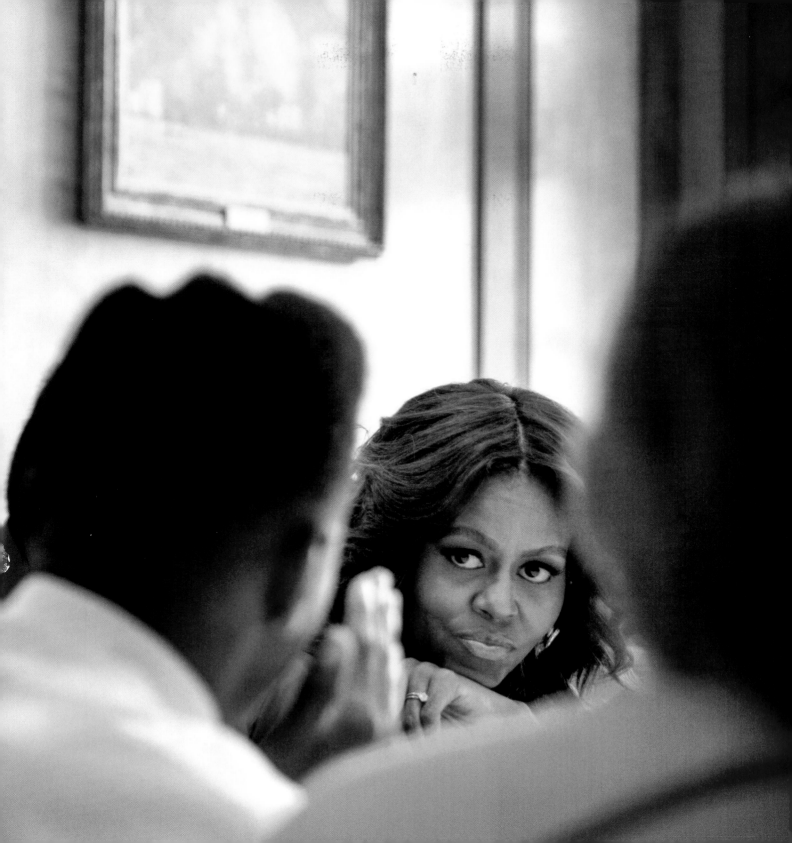

Above and Right: Mrs. Obama speaks
at the King College Prep graduation
ceremony at Chicago State University's
Jones Convocation Center in Chicago,
Illinois, June 9, 2015. Mrs. Obama and
the graduating class paid tribute to
Hadiya Pendleton, who was killed by gun
violence in 2013. She would have received
her diploma with King's class of 2015.

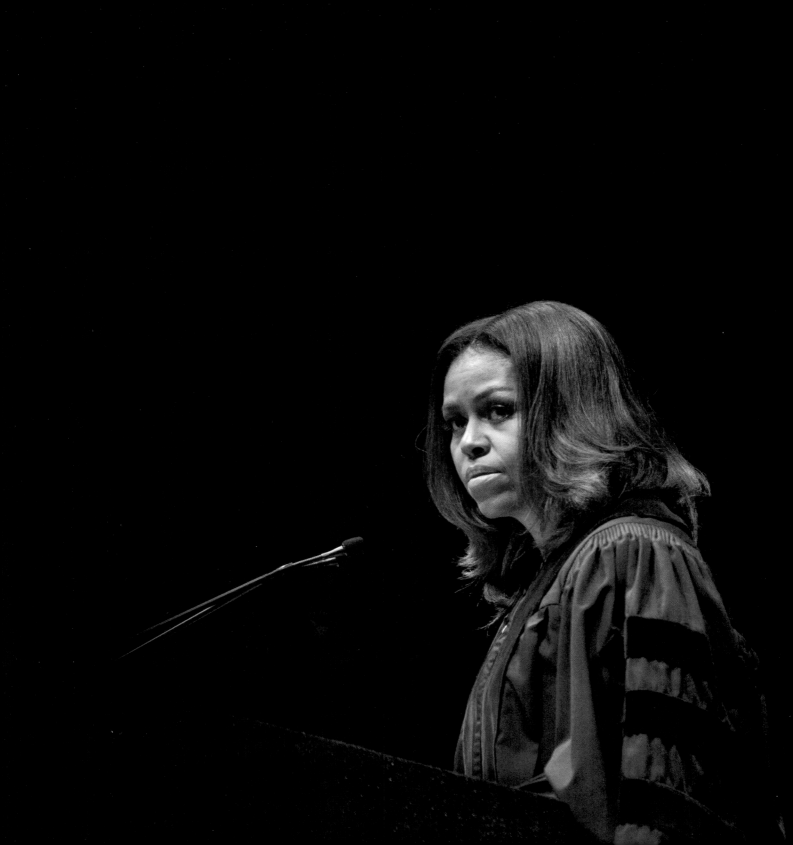

The First Lady attends the City College of New York commencement ceremony on the CCNY Harlem campus in New York, New York, June 3, 2016. Orubba Almansouri, who was born and raised in Yemen, delivered an empowering salutatory address about the importance of giving girls the opportunity to get an education.

It was a rainy, windy day, and we were all glad that the weather cleared long enough for us to visit the rooftop garden at Philip's Academy Charter School in New Jersey, one of the stops on Mrs. Obama's school gardens tour. She wanted to highlight many of the inspiring garden programs for the Let's Move! initiative.

Students were so excited to show off what they had learned about composting. They offered Mrs. Obama gardening gloves, but she declined, telling them that she doesn't mind getting her hands dirty. While demonstrating the different stages of composting, one of the girls found a worm. She hadn't expected to find it, and she laughed. Mrs. Obama picked the worm out of her hands and lifted it up to eye level. Then a sudden gust of wind sent her hair flying, and everyone laughed. It was a fun moment to capture.

Right: Mrs. Obama learns about composting with students at Philip's Academy Charter School in Newark, New Jersey, April 7, 2016.

Following spread: Mrs. Obama gardens with students in the White House Kitchen Garden, April 2, 2014 (left), April 5, 2016 (top right), October 6, 2015 (bottom right).

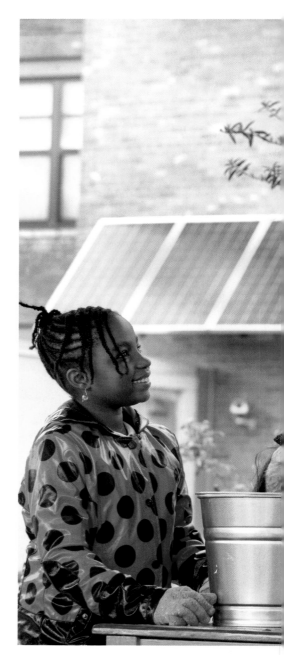

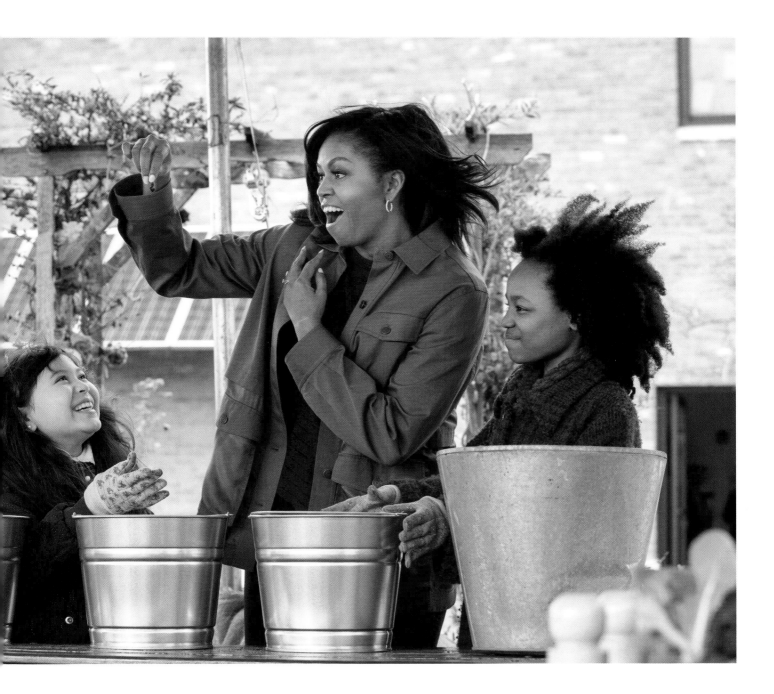

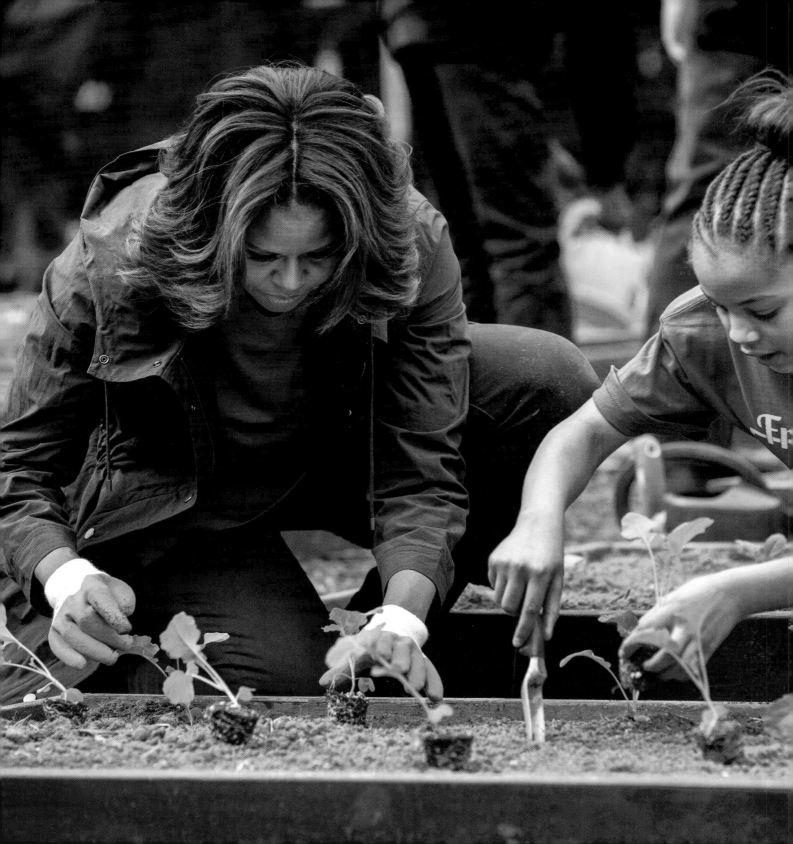

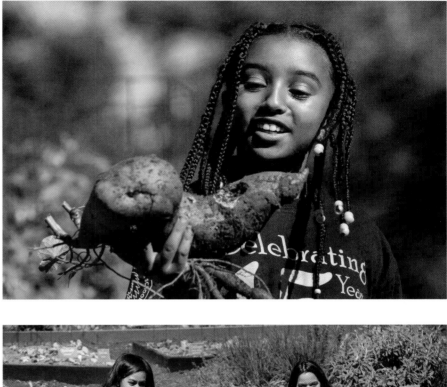

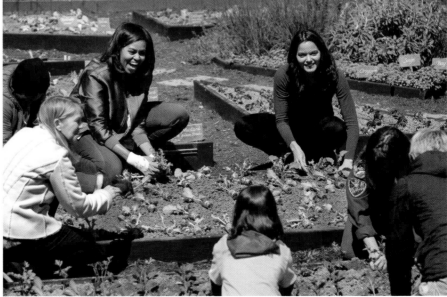

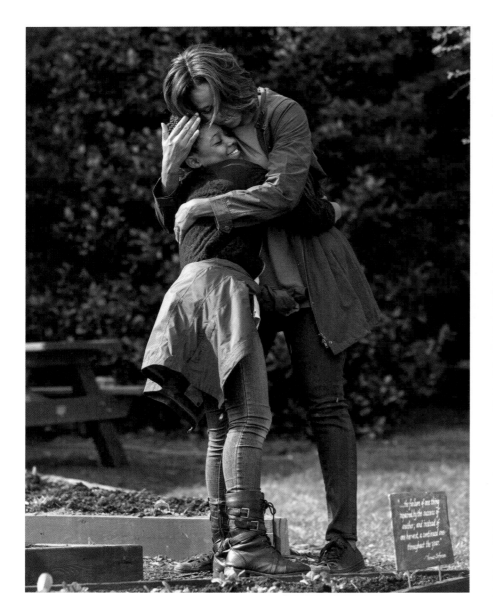

Above: The First Lady hugs a student following the spring garden planting in the White House Kitchen Garden, April 2, 2014.

Right: Mrs. Obama eats with students in the White House Kitchen Garden, June 6, 2016.

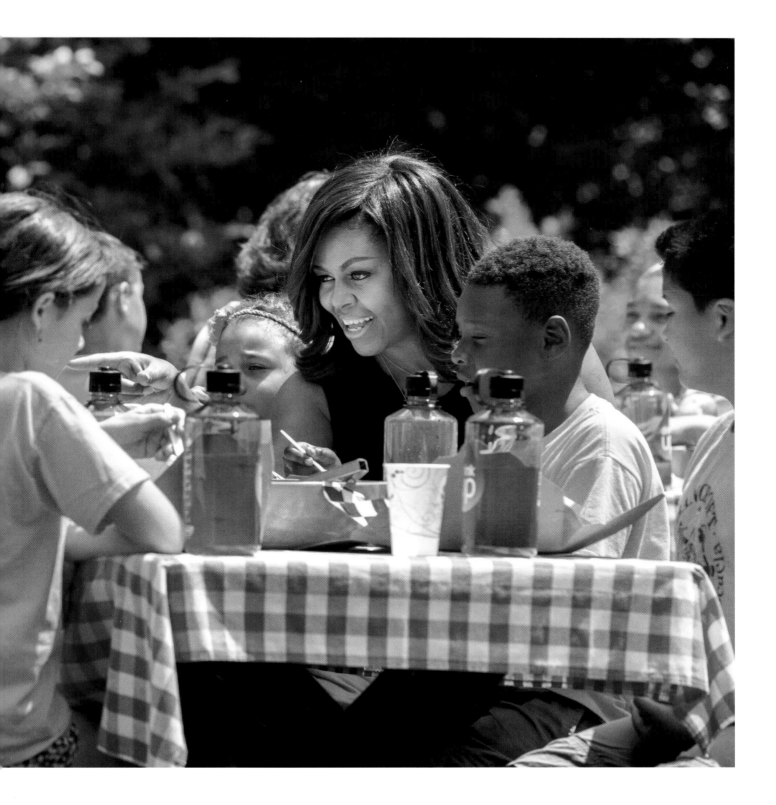

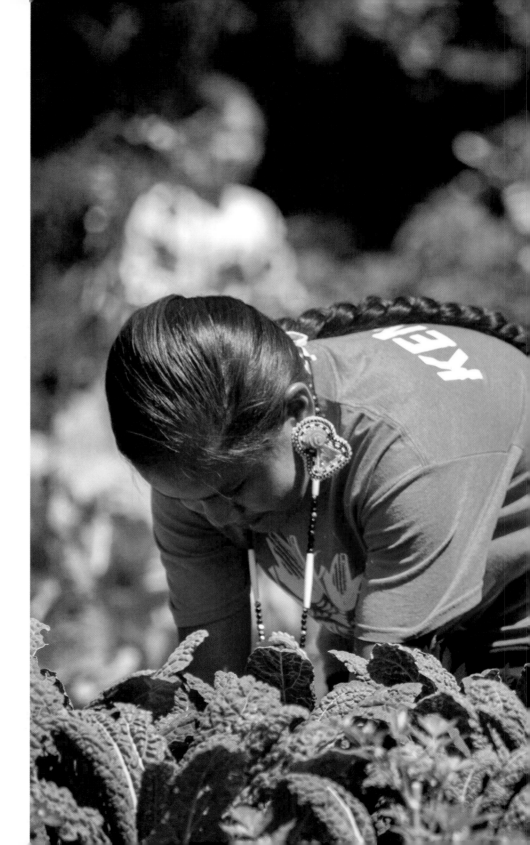

Mrs. Obama harvests kale with students in the White House Kitchen Garden, June 6, 2016.

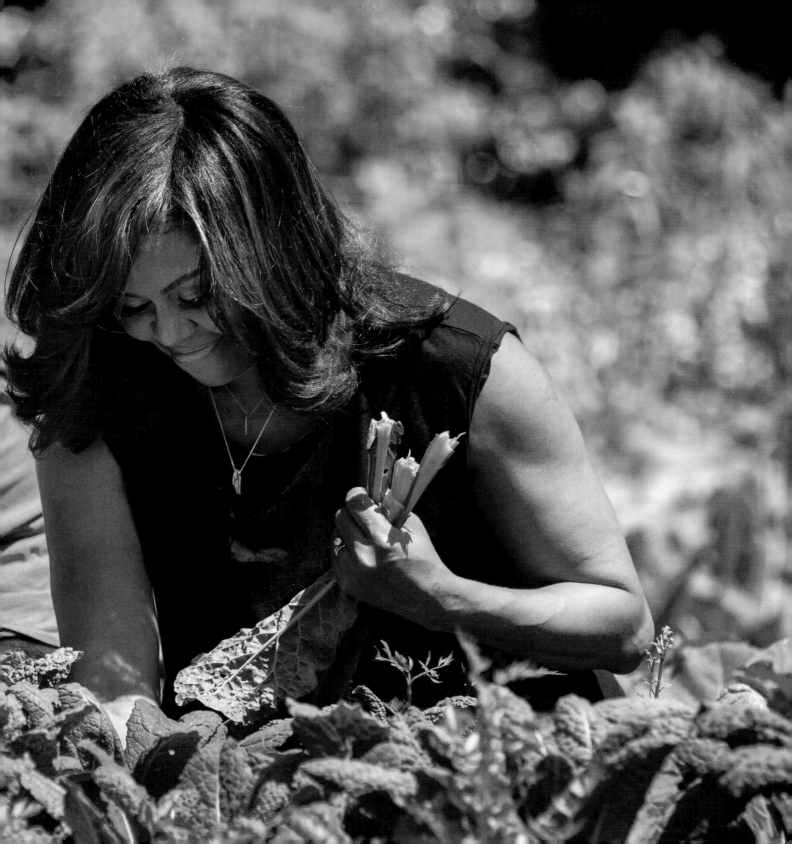

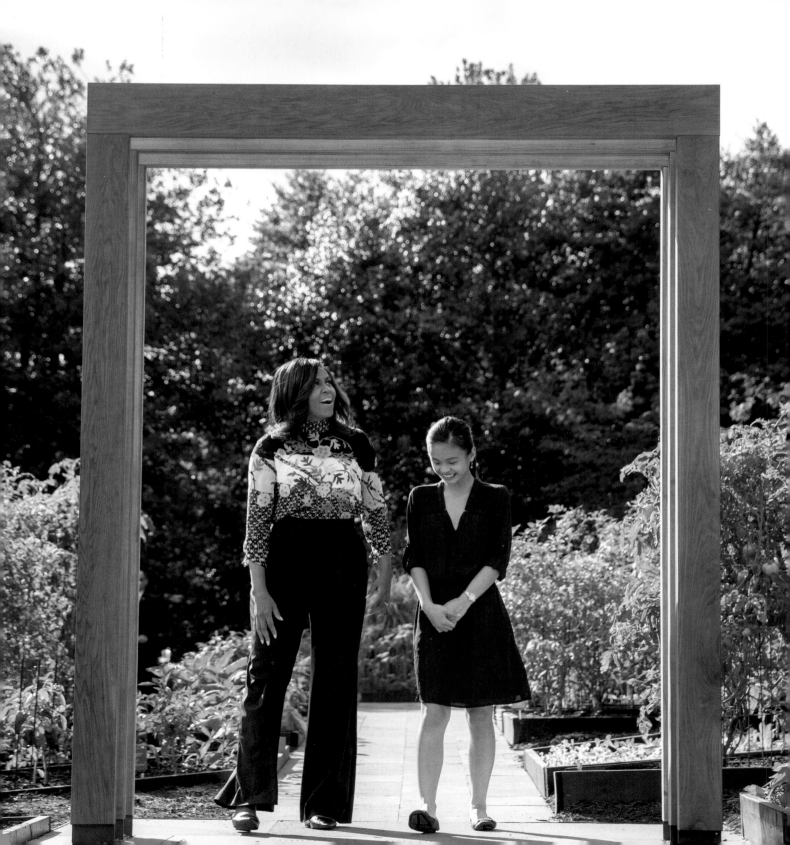

Before the dedication of the White House Kitchen Garden, Mrs. Obama walked under the new arbor with student Tammy Nguyen. Tammy introduced the First Lady for the garden dedication, as she had six years earlier during the launch of the Let's Move! initiative.

The new arbor was crafted from wood sourced throughout the United States, including pine and walnut harvested from the estates of Thomas Jefferson, James Madison, and James Monroe and the birthplace of Martin Luther King Jr. The First Lady stood under it as she spoke:

> "This garden has taught us that if we have the courage to plant a seed, then take care of it, water it . . . weather the storms that inevitably come, if we have the courage to do that, we never know what might grow. Now that's what this garden has taught me, to be fearless in those efforts, to try some new things, to not be afraid to mess up."

The First Lady and Tammy Nguyen walk under the new arbor in the White House Kitchen Garden, October 5, 2015.

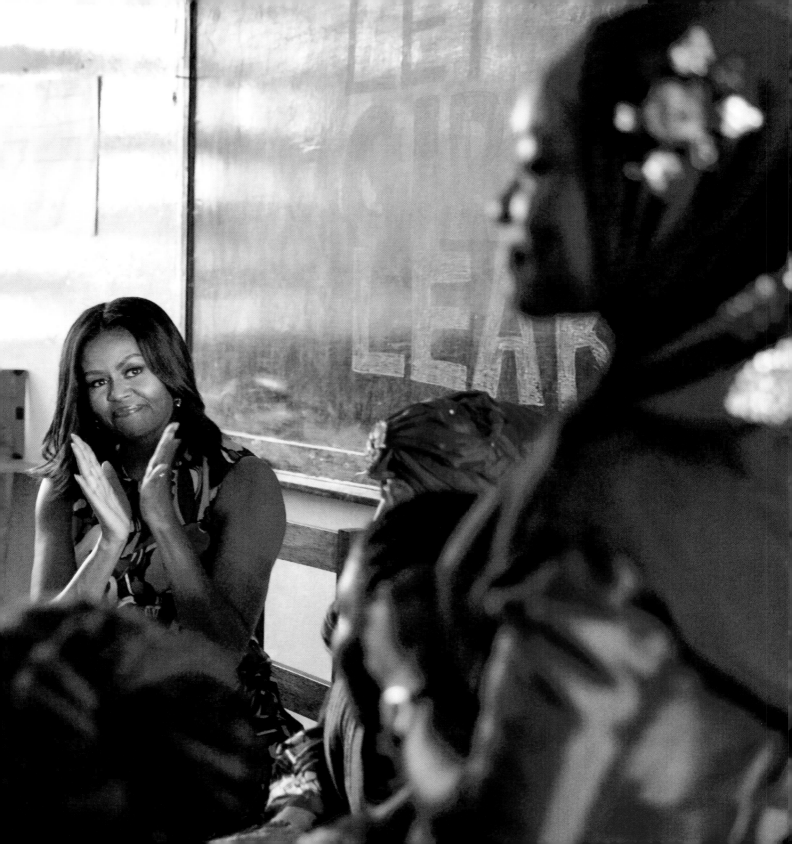

A WORLD OF POSSIBILITY

My time as a White House photographer moved as quickly as our motorcade. The faces of the people we met, the stories we heard, the lessons we learned, the interesting places we visited—the colors, the culture, the history—everything was being absorbed as quickly as the eye could see. Yet each of these experiences left lasting impressions.

In my four years at the White House, I traveled to twenty countries and countless cities across the United States. I documented Mrs. Obama as she visited schools, gardens, palaces, ancient ruins, sacred sites, and cultural and historical landmarks. I photographed her as she met dignitaries, royalty, celebrities, artists, and students.

Overseas travel was important to strengthen America's bond with other countries, as well as to promote the issues most important to Mrs. Obama. This was especially true for her Let Girls Learn initiative, which focuses on global education for girls. I was fortunate to be able to witness and document the growth of this program since its launch. I will never forget the young women we met around the world and their inspirational stories of courage, strength, and determination. It was a life-changing experience to be in the presence of such hope in the face of adversity.

Mrs. Obama encouraged the students to believe in themselves and not let any negative voices hold them back from achieving their dreams. Her words made me think of my own career path, and the negative voices I had encountered. I blocked out the voices of those who told me to get a "real" job, who told me that it wouldn't be possible to make a living as an artist. Instead, I chose to listen to another artist, my father, who was a landscape architect. He said, "Put cotton in your ears and keep on going." It was a silly saying but it worked.

I had always dreamed that being a photographer would take me to faraway places, and I was so grateful to be able to travel as part of the First Lady's team. Every day, I was able to see the world and all its possibilities.

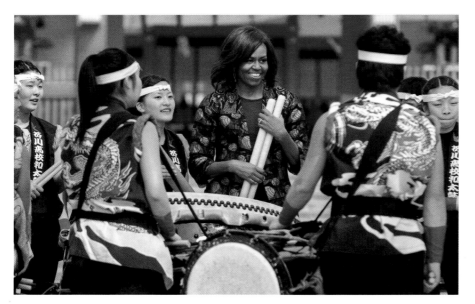

Above: The First Lady joins Taiko drummers at center drum prior to a tour of the Fushimi Inari Shinto Shrine in Kyoto, Japan, March 20, 2015.

Right: Mrs. Obama walks through a tunnel of torii gates at the Fushimi Inari Shinto Shrine.

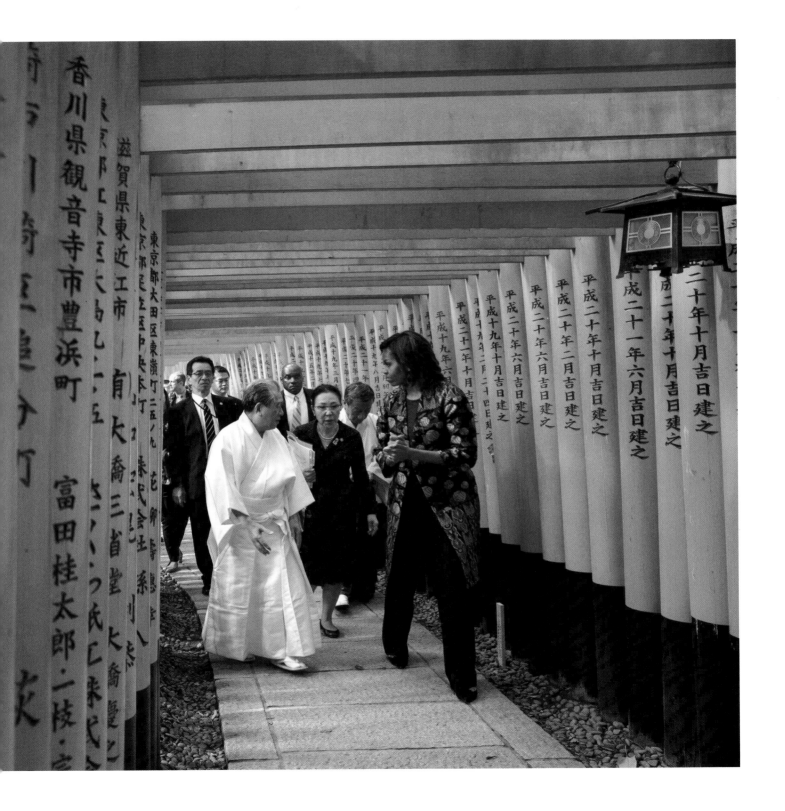

First Lady Michelle Obama participates in a traditional tea ceremony with Caroline Kennedy, US Ambassador to Japan, at the Kiyomizu-dera Buddhist temple in Kyoto, Japan, March 20, 2015.

Following spread: First Lady Michelle Obama is welcomed by a student at Hun Sen Prasat Bakong High School in Siem Reap, Cambodia, March 21, 2015.

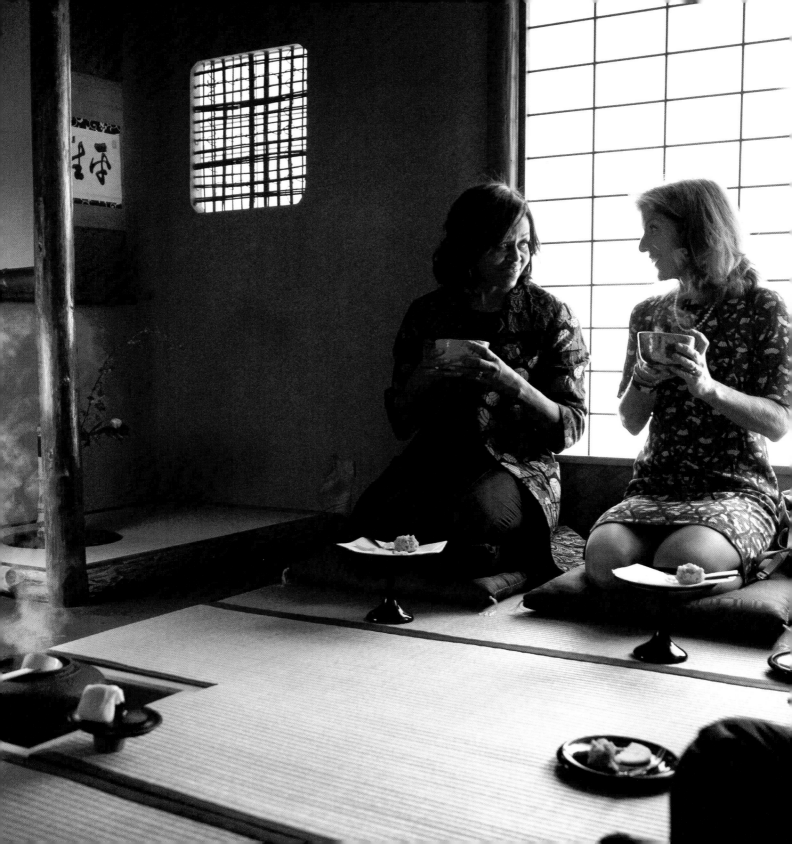

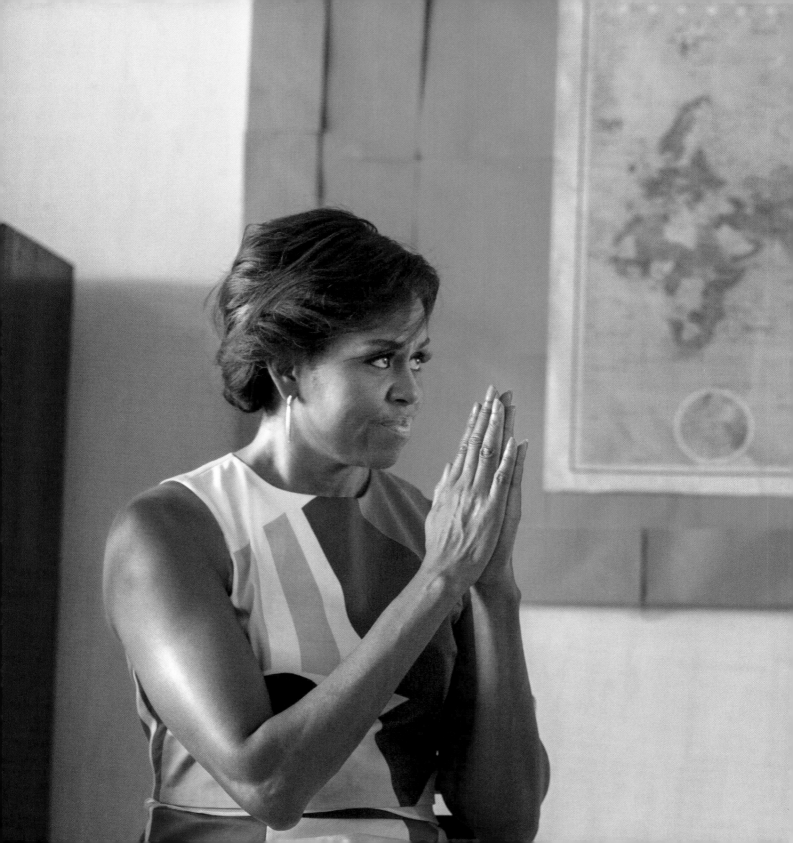

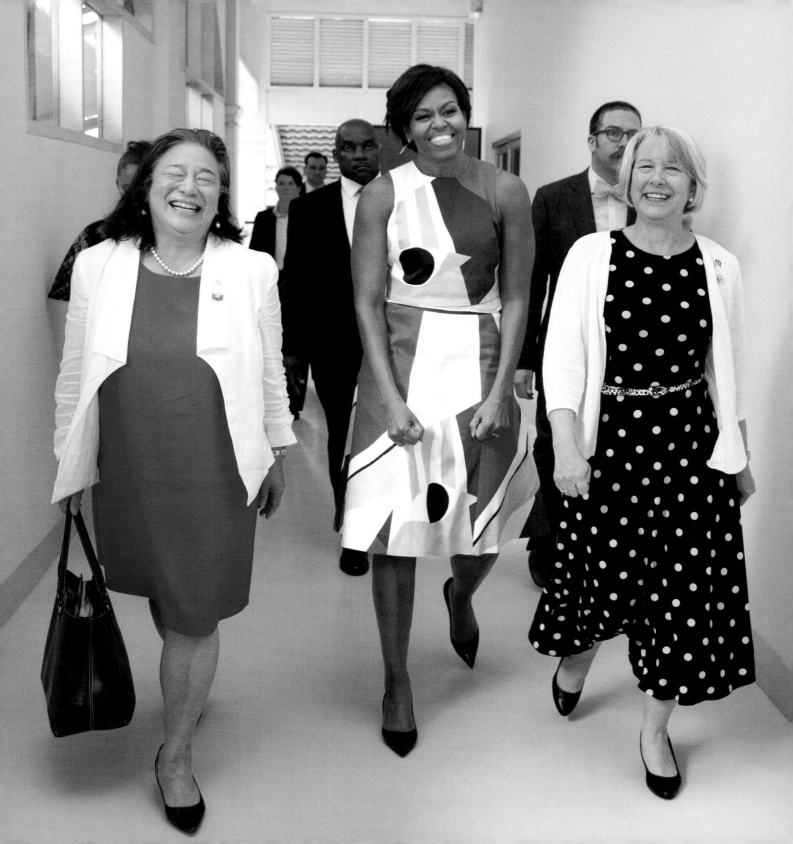

This was a really exciting day because the First Lady, along with her Chief of Staff Tina Tchen and Peace Corps Director Carrie Hessler Radelet, had the opportunity to meet with young women from Siem Reap, Cambodia, who benefited from the Let Girls Learn initiative.

Let Girls Learn shed light on the sixty-two million girls worldwide who do not have the opportunity to get an education. Let Girls Learn addressed the range of challenges preventing adolescent girls from reaching their full potential.

This initiative began as a dream of Mrs. Obama's. And after many years of work and creating partnerships with organizations such as the Peace Corps, in 2015 this dream became a reality. The other organizations involved include the Department of State, the US Agency for International Development, the US Department of Labor, the US Department of Agriculture, the Millennium Challenge Corporation, and the US President's Emergency Fund for AIDS Relief.

In the years to follow, we would travel all over the world, meeting courageous young women who were determined to get an education, despite their circumstances.

First Lady Michelle Obama, Peace Corps Director Carrie Hessler Radelet, and Chief of Staff Tina Tchen celebrate after a Let Girls Learn event in Siem Reap, Cambodia, March 21, 2015.

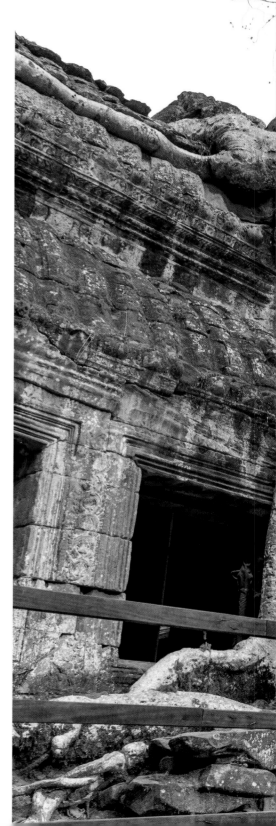

Above and Right: First Lady Michelle
Obama tours Angkor Wat in Siem Reap,
Cambodia, March 21, 2015.

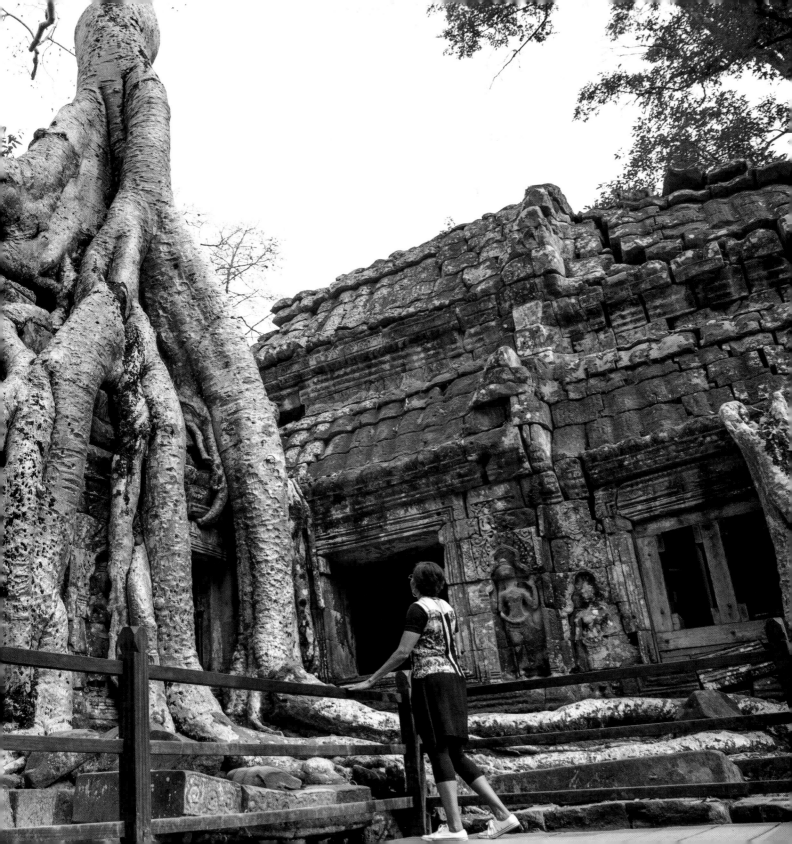

The First Lady waves as she departs Siem
Reap International Airport in Siem Reap,
Cambodia, March 22, 2015.

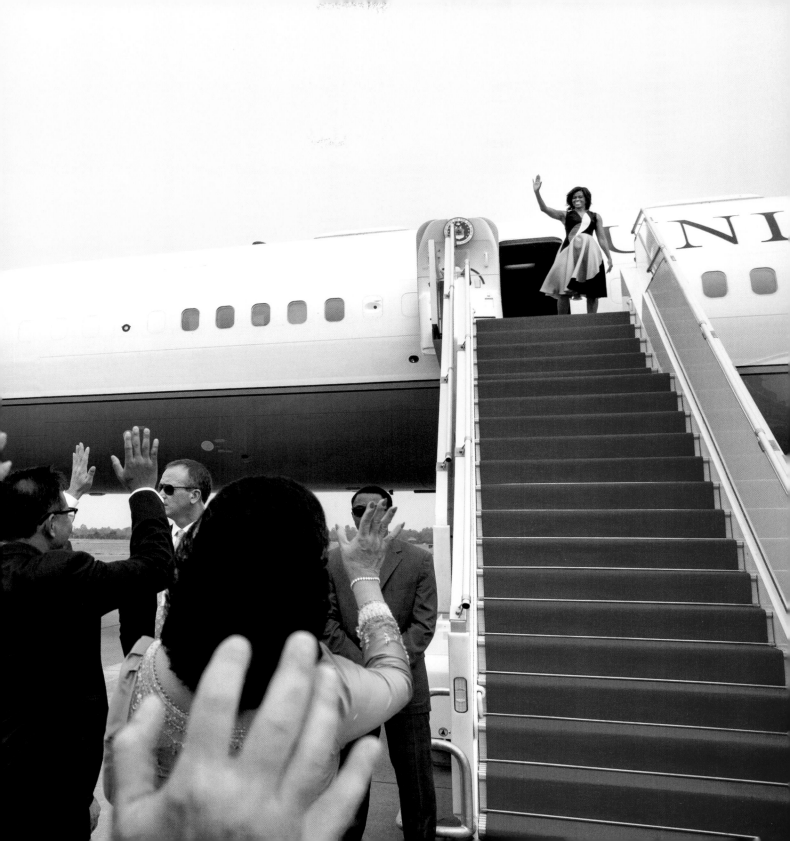

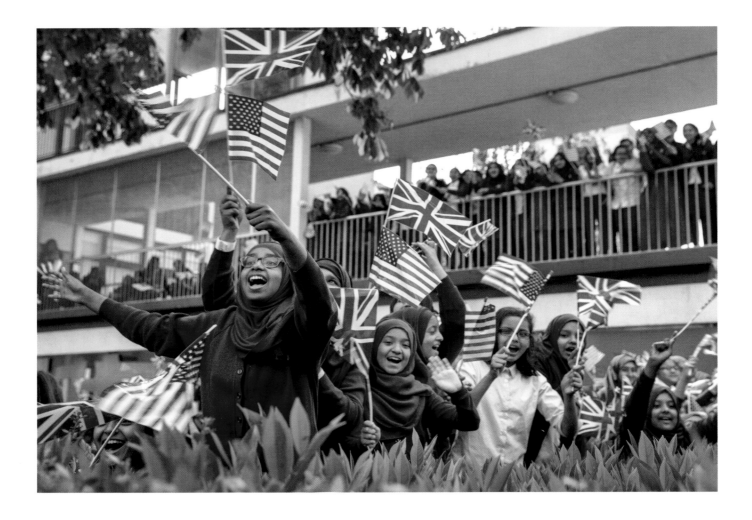

The First Lady is welcomed by students at Mulberry School for Girls in London, England, June 16, 2015. She visited the school to discuss cooperation between the United States and the United Kingdom to improve educational opportunities for girls around the world through the Let Girls Learn initiative.

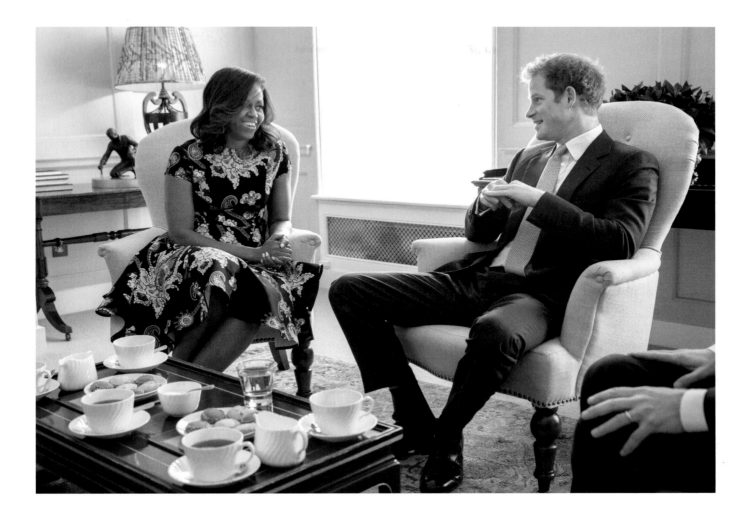

The First Lady meets with Prince Harry for tea to discuss the Let Girls Learn initiative and support for veterans, at Kensington Palace in London, England, June 16, 2015.

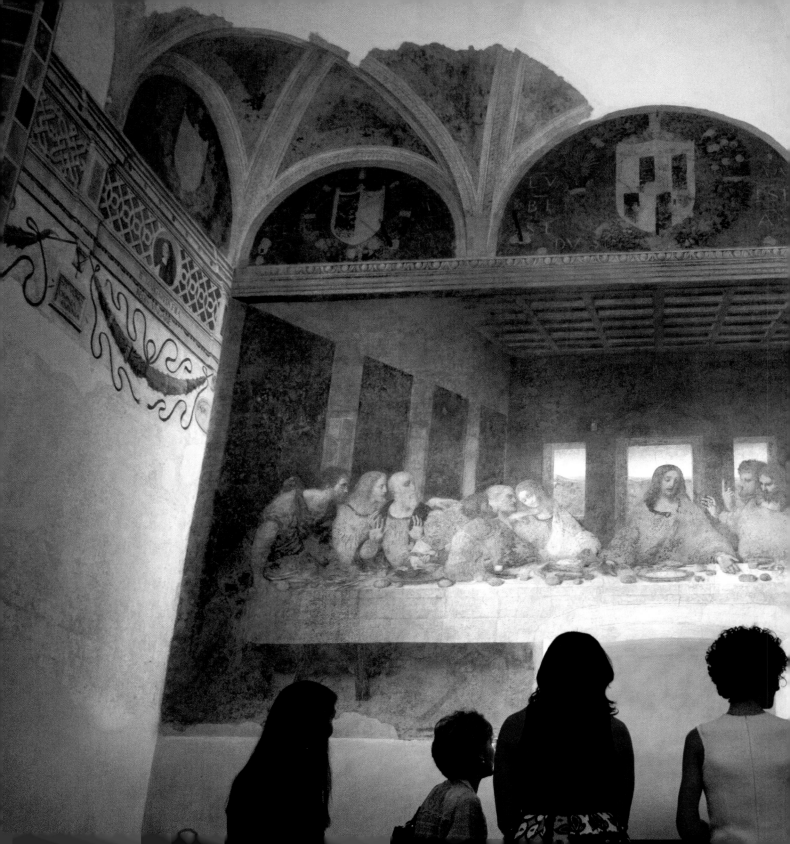

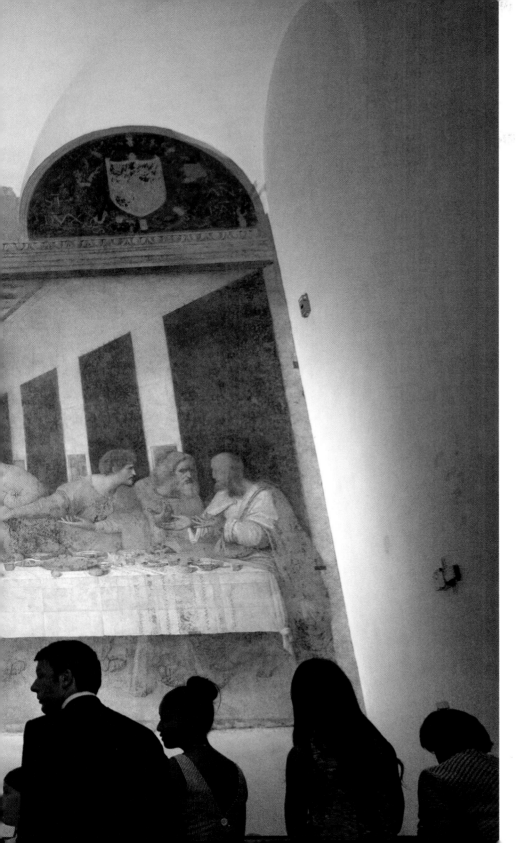

The First Lady, along with daughters Sasha and Malia, views Leonardo da Vinci's *The Last Supper* with Prime Minister Matteo Renzi and his wife, Agnese Landini, and daughter, Ester Renzi, at the Church of Santa Maria delle Grazie in Milan, Italy, June 17, 2015.

At the Milan Expo, a range of the latest technology was on display. The Mirror Room was one of the most visually engaging stops on our tour with Mrs. Agnese Landini, the wife of Italian Prime Minister Matteo Renzi.

The room was filled with mirrors, and on one wall constantly changing scenes were projected. It was a particularly interesting challenge to keep myself out of the picture while photographing in a room full of mirrors.

First Lady Michelle Obama tours the Mirror Room in the Italian Pavilion with Mrs. Agnese Landini at the Milan Expo 2015 in Milan, Italy, June 18, 2015. Mrs. Obama led the presidential delegation to the expo, "Feeding the Planet, Energy for Life."

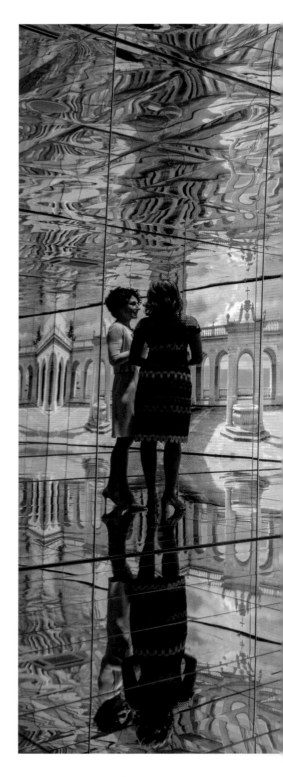

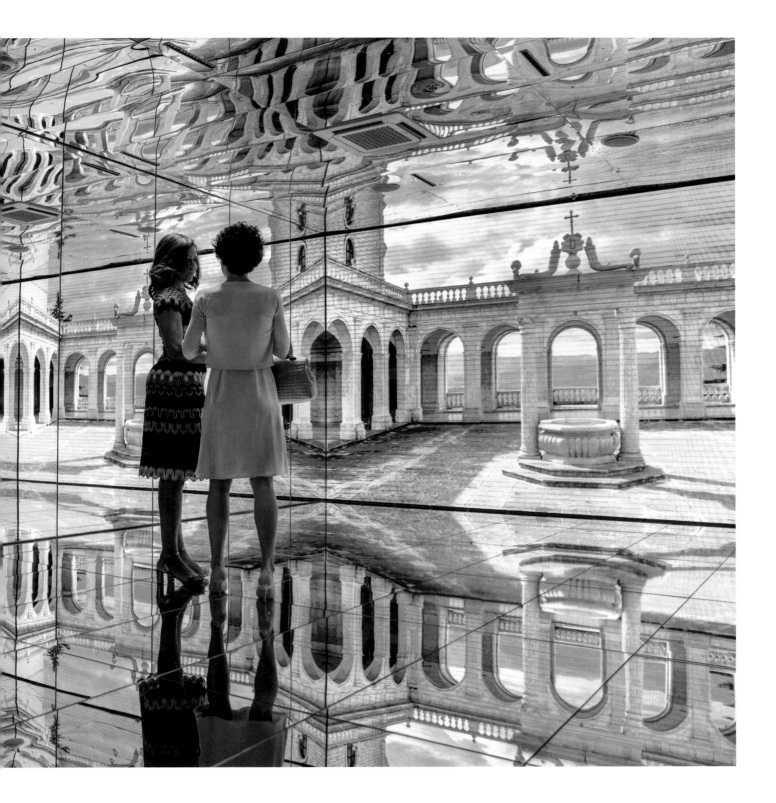

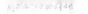

The First Lady travels by boat
in Venice, Italy, June 19, 2015.

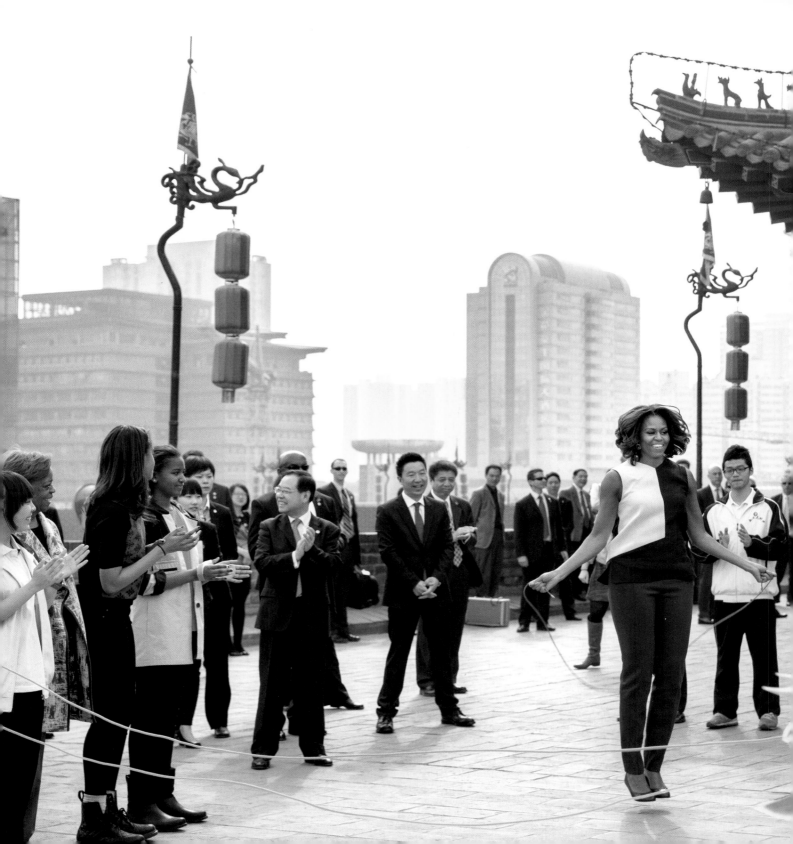

Mrs. Obama jumps rope during a game demonstration with students, daughters Sasha and Malia, and her mother, Mrs. Marian Robinson, at the City Wall in Xi'an, China, March 24, 2014.

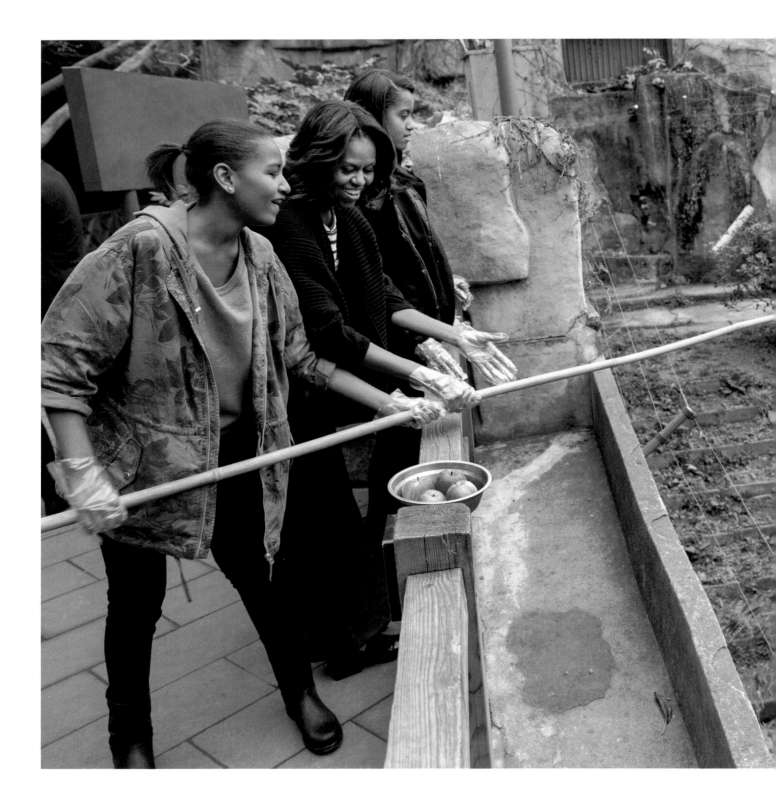

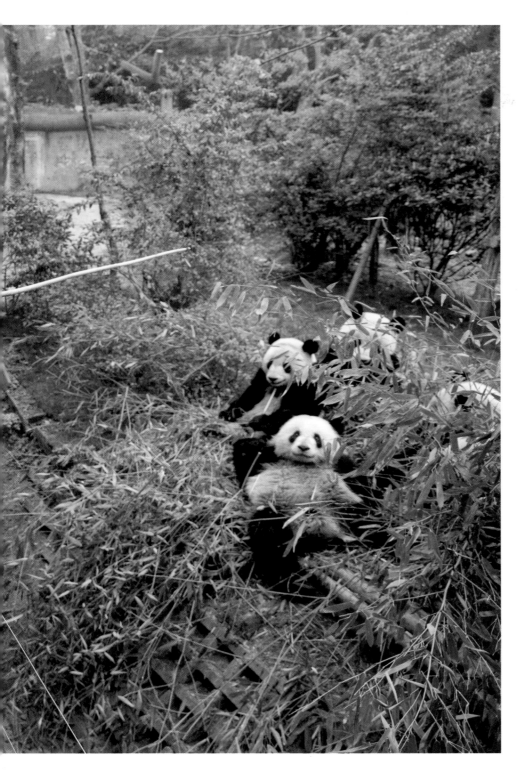

The First Lady and daughters Sasha and Malia feed apples to giant pandas during a visit to the Giant Panda Research Base in Chengdu, China, March 26, 2014.

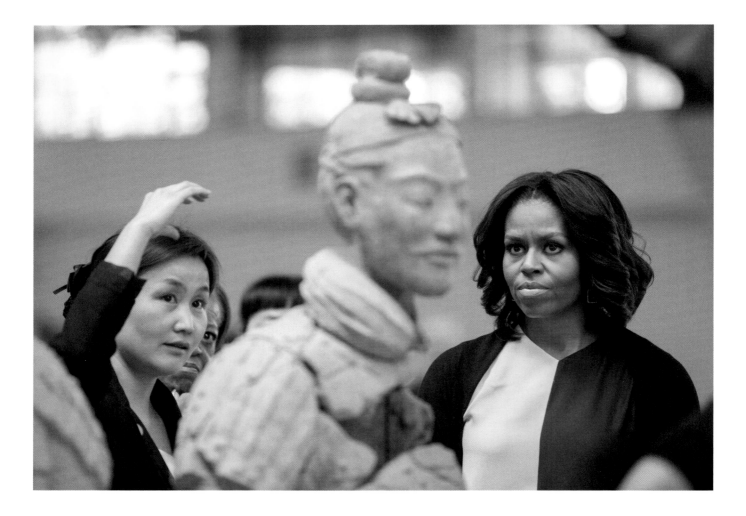

Mrs. Obama gets a closer look at the Terra-
cotta Warriors in Xi'an, Shaanxi Province,
China, March 24, 2014. Cao Wei, Director
of Terracotta Warriors, leads the tour.

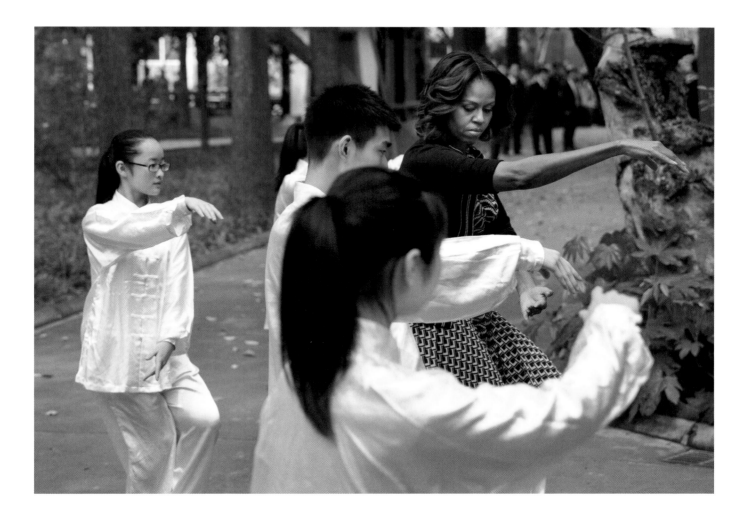

The First Lady participates in tai chi
with students from Number 7 School
in Chengdu, China, March 25, 2014.

The First Lady hugs her daughters Sasha and Malia as they visit the Great Wall of China in Mutianyu, China, March 23, 2014.

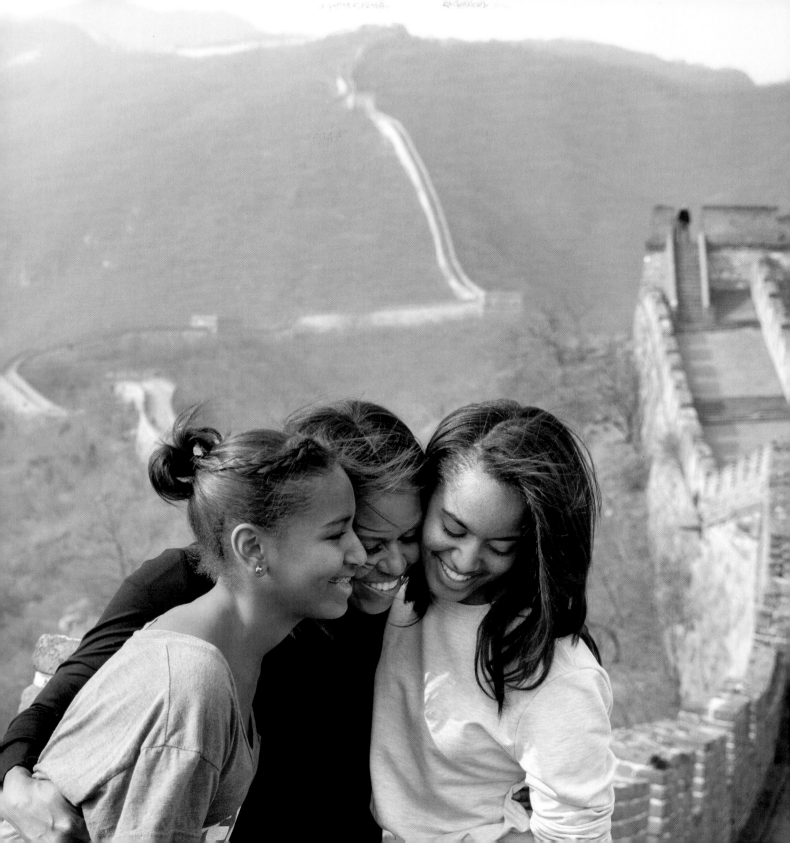

It was a welcome surprise to learn that we would be riding the toboggan on the Great Wall of China. I needed to get to the bottom early in order to capture photos of Mrs. Obama's experience, so I was one of the first people in our group to ride down. I must've looked funny cruising down on the small sled loaded up with all my camera gear. It was entertaining to see everyone in our group ride down, especially the line of Chinese Secret Service agents in suits! I loved capturing this photo of Mrs. Obama—it was refreshing to see her smiling face as she sped down the hill with her Secret Service agent behind her.

Mrs. Obama rides a toboggan at the
Great Wall of China in Mutianyu, China,
March 23, 2014.

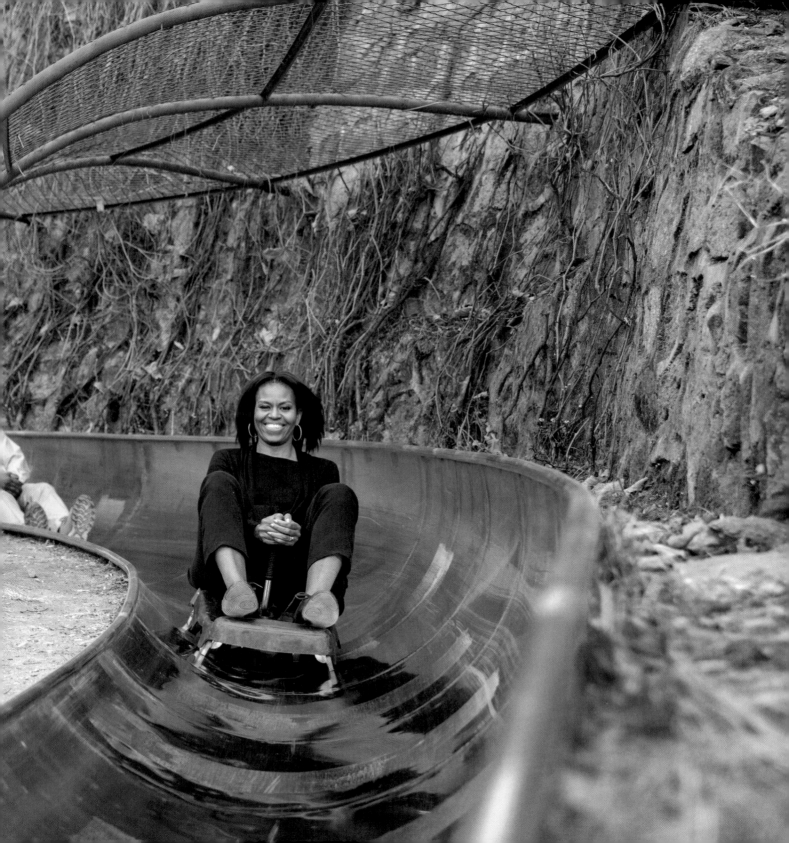

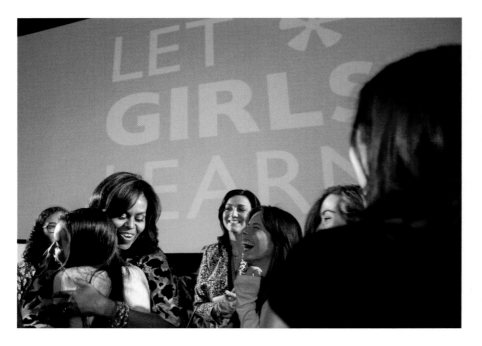

Above: Mrs. Obama greets students following a Let Girls Learn discussion with Soledad O'Brien at Fabrica de Arte in Havana, Cuba, March 21, 2016.

Right: The First Lady takes a photo with audience members during a Let Girls Learn event at Centro Metropolitano de Desino in Buenos Aires, Argentina, March 23, 2016.

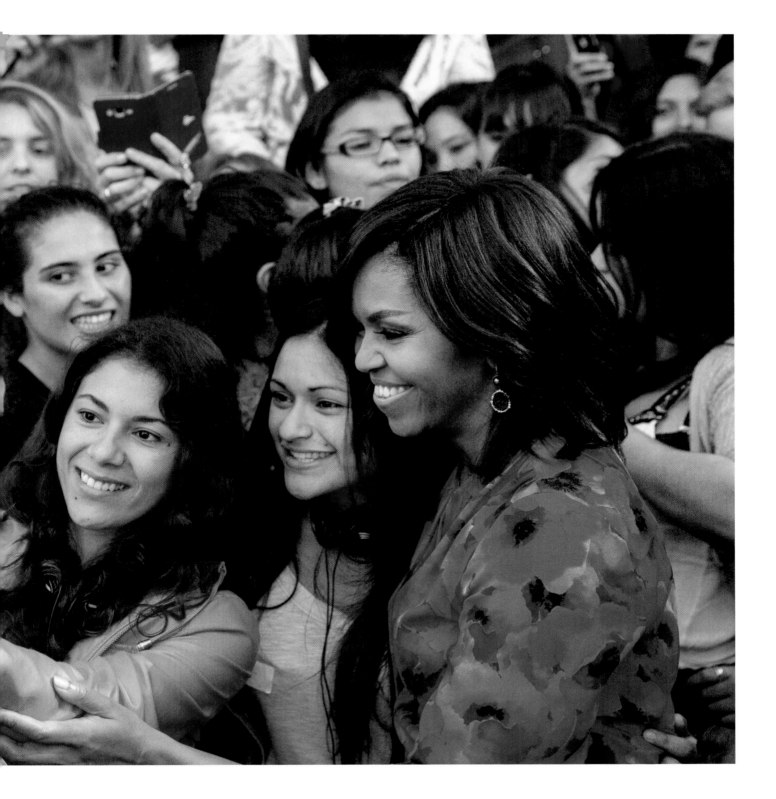

During the official State Dinner in Buenos Aires, Argentina, President Obama and Mrs. Obama were invited to dance the tango with the performers.

Most of the cameras were focused on the President, and I knew that Chief White House Photographer, Pete Souza, would get great images of him. So, I turned my lens toward the First Lady to document her having fun and dancing, too.

The First Lady dances with José Lugones during a State Dinner hosted by President Mauricio Macri and Juliana Awada, First Lady of Argentina, at Centro Cultural Kirchner in Buenos Aires, Argentina, March 23, 2016.

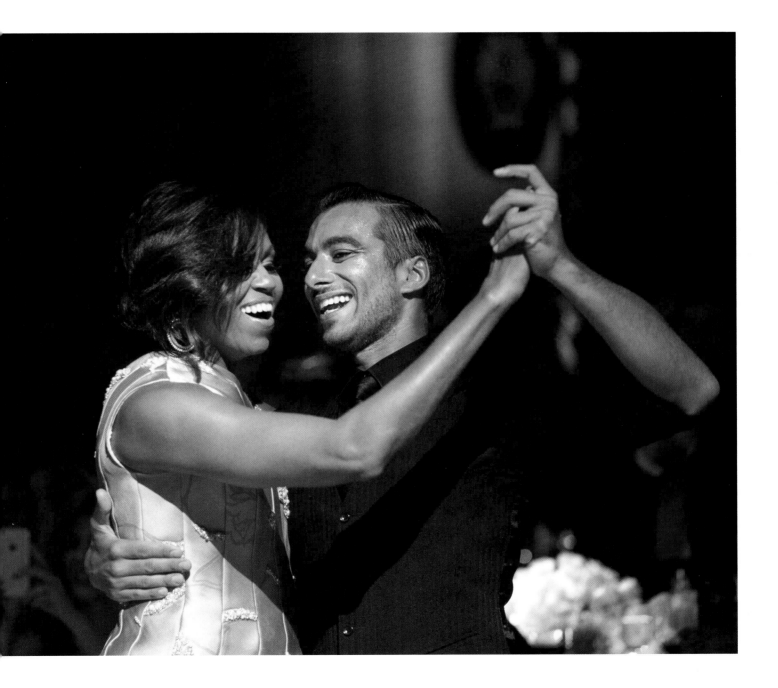

Bystanders line the road to get a glimpse of the motorcade as the First Lady travels through Havana, Cuba, March 21, 2016.

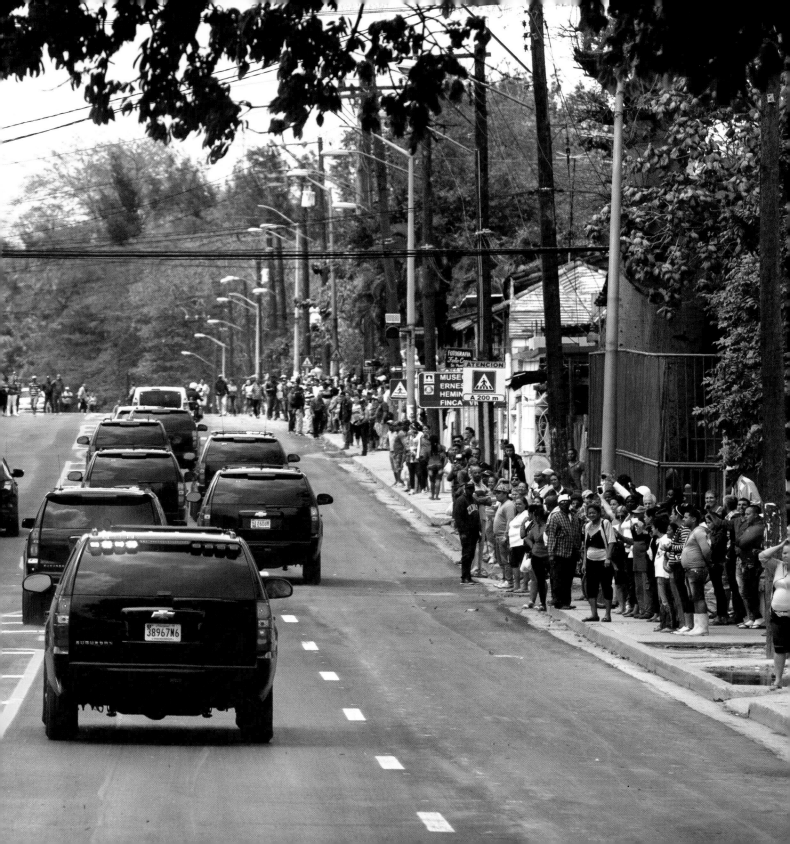

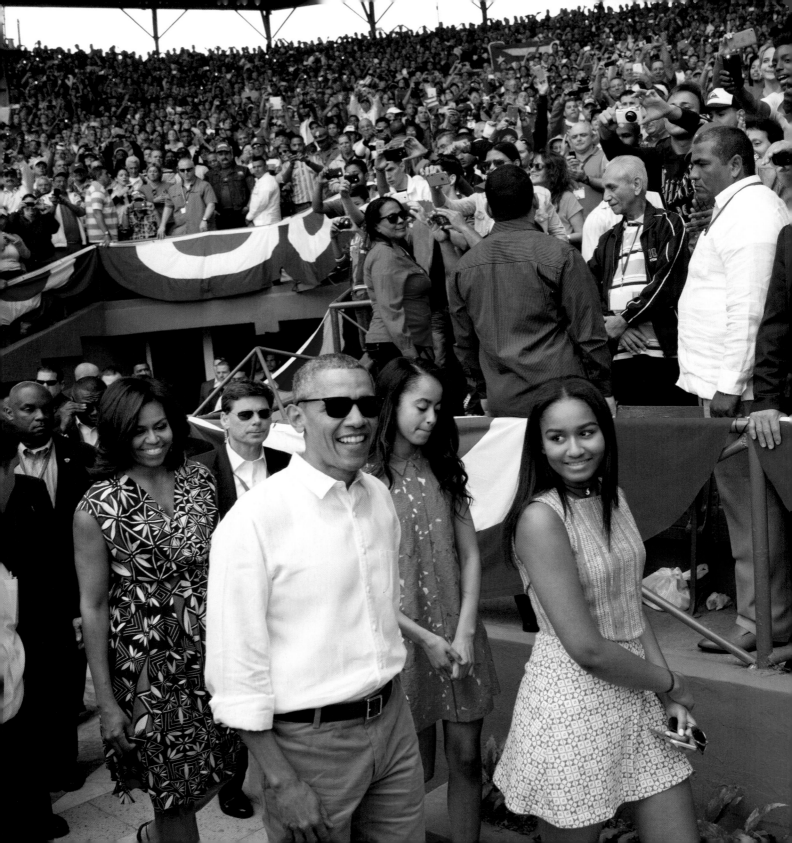

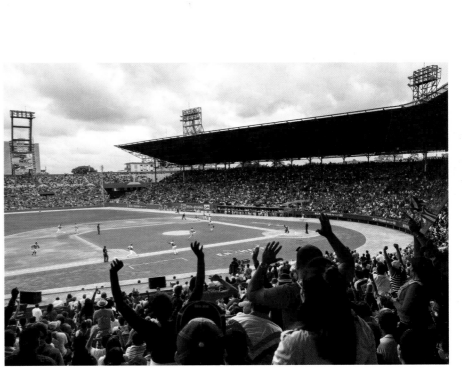

Left and Above: President Obama and Mrs. Obama, along with daughters Sasha and Malia, attend an exhibition game between the Tampa Bay Rays and the Cuban National Team at the Latin American Stadium in Havana, Cuba, March 22, 2016.

First Lady Michelle Obama
and Meryl Streep, along with
Martha Adams and Beth Osisek,
producers of the *We Will Rise*
documentary, share a laugh
backstage prior to an interview
with Isha Sesay in Marrakech,
Morocco, June 28, 2016.

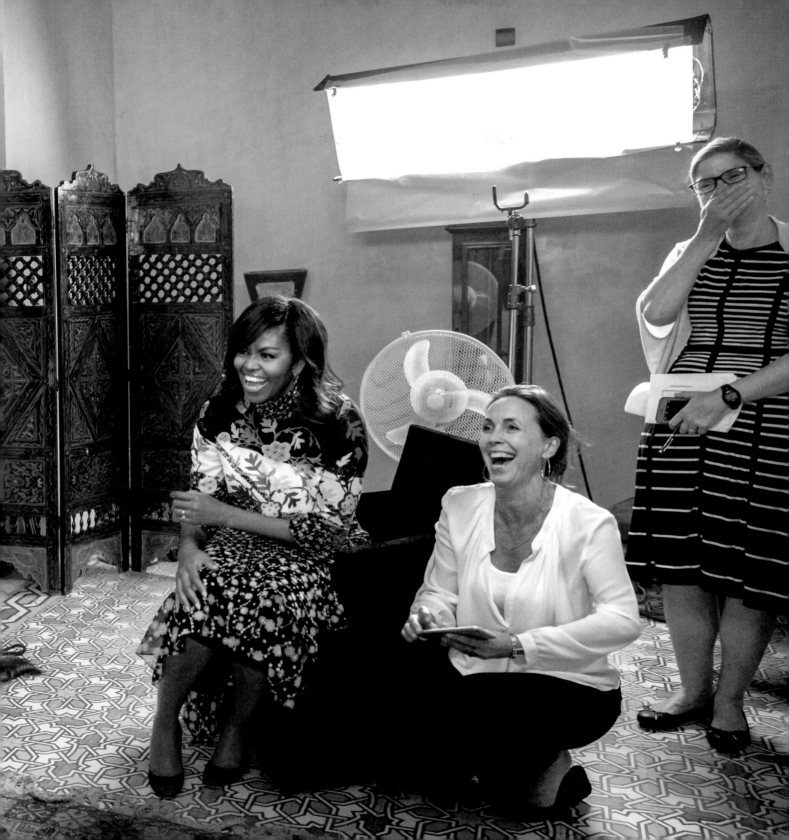

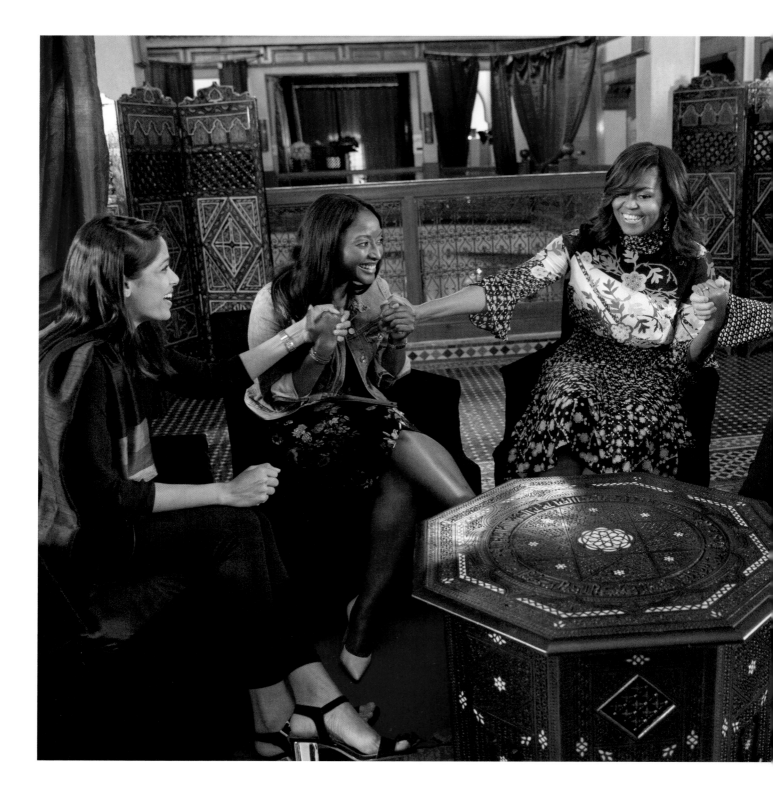

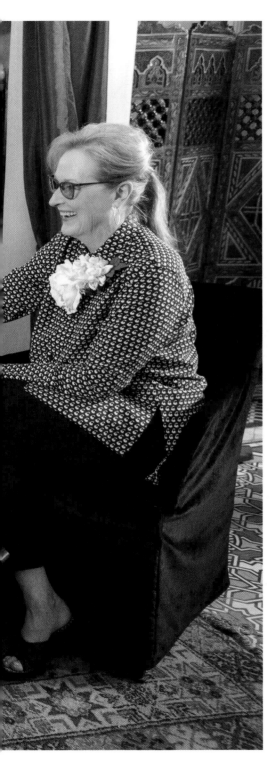

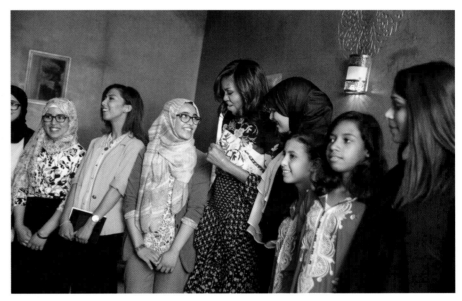

Above: Mrs. Obama greets students prior to a discussion about girls' education in Marrakech, Morocco, June 28, 2016.

Left: First Lady Michelle Obama, Meryl Streep, and Freida Pinto participate in a CNN interview with Isha Sesay, in support of the Let Girls Learn initiative in Marrakech, Morocco, June 28, 2016.

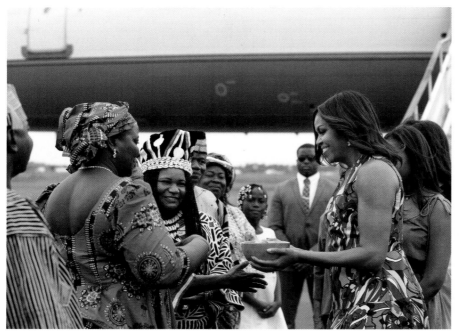

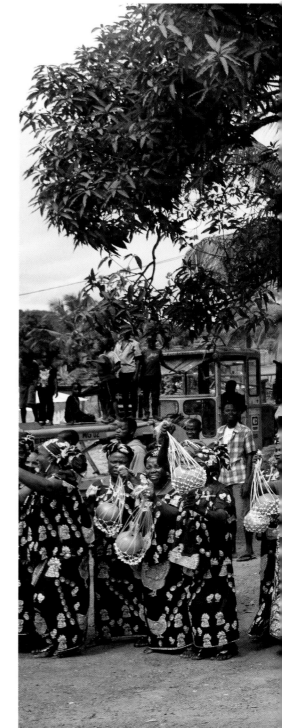

Above: First Lady Michelle Obama is welcomed upon arrival at Monrovia/ Roberts International Airport in Monrovia, Liberia, June 27, 2016.

Right: Bystanders watch as the First Lady's motorcade travels to the Peace Corps Training Center in Kakata, Liberia, June 27, 2016.

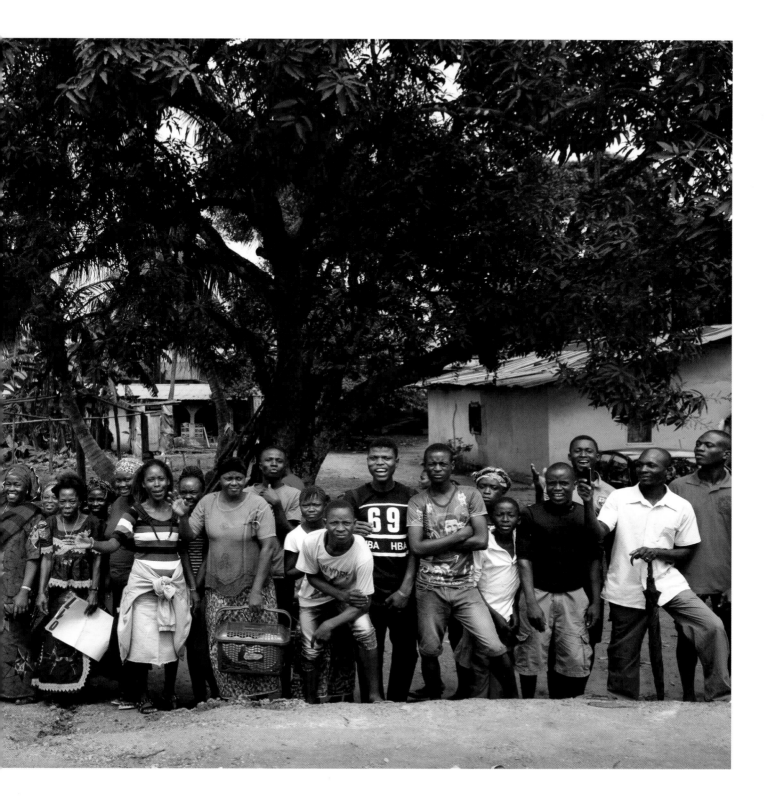

The First Lady hugs a student following a lesson about girls' leadership and self-esteem at the Peace Corps Training Center in Kakata, Liberia, June 27, 2016.

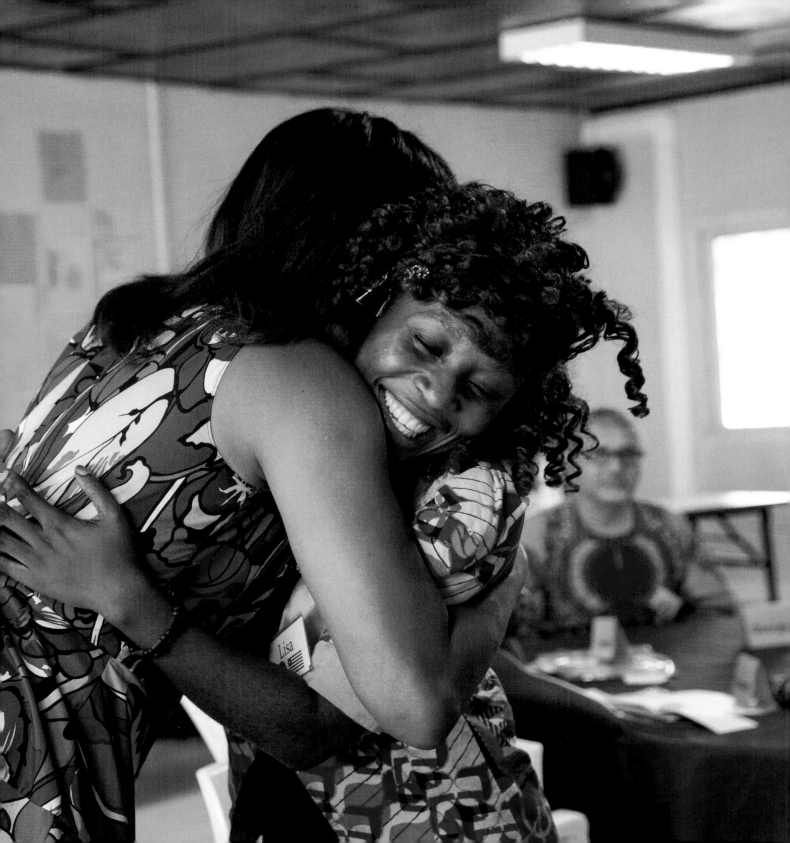

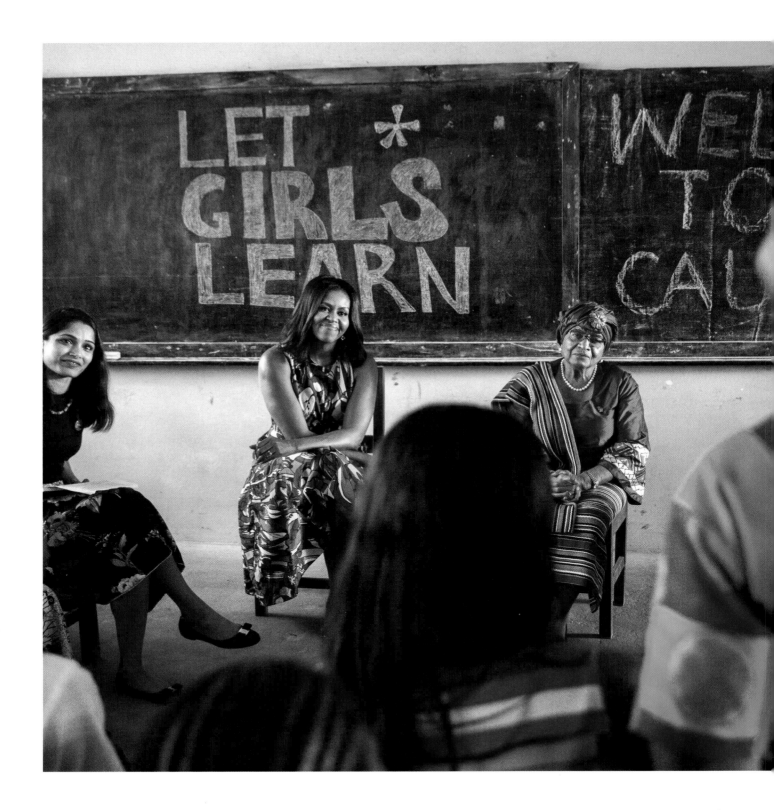

We arrived in Liberia in a rainstorm and drove for forty-five minutes on washed-out dirt roads to reach R. S. Caulfield Senior High School. All along the way, Liberians lined the road to show their excitement about Mrs. Obama's visit to their country.

The school was constructed with cinder blocks and had a dirt floor. There was no electricity, and the classroom was made darker by the passing storm. But the radiance of these young girls filled the room. They shared their stories of struggle and resilience.

While the school appeared rudimentary to us, the girls were proud of it and of the efforts they made to attend school every day. Some students related how they had to walk several hours through dangerous areas; others told us how they studied by candlelight at night after they finished working and doing the cooking and cleaning for their family.

The girls were in awe that Mrs. Obama and President Ellen Johnson Sirleaf, the first female elected head of state in Africa, would take the time to visit them. But Mrs. Obama was equally impressed with the girls she met that day.

First Lady Michelle Obama participates in a discussion with President Ellen Johnson Sirleaf, Freida Pinto, and students at R. S. Caulfield Senior High School in Unification Town, Liberia, June 27, 2016.

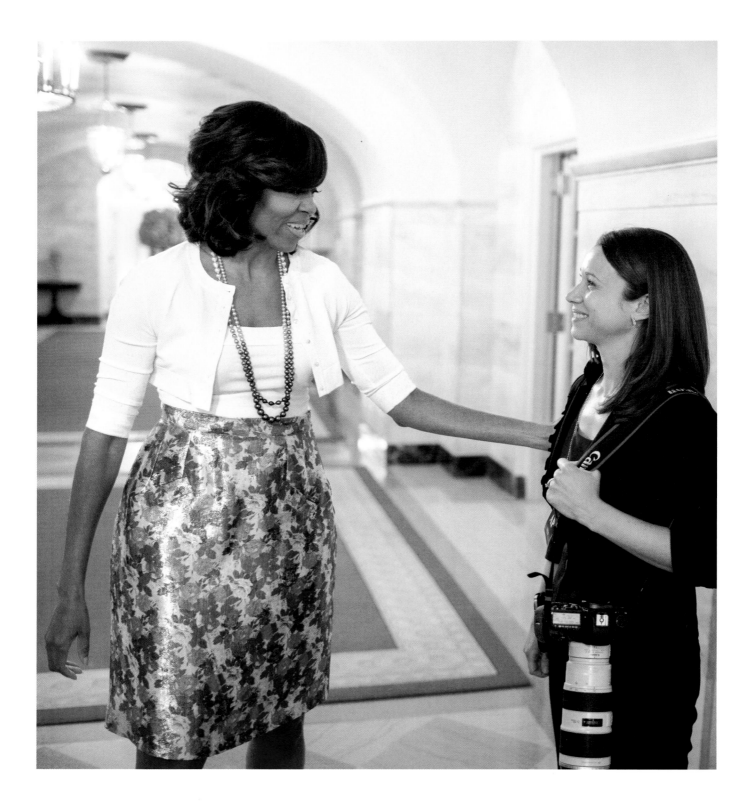

CHASING LIGHT

Before the end of the Obama Administration, I waited in the East Wing Reception Room with a handful of staff members and their families to have our departure photos taken with the First Lady. As I caught my reflection in the large gold-framed mirror above the couch, I remembered being in that room four years earlier to interview for the job as a White House photographer.

Back then, I'd been completely amazed to be alone in this beautiful room. The room was dimly lit, the paintings were elegant, the furniture was ornate, and the decor was sophisticated. I looked around at all the artists and craftspeople represented in the room and quietly thanked and congratulated them for their mastery. It is the highest honor to make it to the White House. As I took a closer look at the paintings, I caught my reflection in the mirror. *If my dad could only see me now*, I thought to myself.

I don't usually take selfies, but it seemed like an appropriate occasion and I shot two pictures of myself in the mirror, trying to be quick in case that sort of thing wasn't allowed. I wasn't confident that I would get the job, but I definitely wanted to have some proof that I had been there for when I told the story to friends and family.

A voice snapped me out of my daydream. "Thank you all for coming," said Sri Gainedi, assistant to the Chief of Staff. "We are going to move into the Diplomatic Reception Room to line up for your departure photos." I looked at my mother, my husband, and our daughter, Eden, who was only two weeks old. So much had changed since the day of my interview.

Sri asked, "Do you mind going last? Mrs. Obama is definitely going to want to hold your baby."

"Of course not," I replied. She hadn't met Eden yet, and I was eager to introduce her because Mrs. Obama absolutely adores babies.

When it was our turn to enter the room, the First Lady greeted us with open arms. The last time she'd seen me was before the First Family left for Christmas vacation, when I was nine months pregnant and days away from my due date, still waddling around with my cameras. Now she finally got to meet the little girl who had been "hitchhiking" a ride around the world with us.

Mrs. Obama was excited to meet and hold Eden. She asked my mom if she was enjoying her granddaughter. As I watched Mrs. Obama interact with my mother and daughter, it was clear how much both women had impacted my life. Both had been my mentors, role models, and sources of strength. I thought about the resounding effects they would in turn have on my own daughter and I felt grateful.

My mother had taught me resilience and grit. She was a single mom who worked three jobs for most of my childhood. She was driven to get us off of welfare and to provide a better life for us. I watched her encounter so many obstacles. Looking back, it's so impressive that a woman of such a small stature—just five feet tall and less than a hundred pounds—could have the courage to overcome so much. The need to provide us with safety and security pushed her past the limits of what she thought was possible.

Mrs. Obama also came from humble beginnings and has worked incredibly hard to make the world better for other people. I listened to her share her story to inspire so many people we had met over the years. I've always admired her ability

to ignite a spark in young people, especially those who struggle to see the light inside themselves. She opened the doors of the White House to so many people who didn't feel they deserved to be there. And she always reassured them that they were as smart, talented, special, and as deserving as anyone else.

Mrs. Obama taught me that too. She has always been a shining example of the light I was chasing in my own life. Watching her through the lens of my camera, I learned so much about myself and the life I wanted to create. And I was finally living it.

On that day, I was grateful for the opportunity to thank my mother and Mrs. Obama at the same time for the positive imprints they have left on my life. I held back tears as I looked at my beautiful daughter and loving husband. None of this would've been possible without the lessons I learned from these two nurturing mothers.

As I walked out of the White House for the last time, I thought about all the times those gates had let me in. I suppose I felt like many of those who were welcomed as guests to the Obama White House. I felt like I didn't belong there, and yet the gates still opened for me. It felt like a dream, but I knew it was real.

What happened on the other side of those gates, in the Obama White House, changed our country's history—and my life—forever.

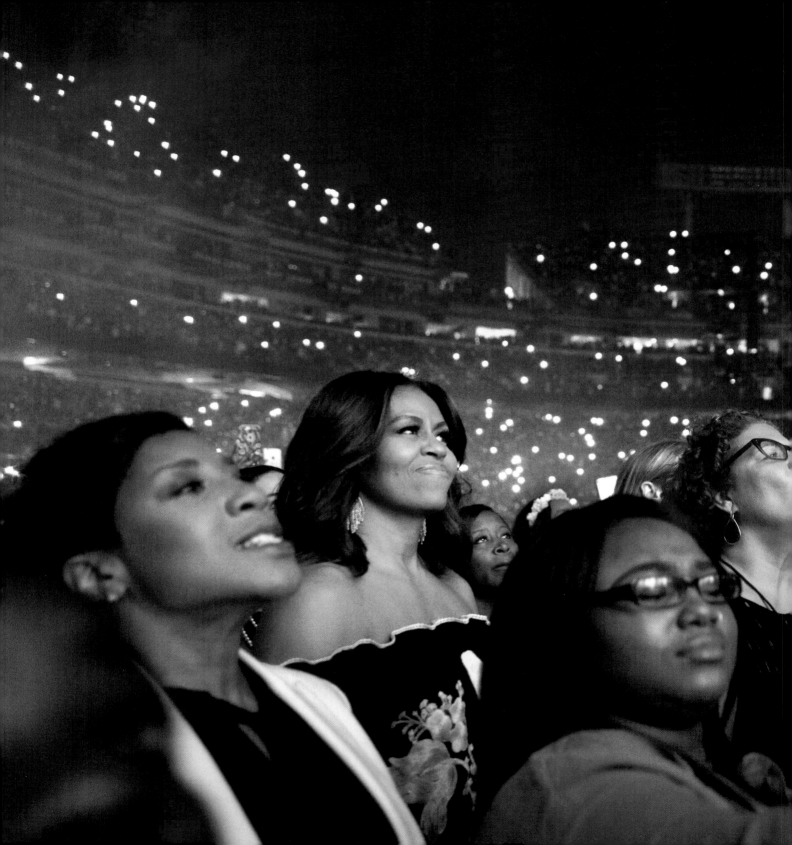

The First Lady attends the Beyoncé
concert with friends and family at
the M&T Bank Stadium in Baltimore,
Maryland, June 10, 2016.

AFTERWORD

I've heard President Obama and Mrs. Obama say time and time again, "Once you've done well . . . make sure you reach back to help give others the same opportunity that you've had."

I am extremely grateful for the opportunity to create this book, which will allow me to donate a portion of the net proceeds to Turnaround Arts.

Turnaround Arts is a program started by First Lady Michelle Obama that introduces high-quality arts education to strengthen school reform efforts, boost academic achievement, and increase student engagement in schools facing the toughest educational challenges in the country.

For more on Turnaround Arts, visit their website at turnaroundarts.kennedy-center.org.

Please visit my website to learn more about *Chasing Light* and the other programs I am supporting: www.chasinglightbook.org.

President Barack Obama and First Lady Michelle Obama go for a hike on the Na Pohaku O Hauwahine trail in Kailua, Hawaii, January 4, 2014.

ACKNOWLEDGMENTS

There are so many people who work behind the scenes to support the First Family and protect and preserve the White House: the West Wing and East Wing staff, the White House Communications Agency, the White House Medical Unit, the Executive Residence staff, the National Park Service, groundskeepers, and Secret Service. Thank you for so many wonderful memories to cherish. You made the long days feel much shorter by offering support, candid conversations, and plenty of laughs. I am grateful to call you my friends.

The White House Photo Office was filled with people who worked diligently behind closed doors to make sure photos are edited, processed, printed, distributed, and archived. Janet Philips, Al Anderson, Anna Ruch, Shelby Leeman, Tim Harville, Chris Mackler, Jim Preston, Kim Hubbard, Keegan Barber, and Katie Waldo—I am grateful not only for your hard work and dedication but for your constant love and encouragement. I was fortunate to work with and learn from some of the best photographers in the business: Pete Souza, Chuck Kennedy, Lawrence Jackson, and David Lienemann. Pete Souza, thank you for being a mentor and a friend, and for giving me the opportunity of a lifetime. We will always remember the dedication, talent, and joy of our beloved photo editor, Rick McKay, whom we lost to cancer. The Photo Office became my second family and my home away from home. I am eternally grateful for all of you.

I had no intentions of writing a book until literary agent Rachel Vogel called me and convinced me otherwise. Thank you for helping me see this through. Thank you, Mrs. Obama and Melissa Winter, for your guidance and support, as well as Tina Tchen, Joe Paulsen, Caroline Adler Morales, Tiffany Drake, Mackenzie Rae Smith,

and Chynna Clayton. To the amazing Ten Speed team—editor Kaitlin Ketchum and designer Emma Campion, as well as Aaron Wehner, Hannah Rahill, Natalie Mulford, Windy Dorresteyn, Kristin Casemore, Jane Chinn, Mari Gill, Ashley Pierce, Maya Mavjee, David Drake, Carisa Hays, and the rest of the Ten Speed and Crown Family— I appreciate your support, encouragement, and vision. Thanks, Shelby Leeman; your talent, dedication, and attention to detail were invaluable to this project. Elizabeth Krist, I am so grateful for your time, patience, and expertise. Laura Pohl, thanks for your endless offers to help. And Maurice Owens, thanks for your guidance, encouragement, and boundless enthusiasm.

Thank you to all of those who made starting over in DC an easier transition with your kindness and generous support—Molly Roberts, Susan Biddle, Mark Suban and the Nikon family, Doug Mills and Stephen Crowley of the *New York Times*, and all of the talented members of Women Photojournalists of Washington. To my mentors—Ronald Juliette, Denise Sanchez, Ed Crisostomo, Jahi Chikwendiu and countless others—your guidance, support, and encouragement have helped me carve this path.

I am nothing without my roots. To my family: life has been quite a journey, but we made it together. To my father: thank you for teaching me the importance of integrity. To my wonderful friends: I am so lucky for your steadiness through all life's ups and downs. To Alan and Eden: there was always something missing until you came into my life. With your love, anything is possible.

Thank you, President Obama and Mrs. Obama, for leading our country with dignity, respect, and integrity. It has been the honor of a lifetime to serve you.

ABOUT THE AUTHOR

How do you break through a glass ceiling? Be the girl with the tallest ladder.

Amanda Lucidon has been breaking boundaries throughout her career as a photographer, filmmaker, and multimedia storyteller.

As an award-winning documentarian, Amanda has taken on some of the most pressing social issues, such as the discrimination faced by same-sex couples under the Defense of Marriage Act, and the plight of migrant farmworkers, pregnant prisoners, and homeless youth. She has used her camera to reveal the injustices faced by underserved communities.

Amanda's work has been honored by Pictures of the Year International, National Press Photographers Association Best of Photojournalism, and White House News Photographers Association, among others. In 2013, her film *Legal Stranger* was showcased in film festivals across the country and sparked discussion around the issue of same-sex marriage before the Supreme Court decision on DOMA.

During her time at the White House, she was the only female photographer on staff. She is one of a few women in history to serve as an official White House photographer.

Amanda Lucidon and the press pool wait for the arrival of President Xi Jinping of China and Madame Peng Liyuan during the State Arrival Ceremony on the South Lawn of the White House, September 25, 2015. Photo by Lawrence Jackson.

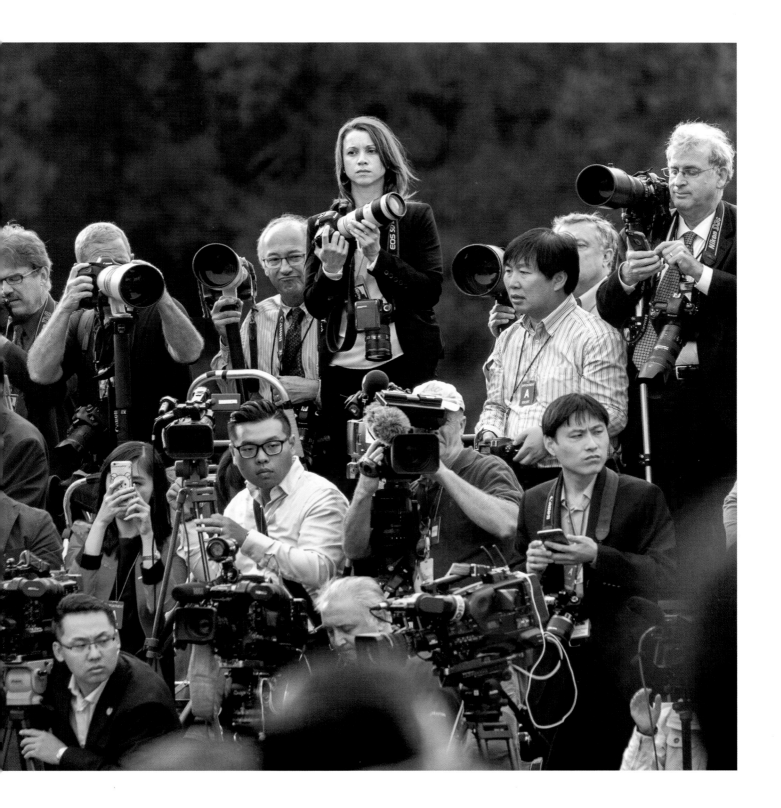

Copyright © 2017 by Amanda Lucidon.

All rights reserved.
Published in the United States by Ten Speed Press, an imprint of the
Crown Publishing Group, a division of Penguin Random House LLC, New York.
www.crownpublishing.com
www.tenspeed.com

Ten Speed Press and the Ten Speed Press colophon are registered
trademarks of Penguin Random House LLC.

All photographs are by Amanda Lucidon, with the exception of those appearing
on page 212, by Chuck Kennedy, and page 223, by Lawrence Jackson.

Library of Congress Cataloging-in-Publication Data is on file with the publisher.

Hardcover ISBN: 978-0-399-58118-2
eBook ISBN: 978-0-399-58119-9

Printed in the United States of America

Design by Emma Campion and Mari Gill

10 9 8 7 6 5 4 3 2 1

First Edition

ADDITIONAL PHOTO CAPTIONS:

Cover: The First Lady waits in the Green Room before being announced during a Counselor of the Year event in the East Room of the White House, January 30, 2015.

Page 2: Mrs. Obama meets with staff aboard her plane, Bright Star, during the flight to Madison, Wisconsin, September 12, 2013.

Page 6: Mrs. Obama hugs a child during a Drink Up event on the South Lawn of the White House, July 22, 2014.

Page 10: Mrs. Obama waits in the Green Room before a White House Historical Association Arts Reception at the White House, June 5, 2013.

Page 14: Mrs. Obama shares a laugh with Sunny and Bo, the family pets, during a video taping in the Map Room of the White House, April 14, 2014.

Page 56: The First Lady takes a selfie with Kevin Vincent (center) and Jeremiah Hall (right), the creators of the "Running Man Challenge," in the Cross Hall of the White House, June 21, 2016.

Page 114: Mrs. Obama gives the keynote speech at the Oberlin College commencement ceremony in Oberlin, Ohio, May 25, 2015.

Page 162: Mrs. Obama participates in a discussion with students at R.S. Caulfield Senior High School in Unification Town, Liberia, June 27, 2016.

Page 212: Mrs. Obama meets Amanda Lucidon, the new White House Photographer, in the Ground Floor Corridor of the White House, June 5, 2013. Photo by Chuck Kennedy.